for Joke M.A. van Hengstum

Light Zone City

Light Planning in the Urban Context

Christa van Santen

Birkhäuser – Publishers for Architecture

Basel · Boston · Berlin

Contents

Foreword

Light in the city is necessary for orientation. Lighting makes it possible to distinguish streets, paths and parks, and allows users of public spaces to see each other. The illumination of buildings, the lighting of objects and of green spots in the city can also serve to beautify the surroundings, providing it is done well.

The use of the incandescent lamp in the public environment has now had its day. The development of new light sources and accompanying luminaires has greatly increased our possibilities. Public lighting nowadays comes in a number of varieties, all supplied with cleverly designed optics. Yet sometimes it seems as though all exterior light, not only for advertising, but also for the illumination of buildings and even street lighting, has become a marketing tool. A fashion item that must be put on display and sold to the consumer. Coloured light is used whether it is suitable or not. It is suitable when a party atmosphere is required or where it plays a functional role without detracting from the other light that is present; it is not suitable when it makes the city resemble theatrical scenery. However charming and enchanting it may be, light that has the function of attracting the attention to advertising or of accentuating decorative elements does not help to make a space more easily navigable. In many places,

rules have been devised so as to avoid an excess of such light.

A master plan for the lighting of a certain area is preferable to individual designs that are aimed at one feature without taking the surroundings into account. A good master plan is tailored to the individual character of the environment and creates coherence in the nighttime appearance of the place. The city at night is different from the city during the daytime. The daytime atmosphere cannot be imitated. The night can certainly be a little more 'mysterious' and have its own ambience. The architecture and town planning of a location should serve as a guideline for a carefully designed lighting concept. In many cities, there are fine examples of buildings that are illuminated in a way that shows understanding of the significance of the architecture.

The thematic chapters of this book throw light upon the function of illumination in the city. To illustrate this, a variety of locations in different cities have been photographed and provided with a commentary. These snapshots in time help to clarify the possibilities and the limitations of illumination.

Christa van Santen, February 2006

The City as an Outside Interior

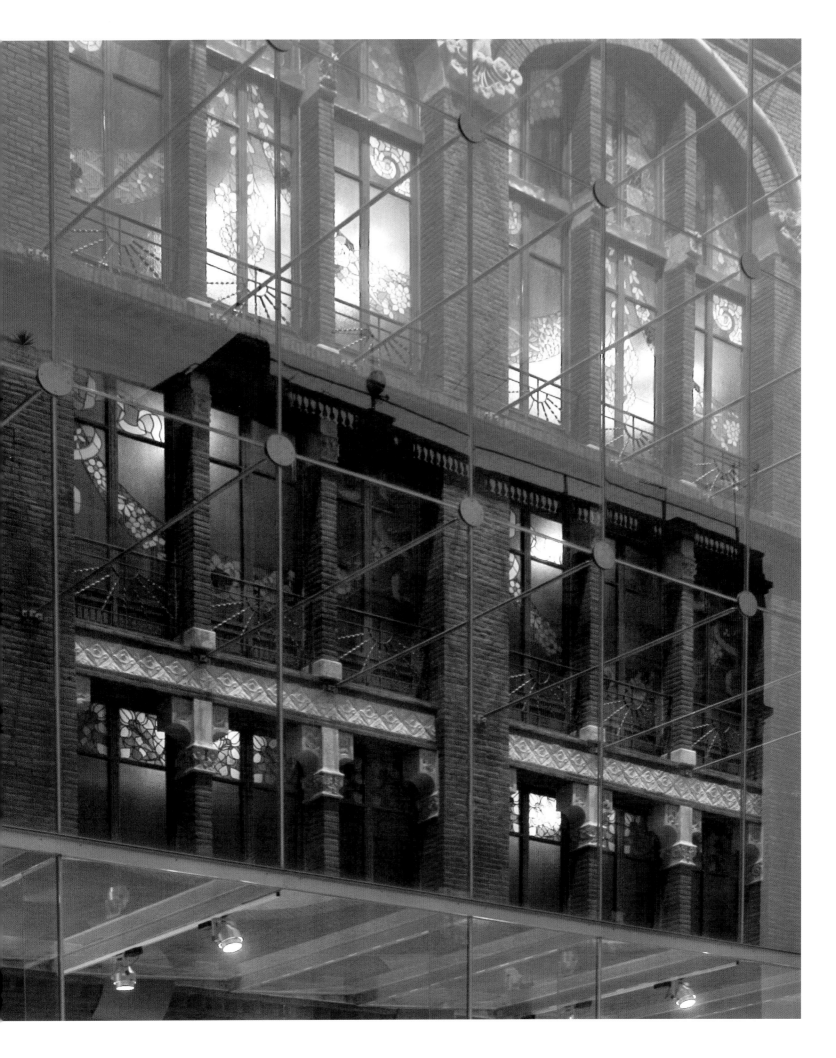

No two interiors are the same; even when a fashion trend is being followed, there are still differences. An interior is the reflection of the character and the circumstances of an individual. Much of what transpires during the design of an interior also plays a role in the design of the 'outside interior', in spite of the differences in scale. An outside interior is still an interior; you can also talk in terms of walls and a floor in this situation. What makes the outside interior of town A different from that of town B, apart from the characteristic accents of the skyline, which makes the town recognisable from a distance? The town may lie on the sea, on a river, there may be canals or there may be no water at all. It may be on a large scale or on a small scale: with narrow streets or wide boulevards, small or large squares. In short, the outside interior, regardless of scale, is formed by the architecture of features including streets, squares, buildings and less obvious elements, such as markets and other functional constructions. The architecture can be cleverly employed in creating the nightscape, and the architect needs to bear this in mind. Functionality and economy are all part of the equation.

The streets, squares and buildings give shape to the city. Experts and interested parties recognise the urban-development and architectural ideas underlying the shape of the town: construction in parallel street layouts, in circles around a centre, and so on. Streets have a direction; the orientation of a square is more complex. When you come out of a street, a square offers an element of surprise: there may be a church, striking buildings, a market, or something special might be happening. A square has a private character, which applies to a lesser extent when, for example, it is situated on a wide thoroughfare. Squares give a feeling of a large scale, openness, or, alternatively, intimacy, with many degrees between. They create an overview and provide orientation in the area, allowing, for example, a view into side streets or of places where roads meet. We also want to benefit from these daytime qualities and characteristics in the evening: the identification of buildings, the view into side streets, the cohesion of the whole. The illumination of water, parks and green spaces in the town also deserves separate attention, because they have their own demands. The character of the town must not be lost through the use of artificial light.

Light is subject to fashion. New sources of light provide more opportunities, such as the use of coloured light, which has become a fad. The town as such needs to be harmonious, with an accent here and there, not a constant disco or fairground, but in itself it's not wrong to use coloured light. The use of coloured light is acceptable and festive when it comes to special events and places that you go for a night out. Use is often made of coloured light for fountains, for example, which makes you wonder whether it is a new interpretation or a fleeting fashion.

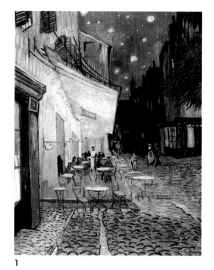

1

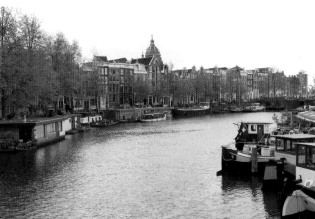

2

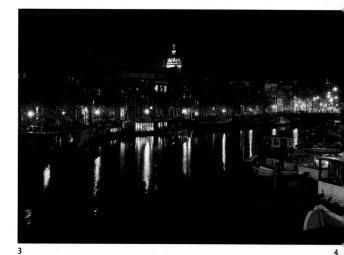

3

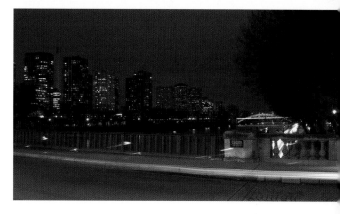

4

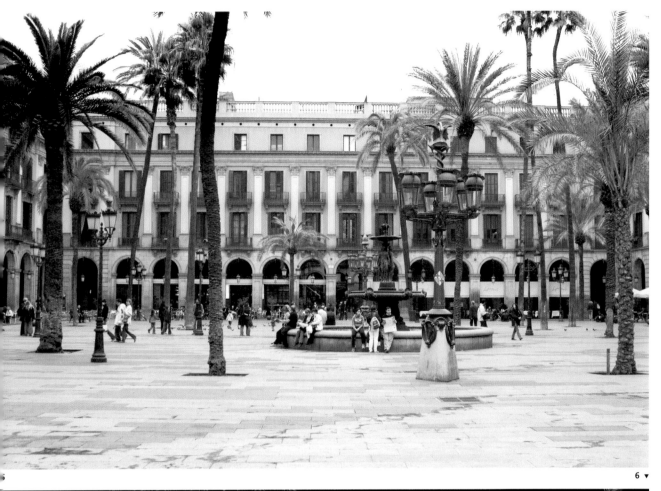

1

Vincent van Gogh, *Café terrace on the Place du Forum*, 1888 This is a picturesque illustration of chance elements coming together to create warm and welcoming surroundings. A single streetlamp lights the terrace. The light from the houses and shop-windows, with the starry sky above, contributes to the inviting nature of this outdoor spot.

2/3

Kromme Waal, Amsterdam. By day we see the surface of the water, the boats and the line of trees. At night, we see the light from the streetlamps, the light from the houses and the reflections in the water. The dome of the Church of St. Nicholas in the background, which is scarcely noticed during the daytime, now becomes a landmark feature.

4

Quai de Grenelle, Paris. One element in the perception of the city: anonymous residential tower blocks. At night, these illuminated objects have a casual coincidence.

5/6

Plaça Reial, Barcelona, is a square with the atmosphere of a 'living room', with a fountain, palm trees and streetlamps with many branches. There is no through traffic. Where there's life, there's light. This, together with the public lighting and the pale colour of the walls and floor of the square, determines the atmosphere.

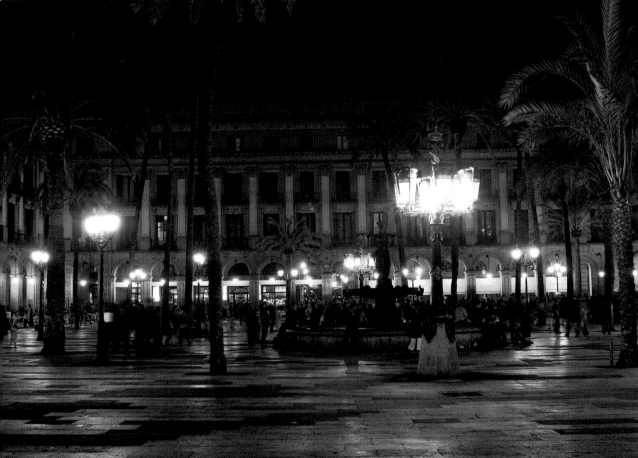

1/2

For this elegant square, Place Ven-dôme in Paris, efforts have been made to achieve unity in its appearance during the day and at night by illuminating the walls in a consistent way. The illumination comes from lights that are incorporated into the public streetlamps. An excess of lampposts has been used to create the desired consistency. It is inevitable that people are bothered by the many lights entering their field of vision.

3/4

Palais du Louvre, Cour Napoleon, Paris. The pyramid is the centre of this space, partly determining the size and scale of the surroundings, both during the daytime and at night. A row of old streetlamps along the façade provides light at pedestrian level. There is sufficient light on the square, which means the indication of pathways in the form of low light-posts is superfluous. This can also be seen from the photo taken in the evening, where one line of lights is not working.

5/6

Piazza del Popolo, Rome. From this elevated position, the shape of the square with its central column and fountain can clearly be seen. It is a large recreational square, with traffic circulating around the outside. A relatively low number of tall posts with a number of lights provides ample light for the whole area including the surrounding walls. The reflections in the wet floor add some extra life to the scene. The water in the fountain is lit up at night, providing a new focal point.

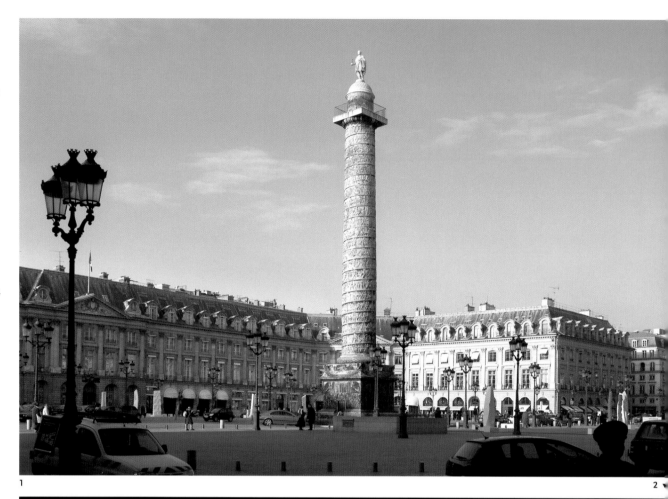

1

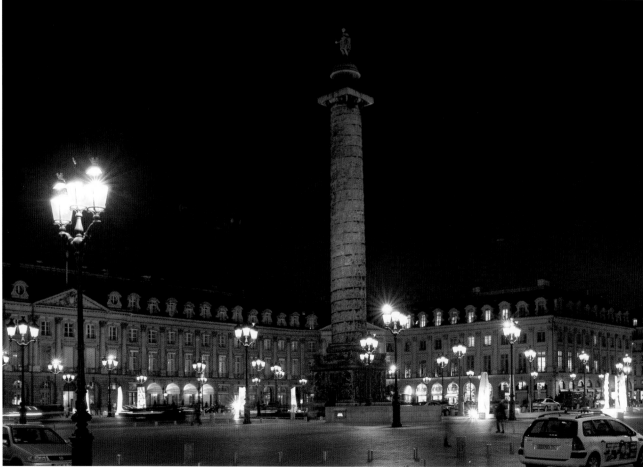

2

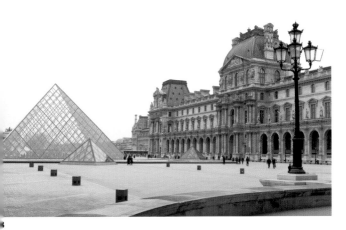

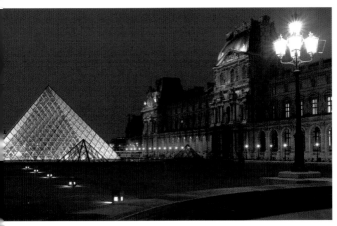

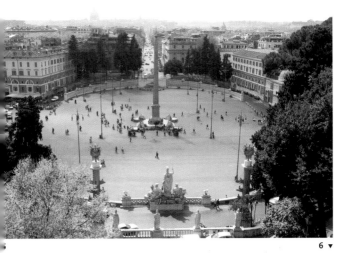

6 ▼

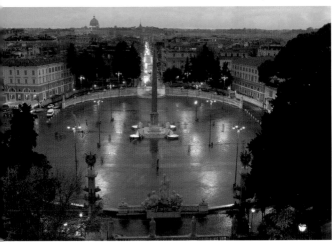

Light is present in the evening and during the daytime. In the evening, the accent falls on the light and its effect. Vertical light is most successful at making us perceive space. During the daytime we see lampposts as part of the street furniture. Their shape and size are important in relation to the environment; they are effective features, although, like any other 'furniture', they often spoil the view. In the redesign or renovation of squares and streets, attempts are made to combine freestanding elements such as benches, litterbins and lampposts, with the intention of creating a harmonious atmosphere. Designers of street furniture nowadays see this as part of their task. There are areas of towns that have their own design and illumination in an attempt to distinguish themselves from other residential areas.

The material and the colour of paving, of house fronts and other buildings have an influence on the light. A dark floor that does not reflect much light is not good for visibility. Very shiny paving disorientates people, as can easily be seen after a rainstorm. Wet streets can look very picturesque, but they create confusion when the light from shop-window displays, advertising boards and public lighting reflects annoyingly in the shiny paving. The pedestrian can have the feeling that they are 'walking on water'.

Dark-coloured walls do not always help to create a pleasant atmosphere. But when all the exterior walls of buildings are lit up, it creates an unreal feeling of space, in contrast to the dark sky. A light-coloured wall reflects a lot of light, more than the average brick wall. Glass façades reflect the light source, which makes them difficult to illuminate. We need to realise that illumination is something extra: it is 'more usual' for the façades to serve as walls for the outside interior.

When a building is illuminated, the colour and material of the façades have their own requirements for the type of light source. Each lamp has a particular colour, which is what we perceive. Then there's the ability to reproduce a particular colour (or colours), the colour rendering. This means that you need to know the colour spectrum of the lamp. There are, it should be said, light sources that reproduce every colour, but some are better than others. So, when illuminating buildings, you have to consider the reflectance of the various materials, the colour and the texture (matt or shiny). More light is not always the solution. The colour spectrum and the amount of light are determining factors in the choice of a light source.

1/2

Plaça Portal del Pau, Barcelona. At the intersection of two roads (at the end of La Rambla) stands a tall column with a statue of Columbus, which can be seen from a distance. The disjointed surroundings mean that this area is not perceived as a square; the column is the only point of orientation. The statues at its foot are so excessively illuminated that the rest of it can hardly be discerned. You need to be a local to find your way around.

3/4

Frankenplatz, Cologne. An outside area bordered by the Kölner Dom, the river, the railway line and the museum. Pedestrians make a great deal of use of the square; it is the way from one part of the city to the other, on either side of the Rhine. The floor and the pathway alongside the railway line link up the individual elements. The choice of low lighting creates a fragmented effect in the evening and breaks up the coherence of the daytime appearance of the area. The tall lampposts along the path keep this route visible.

5/6

Piazza Navona, Rome, is an elongated square with narrow entrances. The axis is marked by three fountains, the central, most monumental one of which is by Bernini. The illumination consists of light from the streetlamps surrounding the central section and the lighting of the fountains from the water basin. Bernini's fountain is the most striking. The terrace by the building has its own lighting under the sunshades. This is an acceptable addition at pedestrian level.

7/8

Piazza della Repubblica, Rome. The fountain in this busy square is the centre of a traffic roundabout. The building in the background has the appearance of a closed façade during the daytime. At night, the illumination of the piers places the emphasis on rhythm. The lights have gone out in places, which is conspicuous in this repetitive rhythm. The different colour of the lights, caused by ageing in this type of light source, is also noticeable.

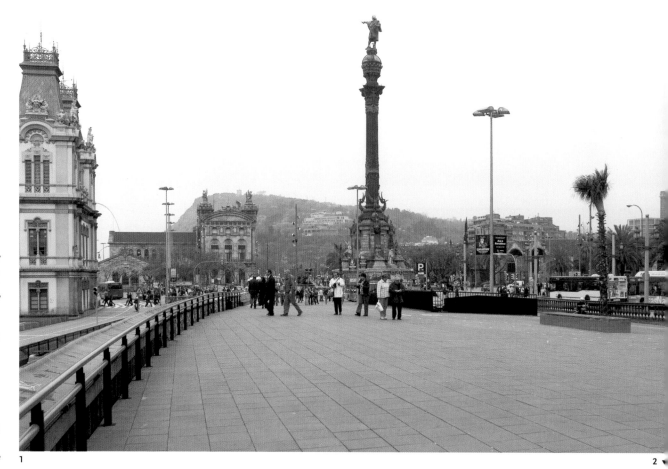

1

2

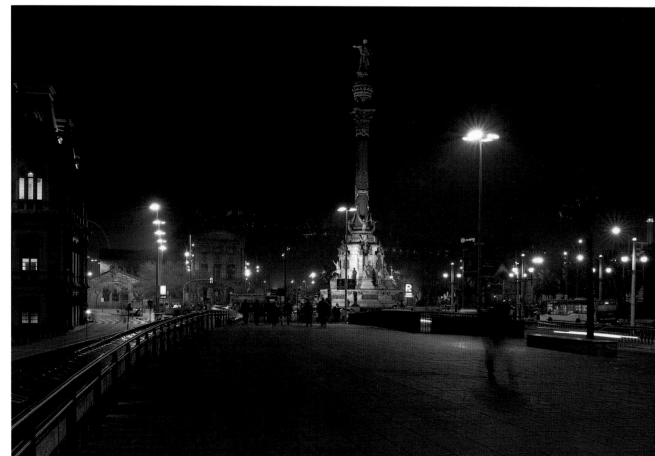

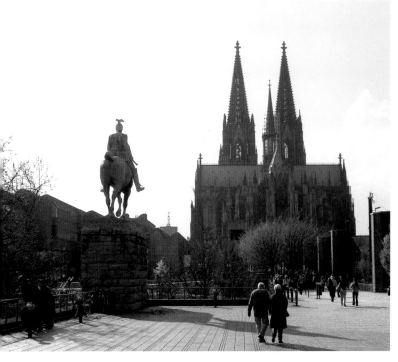

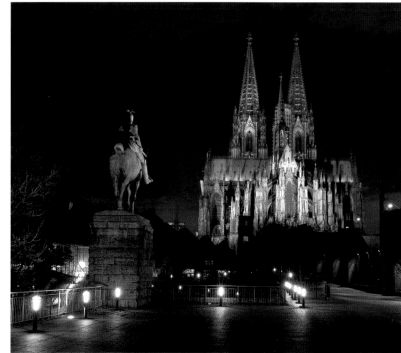

4 ▼

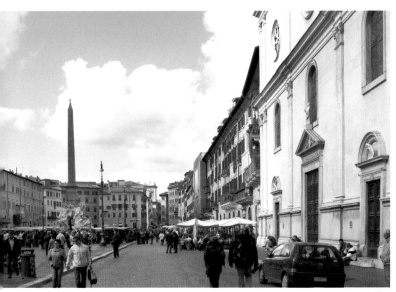

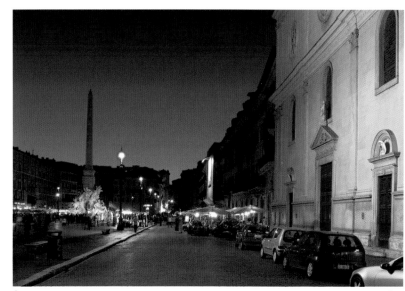

7 ▼ 6 8 ▼

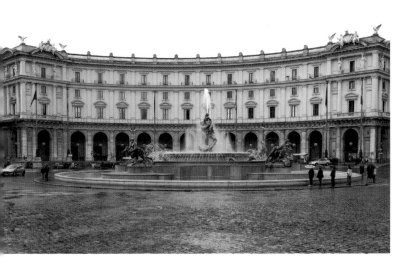

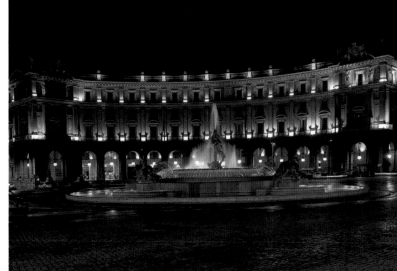

1/2

Place des Terreaux in the heart of Lyons, with the front face of the town hall. A characteristic feature of this square is the fact that there are no lampposts and the luminaires for the illumination of the buildings are mounted on the façades. The central part of the town hall with the tower forms an unbalanced element in the otherwise harmoniously illuminated building.

A concept has been developed for the whole square. Bartholdi's fountain is positioned off-centre and lit from the water basin. A design of spouting water and light is incorporated into the floor.

Architect/design Christian Drevet, Lyons, and Daniel Buren, Paris
Lighting technology Les Eclairagistes Ass., Lyon

3/4

The Musée d'Orsay, Paris, can be recognised from miles around, a landmark feature with its illuminated strip and two clocks, which are a legacy of its earlier days as a station.

5/6

The Museumplein, Amsterdam, is a large open green plain in the city, between a number of famous buildings: the Van Gogh Museum, the Rijksmuseum, the Stedelijk Museum (not visible) and the Concertgebouw. It is clearly an attractive backdrop in the dark, but forms an 'unassailable' barrier for pedestrians. The illuminated pathways provide a direction, but do not promote recognition.

The cool lighting of the extension of the Van Gogh Museum and the warm lighting of the Rijksmuseum, created by the different materials and the selected light sources, is a striking combination.

Landscape architect S.I. Andersson, Kopenhagen
Architects Van Gogh Museum Rietveld / Van Dillen / Van Tricht
Van Gogh Museum extension K. Kurokawa, Tokyo
Rijksmuseum P.J.H. Cuypers

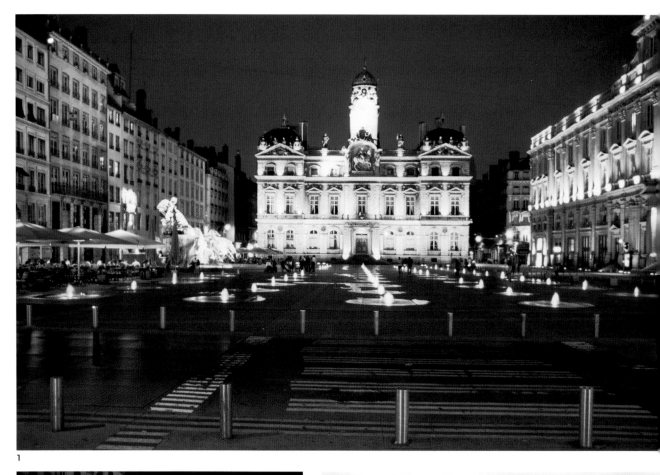

1

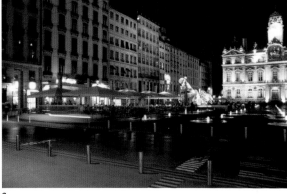

2

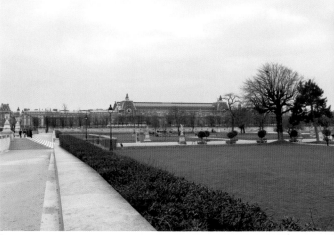

3

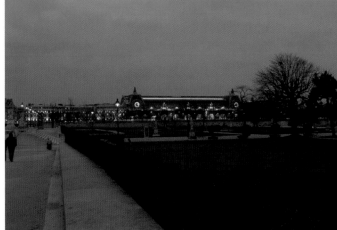

4

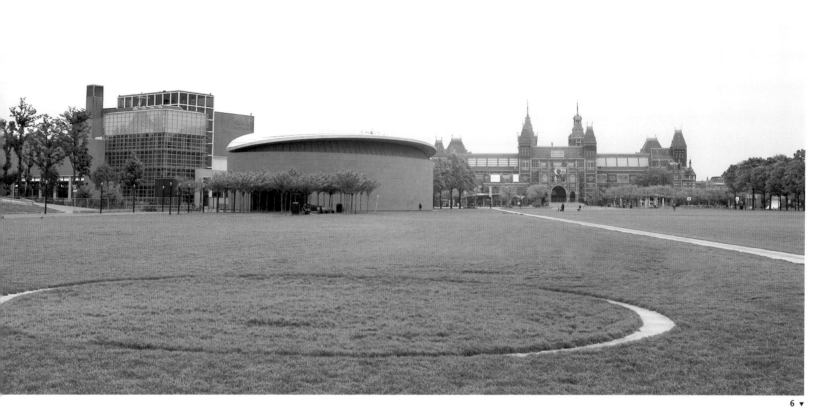

6 ▼

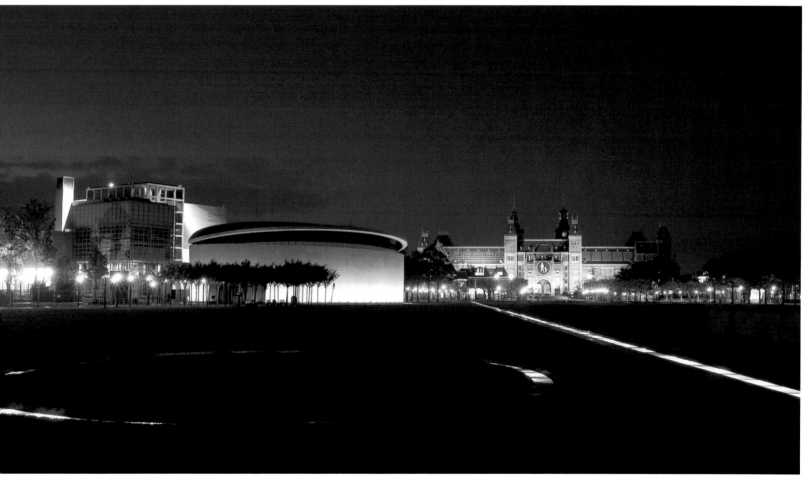

1

Avenue de Breteuil, Paris. This outside space is visually rounded off by one of Paris' famous monuments: the Dôme des Invalides. The perspective is emphasised by the public street-lamps to the left and right.

2

In the Jardin du Luxembourg (southern point), Paris, a fountain functions as a partition in the park. It is an individual object with no relation to the surroundings, but nevertheless a landmark. The illuminated sculptures and the jets of water reflecting the light come together to form an image that is consistent with the daytime appearance of the area.

3/4

The Eiffel Tower, Paris, is an icon of the city, both in the daytime and at night. The lighting plan for this tower is an important element of advertising campaigns and its variety always attracts attention.
Lighting design Pierre Bideau

Page 20/21

The 'Du Collège' pedestrian bridge, Lyons, forms a connecting route for pedestrians over the River Rhône. The (warm) light is incorporated into the railings of the bridge, creating a striking boundary to the walkway without spoiling the view of the river.
Lighting plan Technical department, Lyons City Council

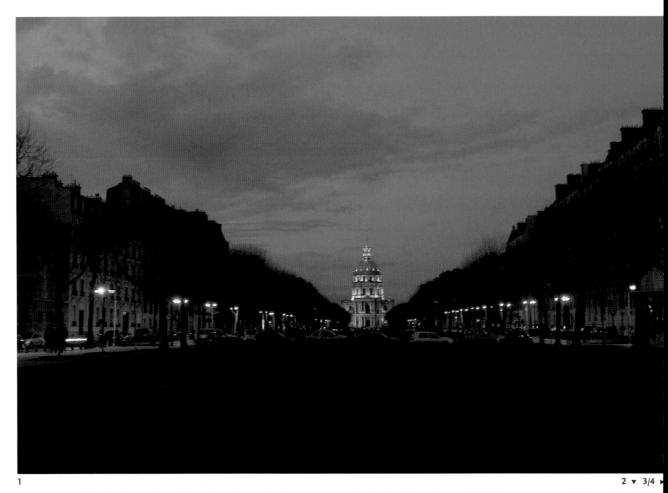

1

2 ▼ 3/4 ▶

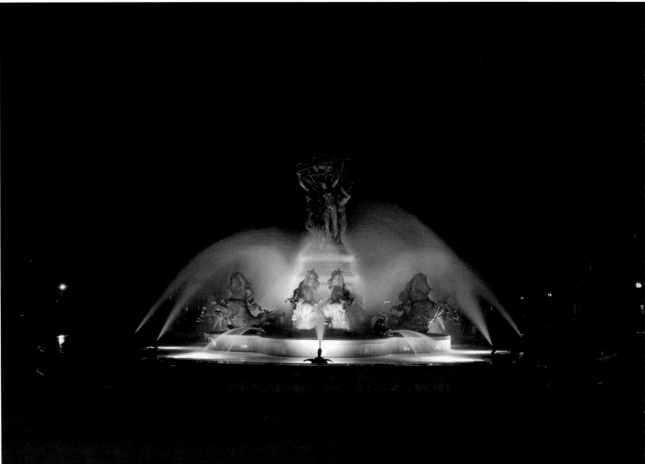

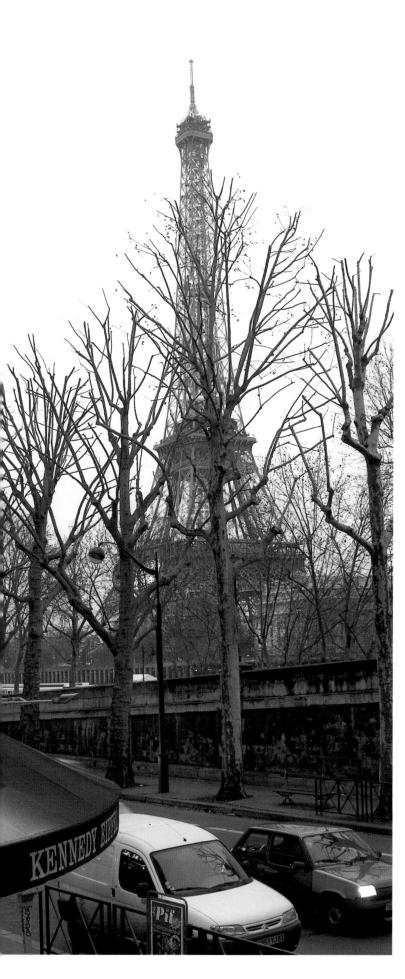
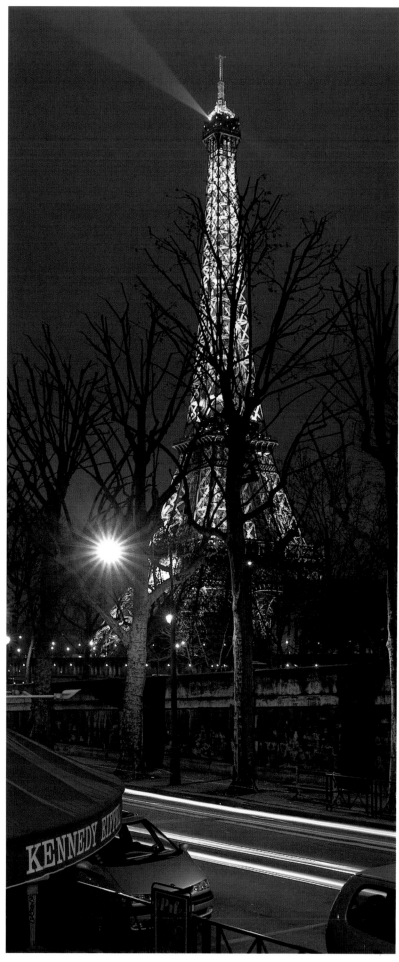

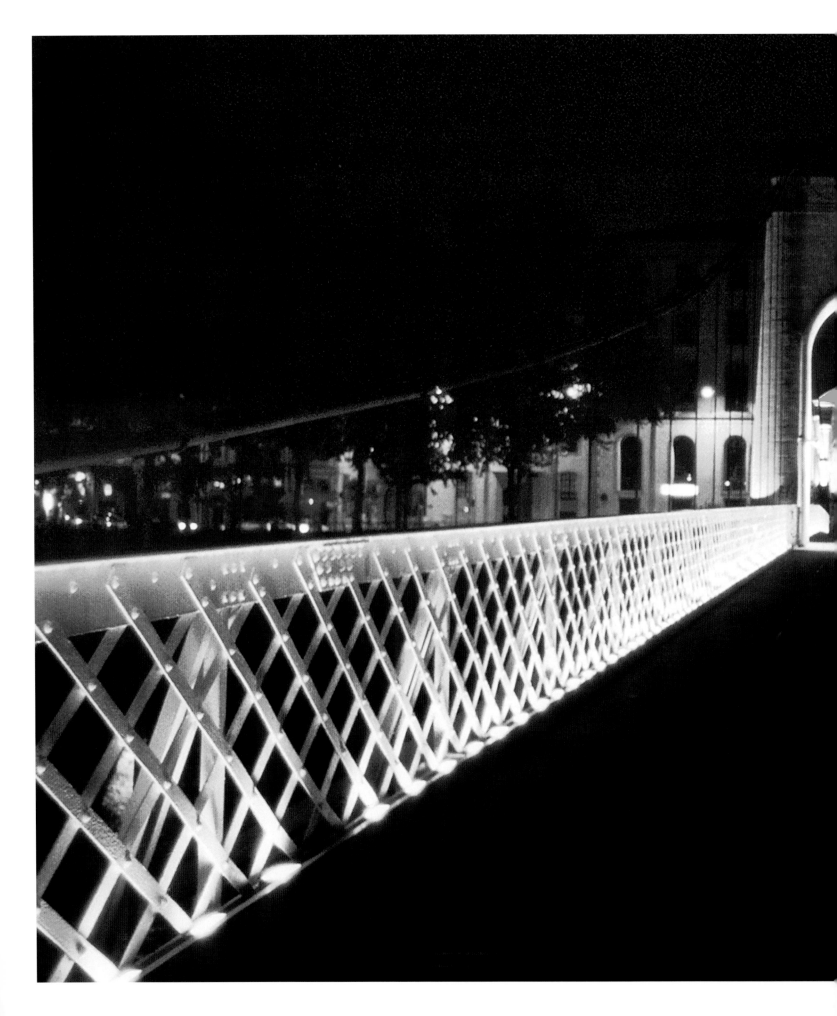

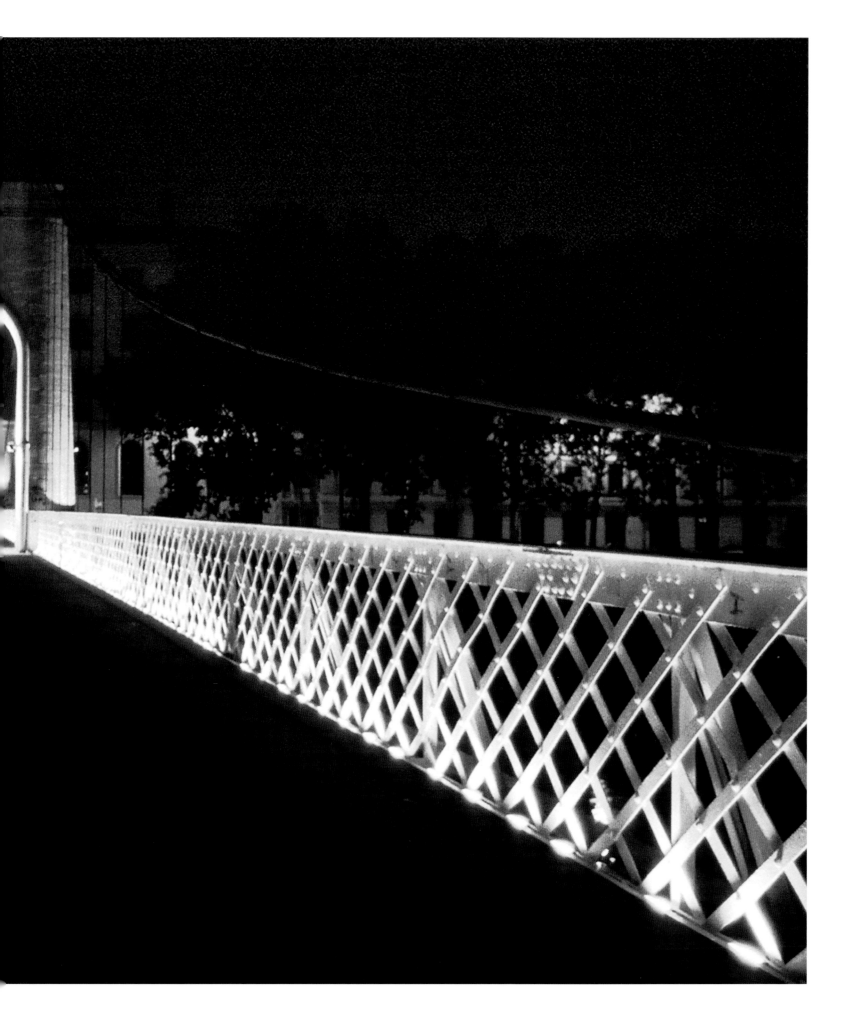

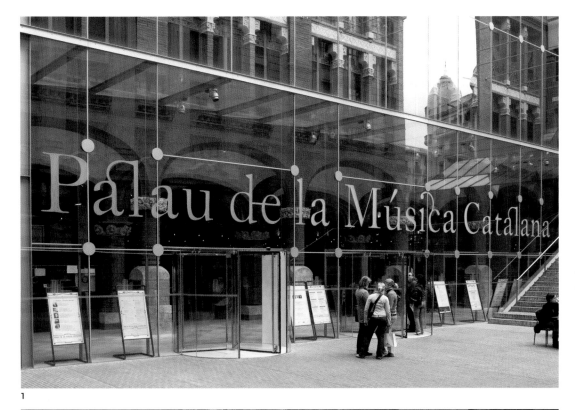

1

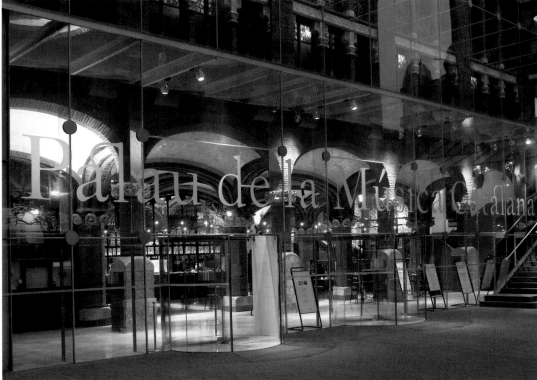

2

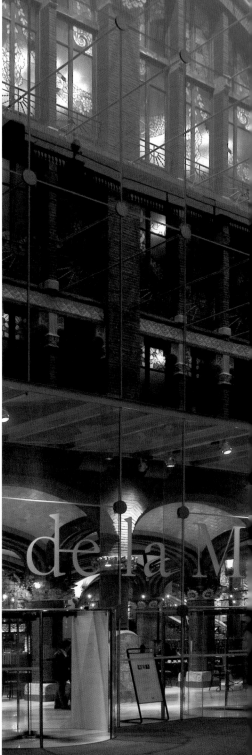

3

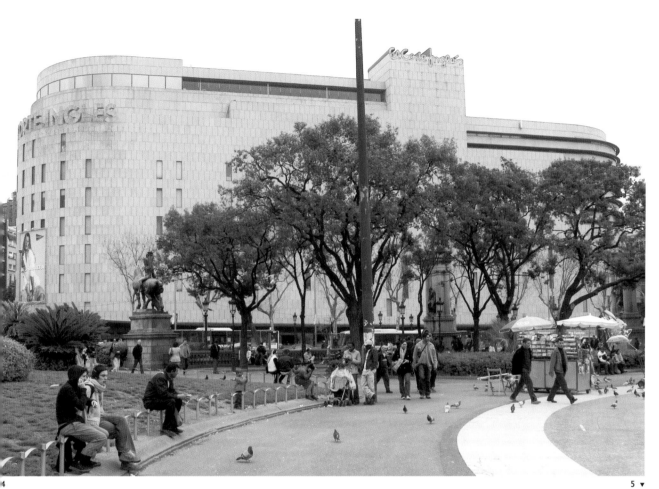

Extension of the Palau de la Música Catalana, Barcelona. During the day-time, the reflection of the glass façade creates a boundary for the square. At night, the light within turns the interior into a component of the exterior space, making the writing on the façade more difficult to read. The ceiling lights on the upper floors behind the glass façade make a con-tribution to the exterior perception of the building at night.
Architects Tusquets-Díaz Architects Studio

4/5

Plaça Catalunya, Barcelona. A depart-ment store can be seen on this large-scale square, as a backdrop to the trees. At night, the light from the dis-play windows, the carefully measured light from the roof, the well-placed illuminated advertisements and the incidental light from the openings in the façade make it into a boundary, in keeping with the scale of the square.

4

5 ▼

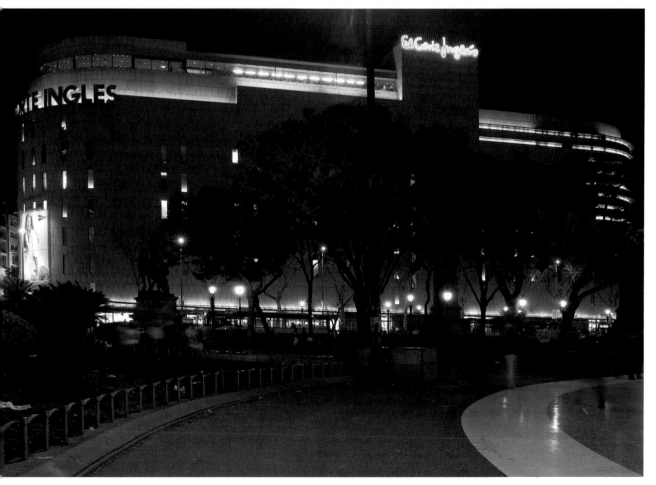

The City as an Outside Interior

Beautification of the City

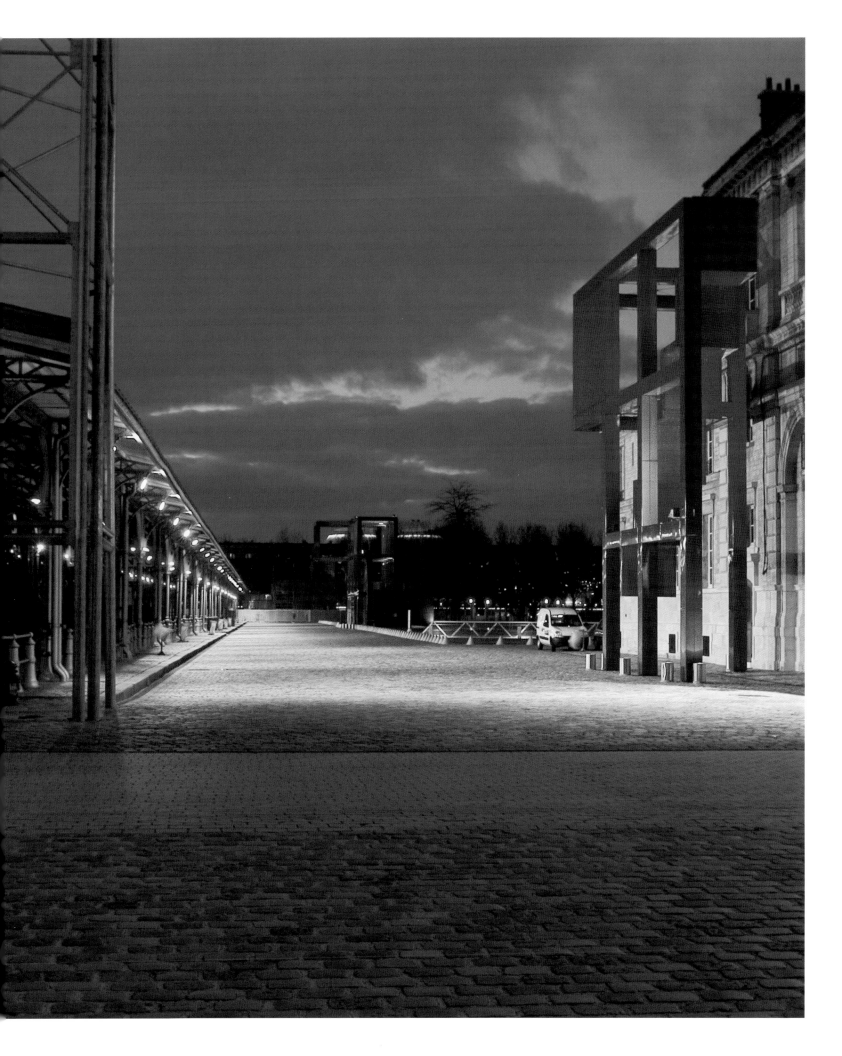

Visitors to European cities will experience most of them as a whole, not as a collection of separate architectural elements. Yet these old centres are frequently a motley selection of individual buildings that have been constructed in different ages. In spite of the architectural differences, during the daytime we experience the city as a whole, because the daylight that is present throughout the city unites it in a natural way. The light in the city at night is determined by all kinds of factors. Many of these are incidental: light emission from shop displays, lighting on terraces, light from cafés, restaurants, houses and other buildings, light from the traffic. It's quite a tall order to achieve a sense of unity at night, so that the layout and structure of the city is still clear and recognisable in spite of all the incidental factors. To do this, it is necessary to bring all the light into harmony, as far as possible. Public lighting is no longer exclusively functional, but should also be pleasing. The illumination of buildings, monuments and bridges and the lighting of fountains and other places of interest is receiving more attention.

Many cities are being redeveloped, tidied up and reorganised. They are being made attractive, and economic interests play a large role in this. The term 'beautification of the city' is often used in this context and everyone understands what it means: a city that has an attractive and inviting appearance, even after dark. This boosts the entertainment scene of the city, not only in terms of visits to the cinema or the theatre, but also to cafés, restaurants and shops. The basic principle lying behind this is: there must be something to do and to see, the city must be 'liveable'. A feeling of safety is also essential.

The lighting in the city in the evening and at night must create a pleasant atmosphere, but should not dominate. When there aren't many people on the streets, the surroundings must still be agreeable and not threatening. This holds the attention of tourists and other visitors for longer, so they make more use of the city. Residents should be pleased because the lights help them to identify people and places.

More demands are being made of public lighting than ten or fifteen years ago. There is more light in pedestrian zones and on cycle paths. Traffic requirements mean that a great deal of light has become necessary on the roads, partly because the traffic density has increased. In parts of the city and in socially deprived areas that have poor visibility, people expect a higher degree of lighting than elsewhere. More light on the street is often transformed into a feeling of safety.

The atmosphere that light creates cannot simply be encapsulated in rules: every situation is different. The situation as a whole is complex, not only involving costs, maintenance, energy – however important these factors might be – but also architectural, aesthetic and emotional values. This demands – and this cannot be emphasised

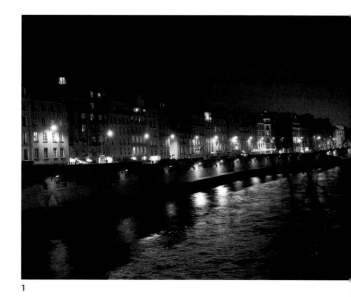

1

2

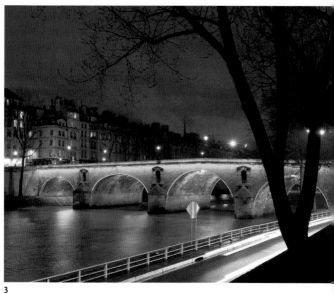

3

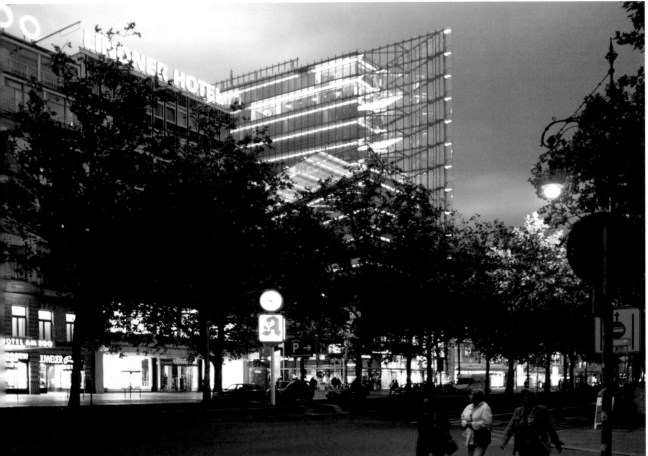

1/2/3
When the cities wishing to hold the 2012 Olympic Games made their presentations, Paris illuminated embankments, bridges and so on. As a display, this is seen as novel and surprising, but as a permanent illumination it comes over as a flashy fun fair.

4/5
This continuous row of shops on the Kurfürstendam in Berlin has an impressive appearance with no great contrasts, which creates a pleasant impression from pedestrian level in the evening. More should be done for orientation: with its focused lighting, the tall building, which isn't noticeable in the daytime, becomes a landmark. The public lighting is limited to the pedestrian area, but the appearance of the street is also determined by the liveliness of the illuminated display windows.
A collection of individual initiatives, a random effect created by advertising. A striking element is the building in the background, where light has been incorporated in the architecture. The rhythm of the façades is created by the light on the reveals.

5 ▼

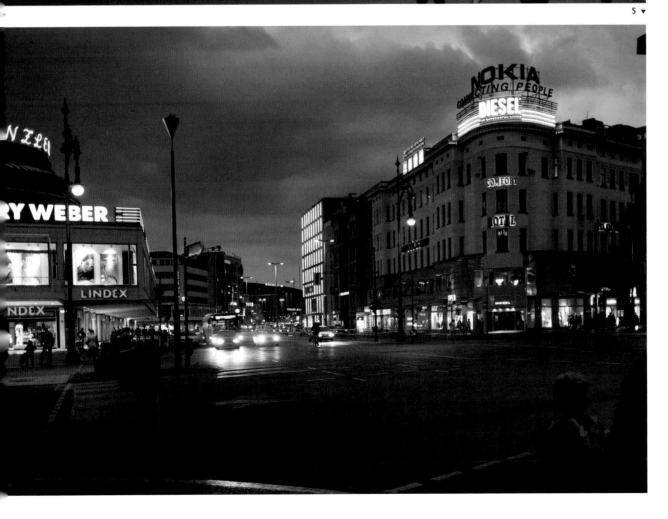

often enough – the involvement of designers with a good overall view, knowledge and insight.

Badly designed lighting plans do harm to the city, bringing about a lack of clarity and not contributing to the desired attractiveness. If they are inefficient, they demand a great deal of energy and maintenance. When the plans are good and it is possible to talk in terms of 'beautification of the city', this is because attention has been paid to the design and finishing features of the public space, so that the light and the layout work together to produce an interesting look. This is not simply a matter of design, but more a result of effective illumination.

Advances in lighting technology have made it possible, and even simple nowadays, to dim the light from gas-discharge lamps. In the same way, (programmed) changes in the colour of the light can also be fully controlled. In principle, this has nothing to do with the architecture itself; it's all about making temporary changes, to create a mood or for a special occasion.

Most European cities consist of old and new architecture that combines to determine the character of the city. Sometimes colour may be used if an unusual effect or a special concept is envisaged. Architectural cohesion requires balance in a three-dimensional, constructional sense, and lighting can help to ensure that the harmony of the daytime appearance of a site may also be experienced at night. The multi-coloured illumination that we see in photos from China and other Asian countries is often in the context of a modern architectural setting and is a particular feature of the local culture.

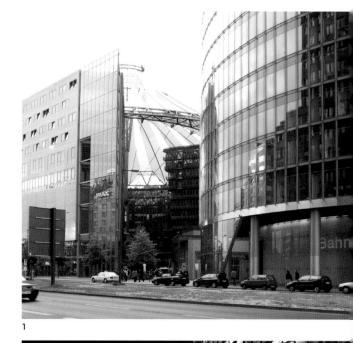

1

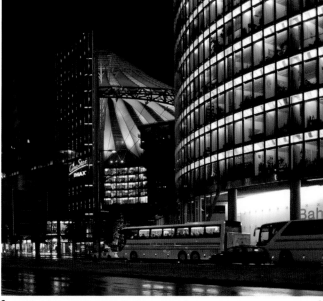

2

3

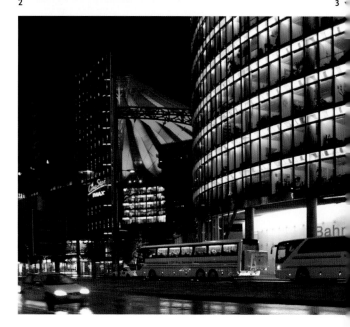

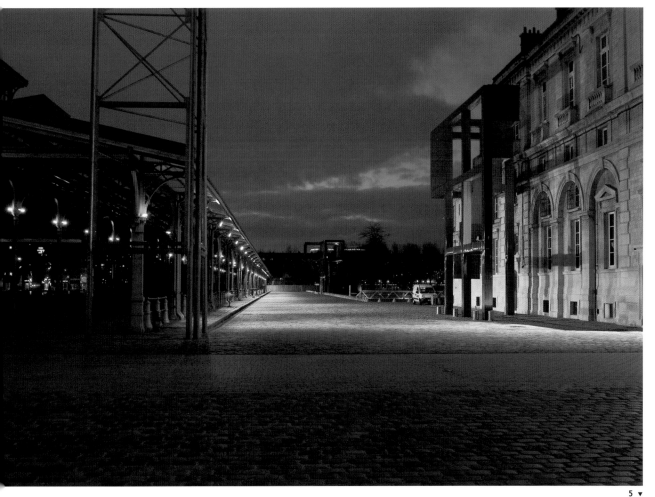

During the day this office district near Potsdamer Platz in Berlin is almost boring at pedestrian level. The façades work like mirrors. It's a great deal livelier in the evening, because it's possible to see into the buildings. The changing colours of the lighting of the Sony Center at night create a surprising effect amongst the unlit buildings.

Architect Helmut Jahn
Lighting design Yann Kersalé

4/5

Parc de la Villette in Paris demonstrates that colour and a large amount of light, combined with a large scale and emptiness, do not have to result in sinister or dismal surroundings. The deserted park looks like an empty film set. In reality, it's a popular area for going out (and also a thoroughfare). Colour works effectively here and makes it lively even when there are no people there.

5 ▼

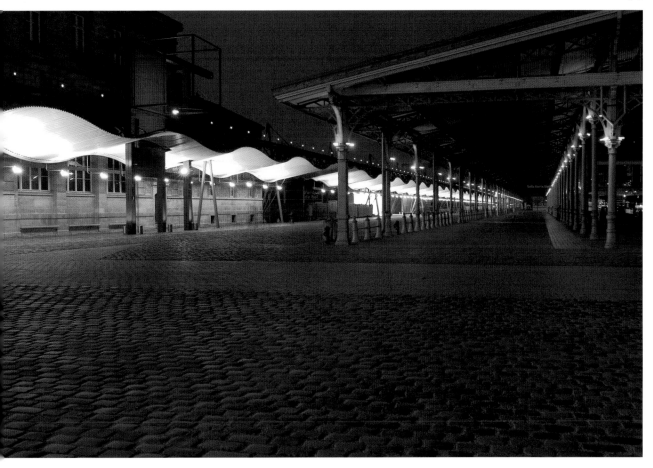

1/2

The Moll del Dipòsit, a busy boulevard along the harbour of Barcelona, with the History Museum of Catalunya at the end. The text on the façade is more visible in the evening than during the daytime. The appearance at night is attractive in every way. The light in the arcade and under the parasols creates a link between the inside and the outside. The bright, lively wall and the head-height columns of light provide sufficient illumination and do not impede the view of the boats in the harbour.

3/4

The high position of Frankenplatz in Cologne, a pedestrian area that forms the link to the Rhine, gives a view of the river and the opposite bank. The steps function as seating for events (music and other performances) on the square below. The low lighting doesn't disturb the view and illuminates the difference in the levels.

5/6

Plein 1992 is in a new district in the town centre of Maastricht. In addition to residential units, it also has a number of public facilities: the public library, shops, a theatre and restaurants. The tall streetlamps form one row with the trees and help to define the spaces on the square. This provides structure. The tall posts, together with the light given off by the buildings, provide sufficient lighting.
Design streetlamps Coenen/Fransen

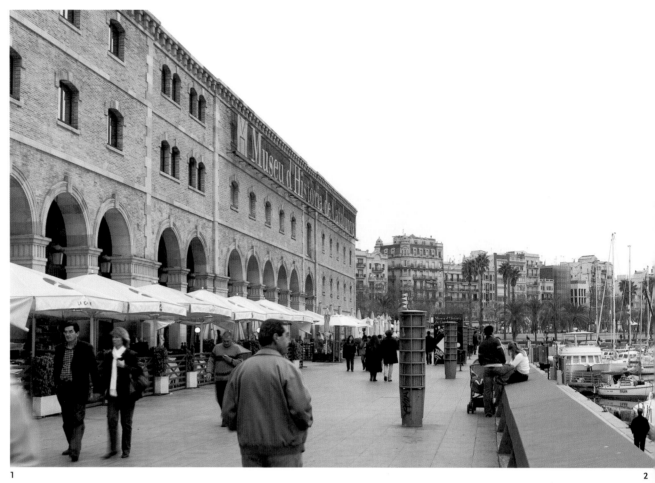

1

2

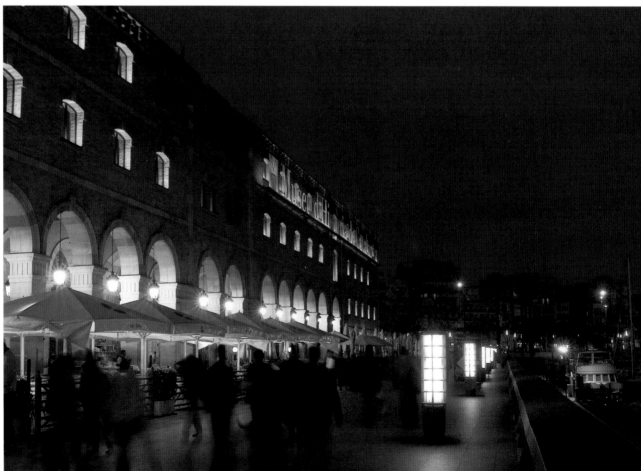

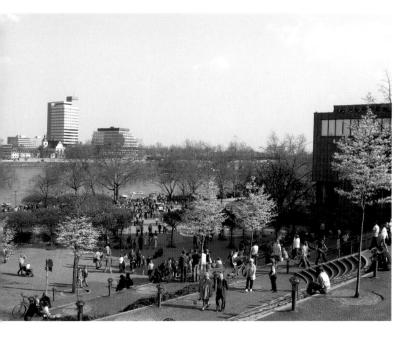

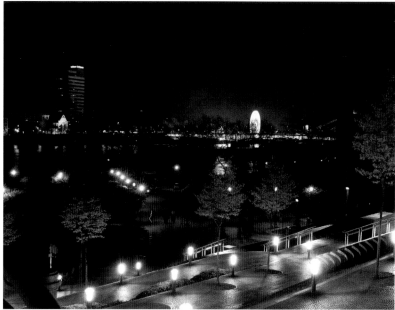

4

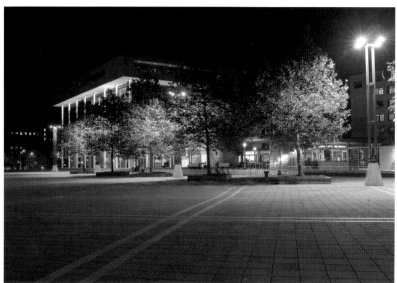

6

1

The street lighting of Corso Vittorio Emanuele in Milan consists of luminaires in the arcades, supplemented by some lights high up on the walls. The street ends with the view of the Duomo, free from lampposts and other illumination that might disturb the field of vision.

2

The layout of the Spui in Amsterdam, a busy thoroughfare for pedestrians and cyclists in the old centre, invites you to stay for a while in the evening as well as during the daytime. The old lamps along the walls have been retained. There is indirect lighting at the division between the cycle path and the pedestrian area, which provides clear signposting in the evening. Light has been installed under the benches, an accent that contributes to the anonymity of the people using this space.
Lighting design Department of Spatial Planning (dRO), Amsterdam

3

The Weesperzijde by the Amstel in Amsterdam is designed as a pedestrian area. The new lighting consists of a number of lights on a post, which illuminate the ground. Above the benches, which are placed back to back, a line of illumination has been installed. A combination of the general and the specific. The use of a number of lights on one post does not disturb the view here, as there are a lot of them and they are carefully directed. The plain nature of the surroundings makes the slight contrasts on the light floor attractive.
Lighting design Department of Spatial Planning (dRO), Amsterdam

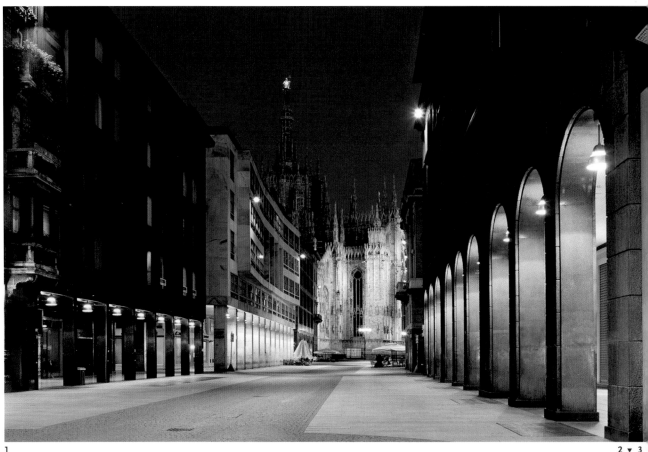

1

2 ▼ 3

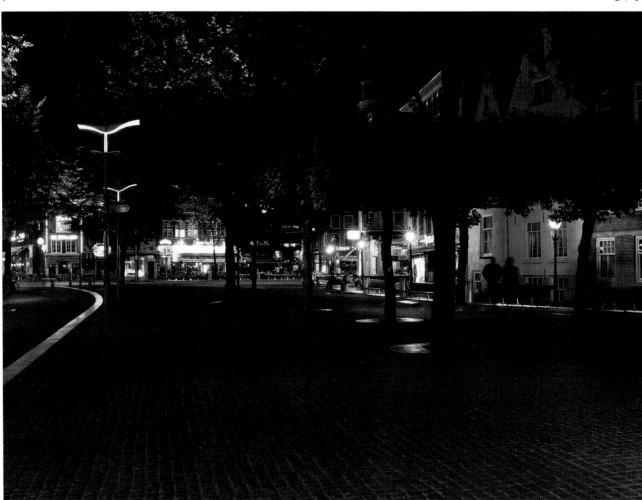

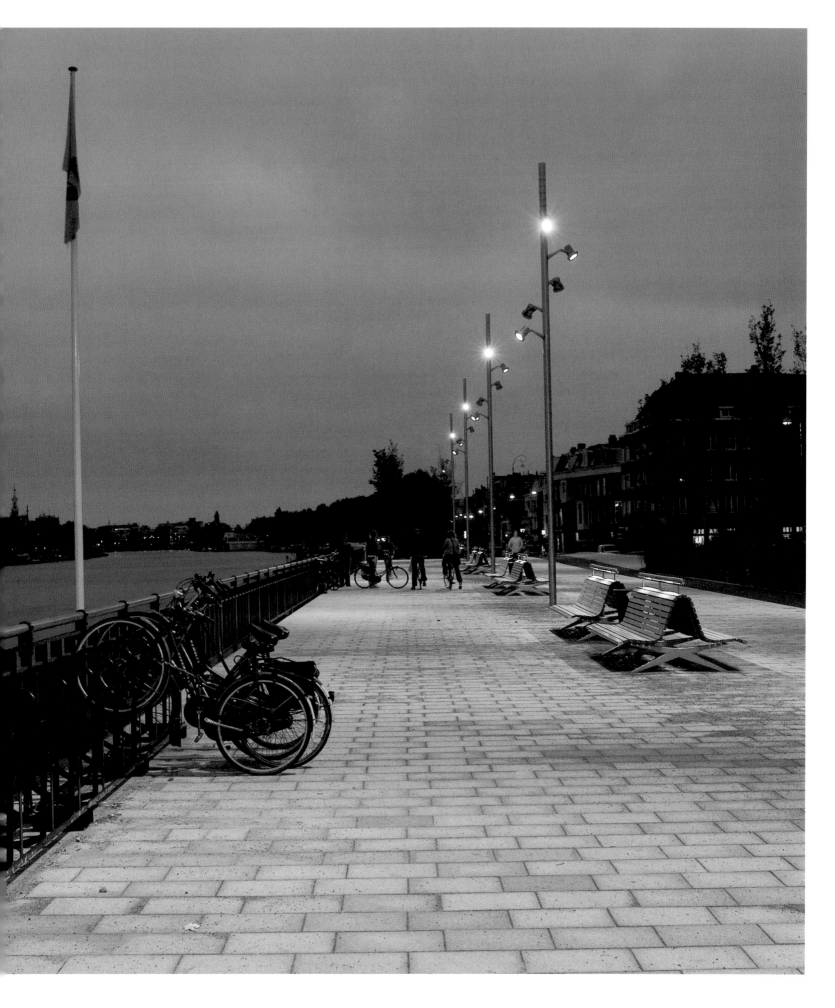

Public Lighting

Public lighting has a history beginning in the sixteenth century with candlelight and the oil lamp, which were superseded at the beginning of the nineteenth century by gas lighting and subsequently, at the beginning of the twentieth century, by the light bulb and the arc lamp. After the First World War, electric light offered a solution to the coal shortage. The most important feature of the light sources that have been developed in the past twenty years has been economical efficiency: more light for less money and a longer life for the bulb.

One year has 8,760 hours: public lighting is on for approximately 4,100 hours of this, and the luminaire is visible in daylight for 4,660 hours. In the evening, attention is focused on the effect of the light; during the daytime it is the support structure (luminaires and posts) that plays a part in determining the appearance of the city. Possible considerations are whether light is necessary, what sort of light and how much, whether the illumination should be evenly distributed, direct or indirect, located on the building, directed at it or a combination of the two. Then comes the selection of the light source and the accompanying luminaire. Light colour, colour rendering and light yield all play a role in determining the choice of lamp. The shape and material of the reflector and the shielding of the lamp are determining factors in light emission. The following criteria apply in the choice of the right illumination:

· is there enough light in the chosen place?
· is the light evenly distributed (if that's the intention)?
· is any inconvenience caused to the people who use the place?

When people speak of sufficient light, they are in fact referring to the luminance, the reflected light. The reflection of the light depends on the type of surface: light or dark paving stones, asphalt, and so on. Dark road surfaces reflect less light than brightly coloured road surfaces. The effect comes from the interaction between lamp and luminaire on the one hand and colour and texture of the road surface on the other.

Depending on the height of the luminaire and the distance between the lampposts, there must always be a measure of uniformity in traffic lighting, and also in lighting for cyclists and pedestrians. The 'cones' of light must overlap with each other. Research has demonstrated that this is at least as important as the amount of light. As a result, recommended values have been established for the average luminance and the uniform distribution of light on traffic routes. For streets with less traffic and squares in built-up areas that have different types of surface, then a requirement for the illuminance is sufficient, depending on the situation. The requirements for the lighting are:

· visibility of objects, to ensure safety and orientation;
· recognition of people;

1

2

3

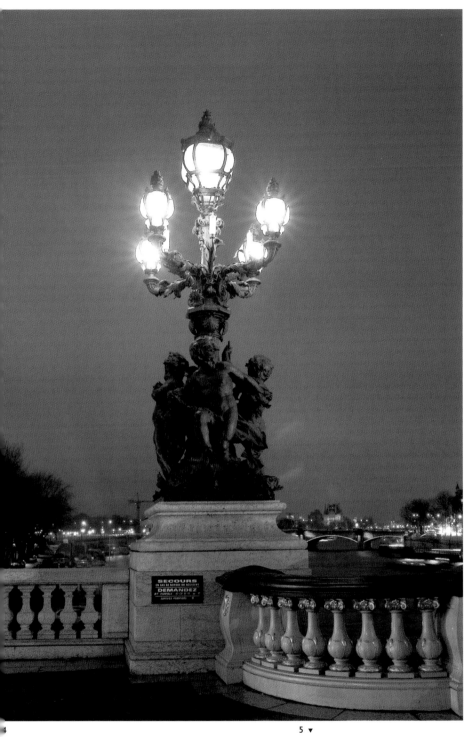

1/2
Three types of public lighting along Passeig de Gracia in Barcelona: 'neutral' street lighting, a streetlamp with five branches and the highly imaginative design of A. Gaudí.
In general, in old town centres it is hard to move away from the original luminaires and streetlamps that have been made over the years for candles, oil lamps, gas mantles and, more recently, the incandescent lamp. They are always adapted as well as possible. Now that light sources are becoming ever brighter, and the requirements for public lighting are defined more precisely, it is often no longer possible to adapt them. The addition of 'neutral' traffic lighting is understandable in this case. As far as the combination of the five-branched streetlamp and Gaudí's design is concerned, a better choice would be to choose one or the other.
Gaudí's design provides road lighting and pedestrian lighting, combined with a bench. A striking and characteristic element in the public space.

3
On the Rambla de Sta Monica in Barcelona, the original streetlights were no longer satisfactory. 'New' lighting has been added, making the old lighting superfluous. The lamppost here does not only support the ordinary lighting, but also the accent lighting. The lighting here consists of a spotlight with glass spar underneath it (to diffuse the light and prevent glare), which is not a good choice, because it gets dirty.

4
A lighting element as part of the architecture of Pont Alexandre III in Paris. It is an ensemble of bridge architecture, sculpture and lighting.

5/6
A view of Pont Alexandre III in the direction of Hotel des Invalides and a daylight view in the direction of the Grand Palais. The historical monument has been treated with care, so that the lighting creates a coherent overall picture.

4

5 ▼

6 ▼

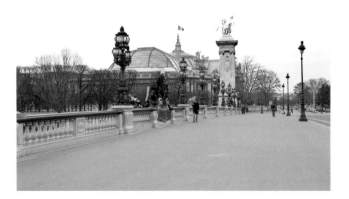

1/2

Passeig Lluís Companys in Barcelona is a pedestrian area. The streetlights are an element of the elongated space that is oriented toward the Arc. Readers make frequent use of the benches under the lampposts, even after dark.

3/4

Two old decorative lampposts form the central point of this enclosed neighbourhood square in the district of El Born (La Ribera) in Barcelona, during the daytime and at night.

5/6

An example of the illumination of a square: Cour Carrée at the Louvre in Paris.
The walls have been illuminated by the simple lights placed along them. The connection with the following space is accentuated by two many-branched streetlights. The footpath lighting, a later addition, does not add anything to the situation.

7

The public lighting on Pont de Bir-Hakeim in Paris is incorporated into the structure of the bridge. The line of illumination is formed by the uppermost part of the bridge, where the Métro runs, and the construction with the luminaires beneath, which provides illumination for the passing traffic on both sides. This means that the pavement along the parapets of the bridge enjoys an unimpeded view of the river.

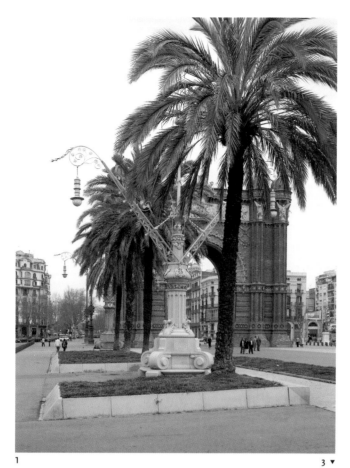

1

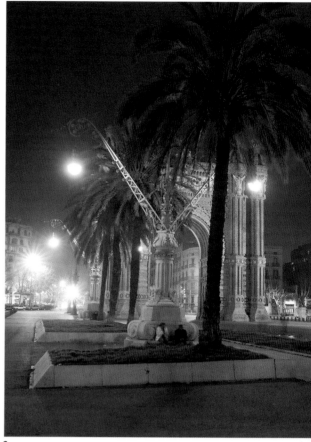

3 ▼

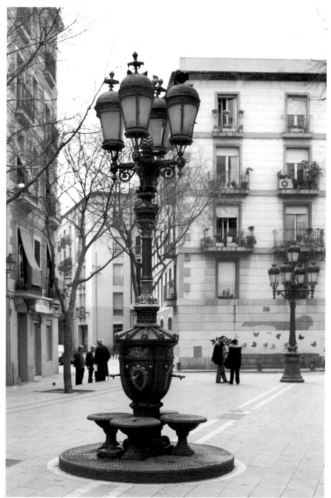

2

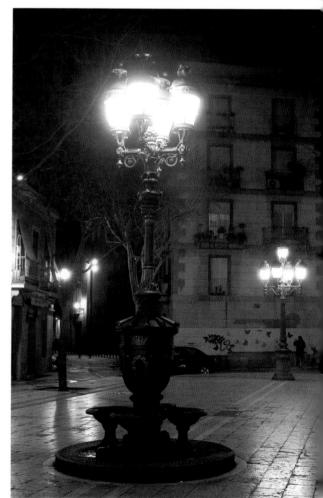

4 ▼

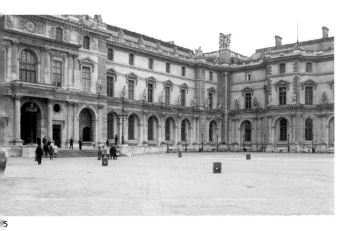

5

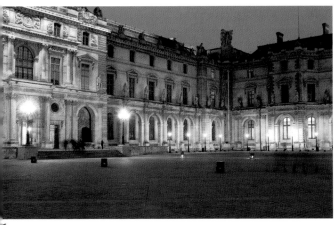

6

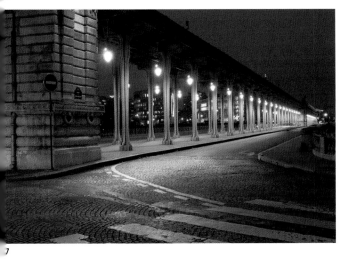

7

- comfort and well-being;
 - the ability to create three-dimensional shapes (plasticity): not only for the recognition of people and objects, but also for general comfort;
 - it is important to prevent glare – the brightness of the light must be limited or shielded in (almost) horizontal directions;
 - light colour: the visible colour of the light must suit the surroundings;
 - colour rendering: doing justice to colours plays a role in social interaction. The colour of clothing, for example, must be clearly identifiable in pedestrian areas. From a security point of view, the recognition of colours is also important, for example, in witness statements to the police;
 - the light source should generally not be visible.

However, when choosing the light it must be possible to have a certain degree of flexibility to deviate from the standard model in order to achieve a more creative approach. Town planners and architects have the tendency to consider the shape of luminaires and street lamps first, the 'daytime look'. The technician pays attention to the practical issues: reliability, soundness, resistance to vandalism, durability. The lighting advisor or lighting designer considers all aspects: functionality and related issues, and then finally the form. The advisor may deviate from the traditional arrangement of posts with luminaires/lamps, for example, in a pedestrian area, where the requirements for the uniform distribution of light are not as stringent as for roads.

Public lighting is now so widely accepted that it is also seen as a way to support the structure of the city. The city has specific spaces and anonymous spaces. If more light has been allocated to the specific spaces (boulevards, entertainment areas) over the course of time, the contrast with the anonymous side streets is too great. In some cities, lampposts are no longer used in such situations and the light source and luminaire are changed. The difference between main streets and side streets, between squares and long avenues, between shopping streets and residential streets is boosted not only by making a difference in the amount of light, but also in the colour of the light. This difference can contribute to clarity, as long as there is a balance and a connection between the two. Public lighting can create a relationship between the light of the illuminated buildings and objects so that, in spite of all the random factors in the illuminated areas of a city, a composition can be achieved that makes it possible to experience the image of the city at night as a pleasant whole. Light is a construction material and that's the way it's used.

Pedestrian areas, cycle paths and roads qualify for public lighting. For all categories, there are recommendations and norms, which are agreed internationally and sometimes adapted to national condi-

tions. The recommendations for pedestrian areas are different everywhere, depending, for example, on the type of district. The focus is always on the feeling of safety, with sufficient light on the street, not too many dark areas and a view of the traffic. Where there is a lot of light, the immediate surroundings may appear darker than they are in reality. People adapt to the light that is present. There is a sense that the light is sufficient when there is no excess of light in the surrounding area. It's about the balance of brightness. A criterion that is currently applied is that people should be able to recognise each other at a distance of four metres. Key factors in this are safety for pedestrians and road-users.

There are also rules for cycle paths now, as the bike is such a popular means of transport. Standards have been set up for motorways, to which people have to adhere. The number of cars has gone up, the density of traffic on the roads has increased and the speed of the traffic is higher. The rules are regularly re-examined and tested for road safety.

Public lighting is autonomous and those responsible for it don't take into account all the other light that is present in the city, from illuminated buildings and all kinds of incidental situations that produce light. In different European countries there are guidelines for public lighting. To achieve some uniformity, a European norm has been established: EN 13201 'Street Lighting'. Given the wide variety of traffic situations, four classes of lighting are distinguished:

ME	lighting class Motorway Europe
CE	lighting class Conflict (area) Europe
S	lighting class Slow (traffic)
ES	lighting class E Semi-cylindrical (facial recognition)

Lighting classes CE and S apply in this context. The CE class relates to the lighting of roads with motor vehicles and other road-users such as cyclists, moped riders and pedestrians, especially in complicated traffic situations such as shopping streets, complicated crossings, traffic roundabouts and areas where lots of traffic jams occur. The standards can be applied to long roads with mixed traffic types and also for sections of road that are intended only for pedestrians and cyclists, such as underpasses.

This table shows the CE-series lighting classes. The meaning of the terms is as follows:

\bar{E}_h	average horizontal illuminance;
U_h	horizontal illuminance uniformity, which is the ratio between the lowest and the average value.

The differences between the classes are linked to the traffic conditions.

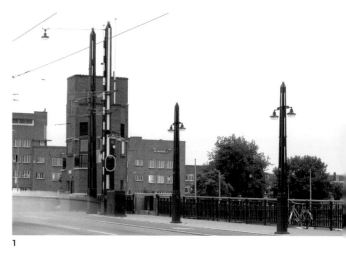

1

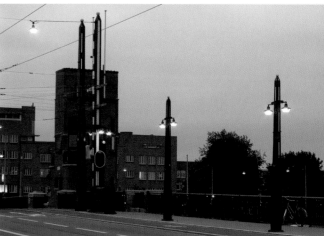

2

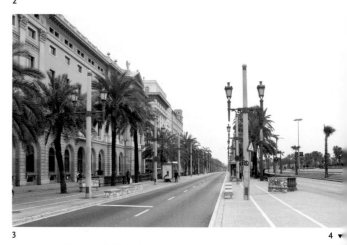

3 4 ▼

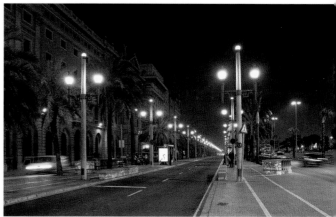

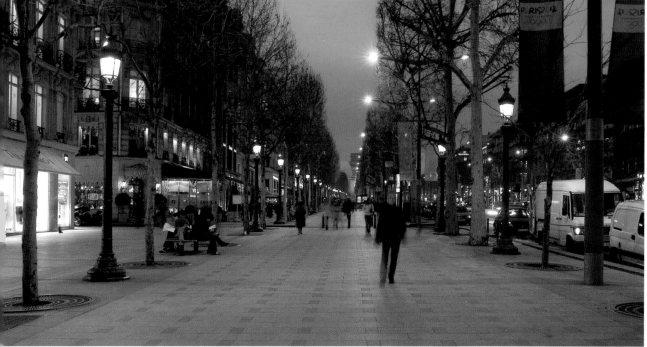

6 ▼

1/2

A total concept for bridge and illumination by architect H.P. Berlage. The illumination of the Berlagebrug in Amsterdam consists of luminaires suspended from cables for the traffic and lampposts with lighting for pedestrians and cyclists. The original incandescent lamps have been replaced by compact fluorescence.

3/4

The public lighting of Passeig de Colon in Barcelona is elegant and timeless, in keeping with the architecture and the public space. It has an impressive, stylish appearance both during the daytime and in the evening.

5

Champs Elysées, Paris: the old lights create the atmosphere and the new, tall lampposts ensure that the light is dispersed. The old lights no longer have any logical relationship to the modern surroundings.

6

It is obvious that public lighting is also expected to support and clarify the structure of the city, and that main traffic arteries should receive more light than side streets and spaces where there is little traffic. In Lyons a distinction is also made in the colour of light used in public illumination.

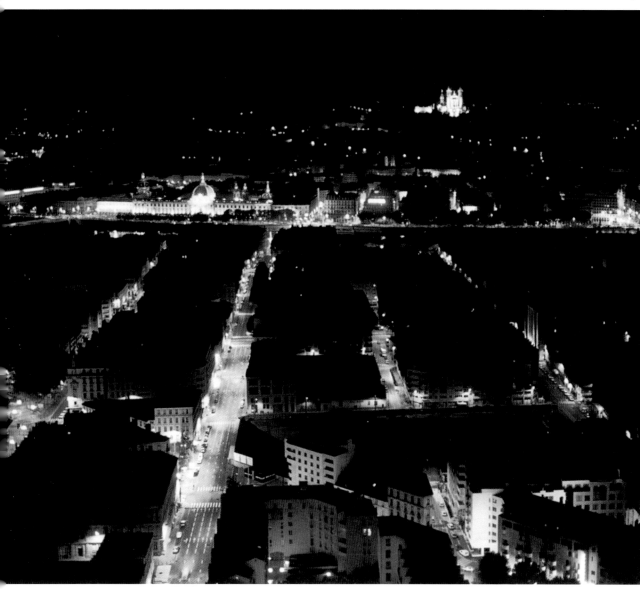

1

Avenue Céramique in Maastricht is a road through a newly developed area on a former industrial estate in the centre of the city. There are tall lampposts for cars and buses, with lower lighting fixed on the same post for cyclists and pedestrians. The division is emphasised by the use of two different colours of light. The light source in the illumination for the traffic has a high light yield and limited colour rendering. The lower light source has a lower light yield and better colour rendering. This is important, because cyclists and pedestrians need to be able to recognise each other easily.
Lighting design LITE – Christa van Santen/ir A.J. Hansen, Amsterdam

2/3

A double wall light on the façade above the pavement on Passeig de Gracia in Barcelona. The old street-light, which has been given a modern light source, is a reminder of the old style of the street.

4/5

The narrow Carrer Sant Francesc de Paula has wall lamps with a white light source, as is often the case in Barcelona. The warm light from the Palau de la Música combines with it to create a pleasant atmosphere.

6

The metropolitan nature of Rue de la République in Lyons is expressed by the high positioning of the wall lights, which also illuminate part of the façade. Together with the lights from the display windows, this creates liveliness and not too much contrast. The ground spotlights are intended for the trees. This sort of lighting is only effective when there are leaves on the trees.

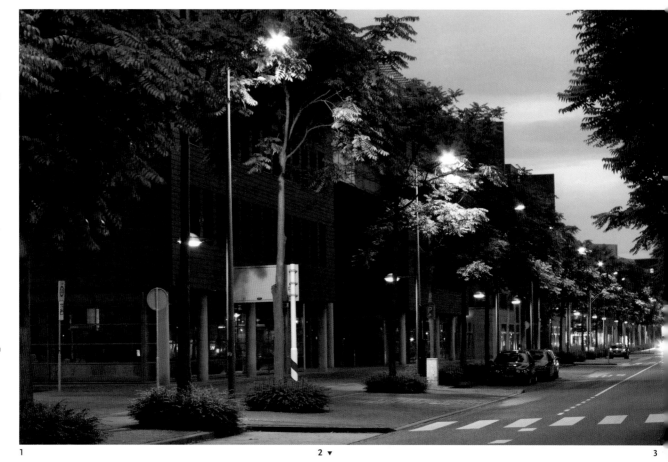

1 2 ▼ 3

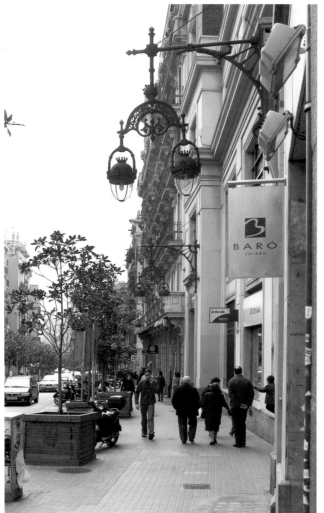

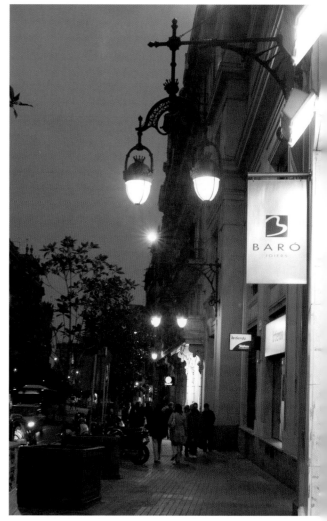

CE lighting classes

Class (decreasing complexity of traffic)	Horizontal illuminance	
	\bar{E}_h 1x	U_h 1x
CE 1	30	0.4
CE 2	20	0.4
CE 3	15	0.4
CE 4	10	0.4
CE 5	7.5	0.4

The s class applies to the illumination of footpaths and cycle paths, hard shoulders and other sections of the road, separate from or alongside the traffic lane; also for streets in residential areas, car parks, and so on.

s lighting classes

Class	Horizontal illuminance		
	\bar{E}_h 1x	\bar{E}_{min} 1x	$U_{h\ min}$ 1x
S 1	15	5	0.3
S 2	10	3	0.3
S 3	7.5	1.5	0.2
S 4	5	1	0.2
S 5	3	0.6	0.2
S 6	2	0.6	0.3
S 7	orientation lighting	–	–

The choice to use an s class depends on factors that include the number of cyclists, the need for recognition of faces (mainly in problem areas). The standard for each of the many possible situations needs to be consulted. The tables indicate the limits within which the requirements lie. It goes without saying that luminaires are designed to direct and diffuse light according to these standards.

Public lighting in pedestrian and residential areas is generally on all night and during the dark hours of the evening. In a large number of European cities, depending on the area, half of the public lighting and the illumination of most of the buildings is switched off after midnight, for example, in order to save energy (and sometimes for the sake of the atmosphere at night). The uniformity of the public lighting must still be preserved, as contrasts are undesirable, partly because of the safety aspect. The luminaires along roads in built-up areas often have a number of light sources, and it is a simple matter to switch off one or two of them in the late evening when there's a lull in the traffic. Less light when there's less traffic and more light when there's more traffic. A more dynamic approach has already been adopted in some places: when busy traffic approaches, more light comes on automatically, and when the frequency of traffic decreases, it goes off again.

Now that many gaseous discharge lamps can be dimmed, this is one of the possibilities. Illumination that is varied in this way saves

energy and generally increases the life of lamps and luminaires. This is an approach that demands the rapid identification of lighting failure, which now happens via computer-controlled systems.

The development of luminaires for public lighting is a steady process; it's not something that is directly subject to fashion. However, it is clear that design is becoming ever more important in this area as well. Street lighting is now seen as an important part of the furniture that adorns the public space. A well-thought-out optical system that directs the light in an effective way is packed into a modern design. In addition to this, there are requirements for resistance to vandalism, prevention of dirt and damp, etc. The design must be able to 'withstand a good bashing'. The required dust and water resistance (IP65) must be satisfactory for roughly ten years.

The illumination of large roads is currently in development, because new light sources are coming onto the market. They have a practical purpose alongside the road, rather than an aesthetic one. Luminaires alongside cycle paths are still much like the illumination alongside large roads; they're just somewhat more modest in size and the posts aren't as high. Illumination of roads and cycle paths may be combined on one mast, with the luminaire for the cycle path positioned somewhat lower: this is functional illumination. It's a different story in pedestrian areas. There are various expectations of the luminaires as far as light emission is concerned, but the appearance of the post and luminaire, as visible in daylight hours, is also of importance, whether it's intended to be unobtrusive or, conversely, to be a striking addition to the other street furniture. In the evening, the design is scarcely visible and only the light it emits is seen and judged.

The old lamps that were once designed for gas mantles and later incandescent lamps are often still used in pedestrian zones in older areas of the city. They have to be adapted to accommodate modern gaseous discharge lamps. These light sources provide a great deal of light and are often so bright that they become a nuisance or are even dazzling. They need to be shielded, for example, by placing slats over the light source. It is also possible to replace the glass with structured plastic, which diffuses the light emitted by the lamp somewhat, or by opaque plastic (available in various degrees of transparency). Opaque globes are often used. There is no objection to the form as such – it's just a covering of the lamp with no further optical devices, which means that the globe lights itself up more than the surroundings. The globes serve more to provide orientation than as effective illumination. However, you can expect some light yield when there are nearby reflective surfaces with a light colour, for example, walls or paving.

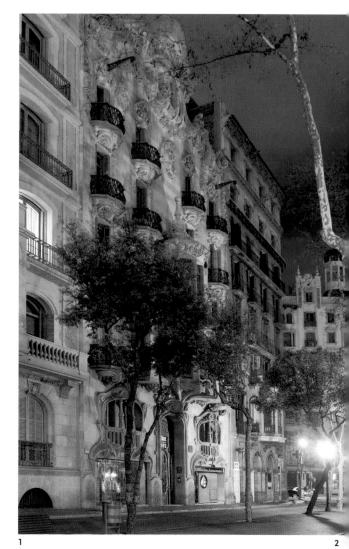

1

2

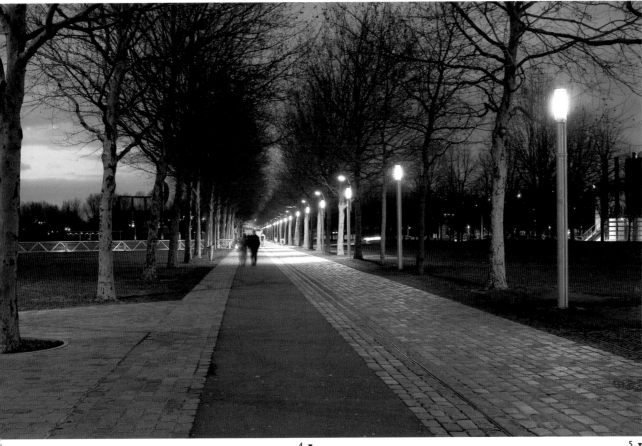

1
Bright façades of rich Spanish architecture on Avinguda Diagonal in Barcelona. The luminaire emits light on all sides, lighting up the footpath and giving a natural look to the façade. The high-positioned street lighting (not visible here) casts some light back, supplementing the existing light.

2
On Rue Clotilde, behind the Pantheon in Paris, there are old streetlights that light up the road and the footpath for pedestrians. Lights for the illumination of the façades opposite have been incorporated into the streetlights. This is a good solution, but lots of streetlights are needed in order to achieve a uniform distribution of light.

3/4/5
This footpath in Parc de la Villette in Paris is marked out by orientation lighting. Where lighting is needed, a light has been added to the original luminaires, as can be seen from the rhythm of light and dark along the path. This combination of new lights and original lighting gives the impression of a stopgap measure.

4 ▼

5 ▼

In recent years, indirect illumination, with a light shining upon the surface mounted above it, has become increasingly common. The diffusion of the light is linked to the way in which this surface is bent or shaped and to the structure of the surface. A light surface has the disadvantage that it may become dirty and is sometimes annoyingly bright against a dark sky. Solutions for this have also been found. This type of lighting is used where there is not one particular spot that needs to be illuminated, such as in parks, green areas, alongside water, and sometimes along boulevards in large cities.

In narrow streets or where there are lots of obstacles in the street, luminaires are hung up on cables strung between one building or post and the next. The same requirements exist for these luminaires as for the luminaires that are mounted directly onto posts. In situations where it is preferable not to place lampposts in the street, wall-mounted luminaires offer a solution. There are old versions and also modern designs. They are additions to the frontage of the building; they must be carefully positioned and the electricity supply must be concealed as elegantly as possible.

Several lights on the same post provide various possibilities. They can be placed around the post and light up the surroundings in different directions. In some cases it's possible to light up an object, a monument or a wall (section) from the group of lights attached to the post.

Lights are originally functional objects and are usually not directly visible. Now that they are increasingly being used in the public space, designers are also paying attention to the way they look – without impairing their functionality.

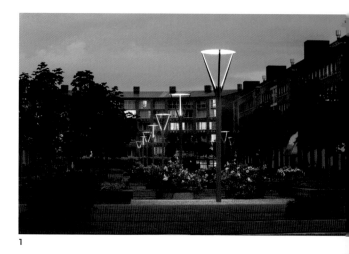

1

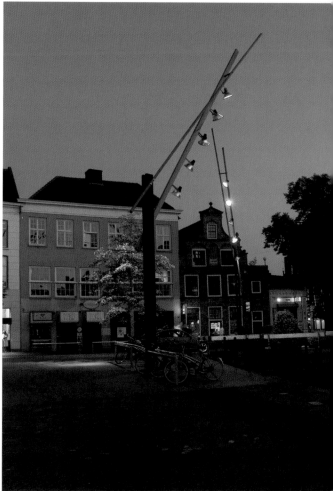

2

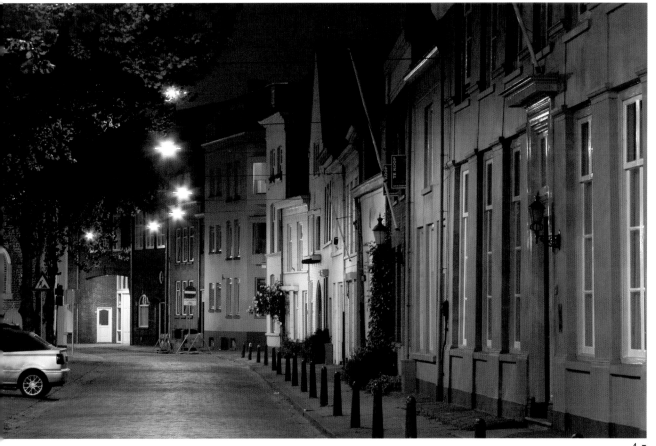

1

The Grote Circus, an indoor public space amongst the modern residential construction on Avenue Céramique in Maastricht, contains greenery that is intended to provide atmosphere for local residents at night. The installation of indirect lighting that illuminates in every direction gives a clear view of this park-like site.
Lighting design LITE – Christa van Santen/ir A.J. Hansen, Amsterdam

2

The design of five lights in a row, distributed over one arm, is problematic. So as to avoid nuisance, they must be directed downwards. With any other direction, there's a considerable risk that they will disturb passers-by and local residents.
Lighting design Beth Galí, Barcelona

3

Lighting suspended on cables between opposite façades, following the movement of the street. There is a good distribution of light and the fronts of the buildings are drawn into the light in a natural way.

4

The Wilhelminabrug in 's-Hertogenbosch has tall pylons on both sides, which means that the bridge functions as a gateway to the city. The pylons have light at the top and the bridge railings are equipped with a line of fluorescent tubes. The distribution of the light over the pavement is good, but the shielding could have been designed better. Seen from a distance, the illumination is dazzling.

4 ▼

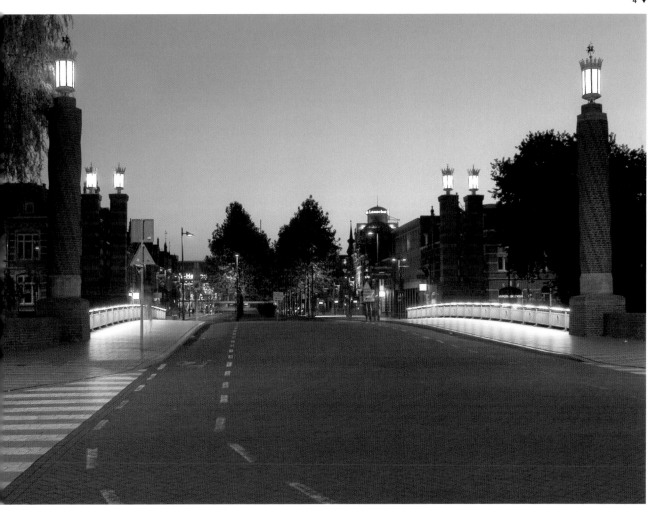

1/2
The somewhat grotesque lampposts
on the Schouwburgplein in Rotterdam,
which can adopt different positions
in the same way as hoisting cranes,
are a reference to the large scale of
the port. Fluorescent tubes are posi-
tioned here and there underneath
the perforated metal floor tiles, con-
tributing a degree of light to the floor.
This is an urban layout with a lot
of design and the light is limited to
a few areas. The symbolism of the
design is more important than the
public lighting.
Design public space Adriaan Geuze/
West 8, Rotterdam

3
The illumination of the Millennium
Bridge over the Thames in London,
the pedestrian link between St. Paul's
Cathedral and Tate Modern, is invis-
ible in the daytime. The strips on both
sides along the aluminium bridge
surface follow the footpath and pro-
vide enough reflection for users of
the bridge to be able to see each other.
The lighting consists of transparent
synthetic tubes with a reflective
material on the inside that is uni-
formly illuminated along the whole
length by a projector with a single
lamp. The projectors are concealed
in the dark sections.
Bridge design architect Sir Norman
Foster, in collaboration with Sir
Anthony Caro.

4
LEDS as a new light source for pedes-
trian routes are becoming increasingly
popular with various lighting design-
ers, partly because they last for so
long (40,000 hours) and have such
small dimensions.
Use has been made of white and
orange LEDS, a combination that gives
a warmer glow. The distribution of
the two light points at a height of
around 4.5 metres is indicated in
illuminance (lux).
Luminaire Equinox, Philips
Nederland

5
The street lighting in Rue du Trésor
in Reims consists of wall lamps. In
the background is the illuminated
Notre Dame cathedral. This is a
harmonious combination of two
different sets of illumination. Was it
coincidental or intentional? Such
harmonious sensitivity is a rarity in
the town.

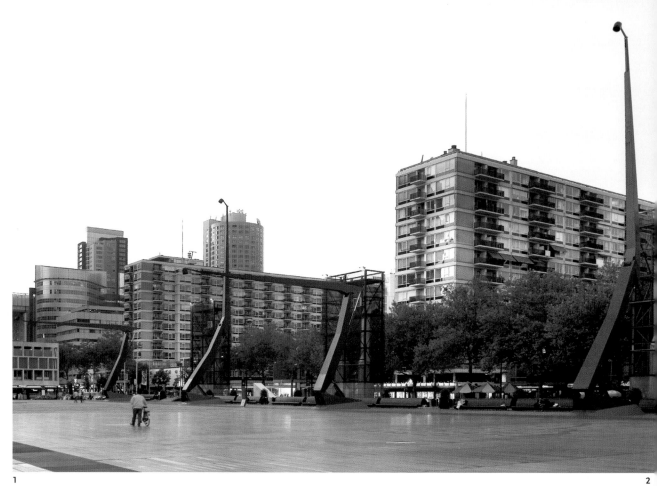

1

2

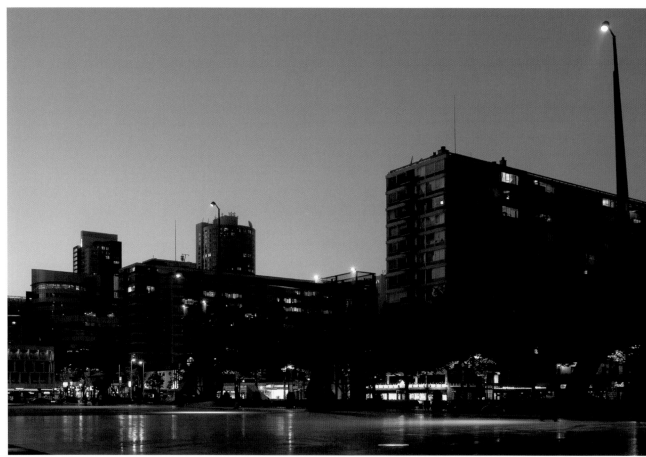

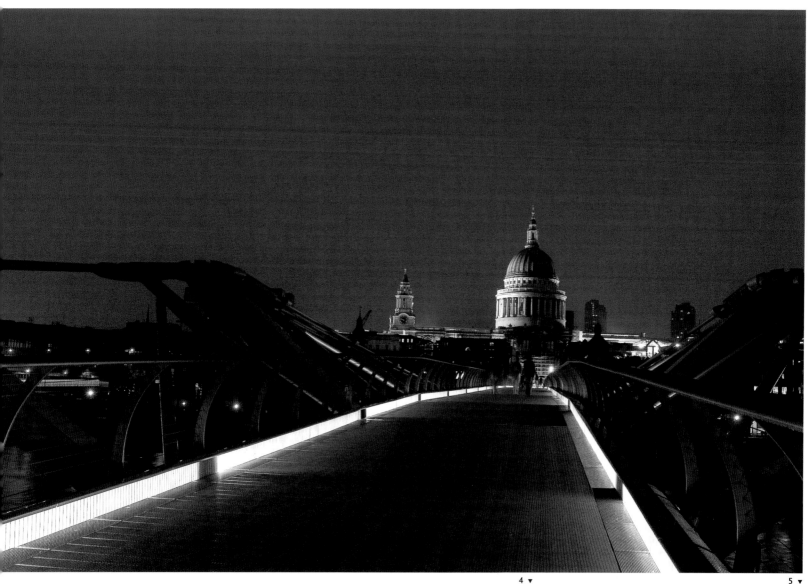

4 ▼

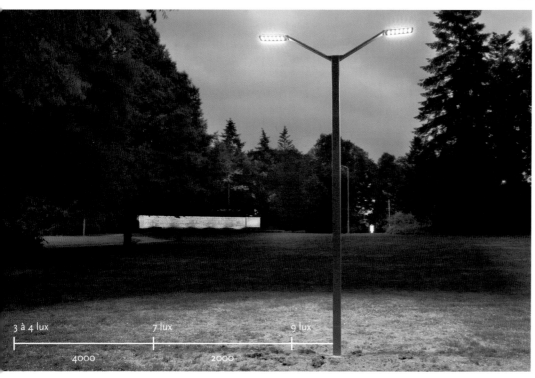

3 à 4 lux 7 lux 9 lux

4000 2000

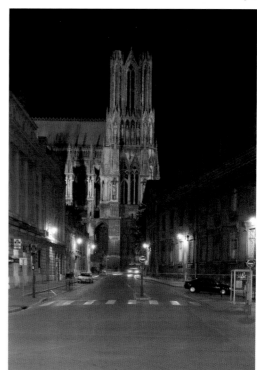

5 ▼

Designing with Light

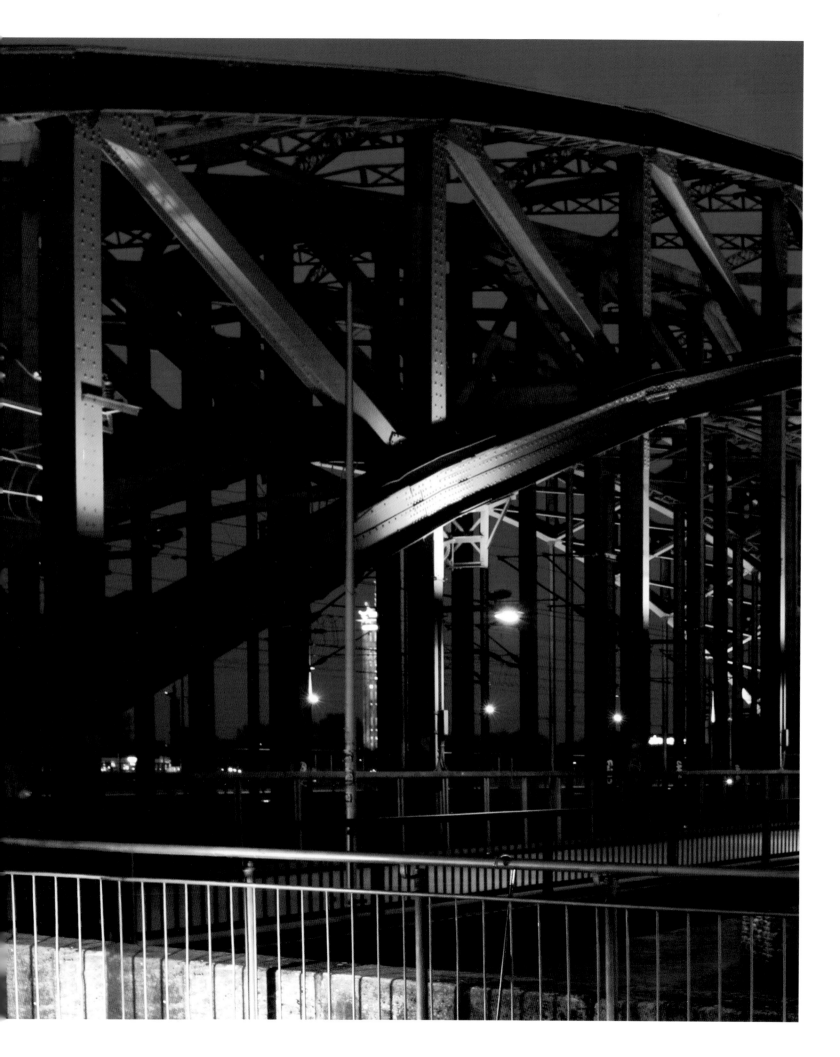

1

French Church, Gendarmenmarkt, Berlin. Limited wall surfaces with relatively high luminances appear too bright. The illuminated sections behind the tympanum contrast so strongly with the foreground that it can hardly be seen. The lights have probably been mounted at too short a distance and the lamps probably have too high a wattage. The jumps from 1 to 9, to 26 cd/m², are too large. The figures indicate the level of luminance.

2

If you look along the path of the light, the lack of shadow means that no relief effect is created. With a detailed façade that is illuminated from one side, the viewer has to look from the opposite standpoint.

3

Façades on the water often have beautiful reflections. When a façade is illuminated, the lights must be placed close enough to the wall that the light does not hit the water first, making reflections of the water appear on the façade.

4

An example of light-source spectra as provided by the manufacturers. This is a graphic representation of the colours that occur in a lamp. It clearly shows that if a colour is absent, or practically absent, from a lamp, then it will not be possible for it to distinguish that colour.
(Details from Osram)

5/6

Piazza del Campidoglio, Rome, a combination of architecture and sculpture. During the daytime, the statue and the building in the background are the same colour. The choice of light source means that the red brick and pale stone can clearly be distinguished at night.

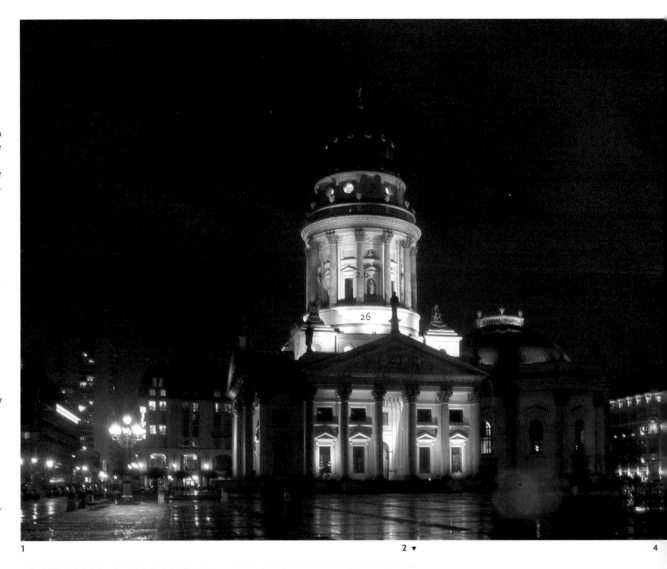

1

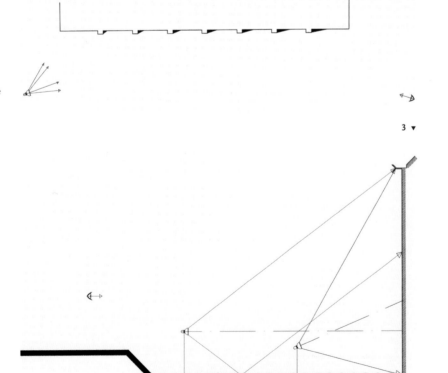

2 ▼

3 ▼

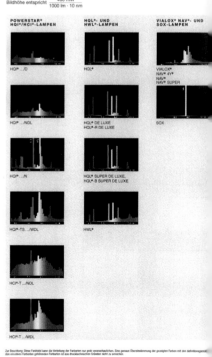

4

Spektrale Strahlungsverteilung von Entladungslampen

Sichtbarer Bereich von 380 bis 780 nm

Bildhöhe entspricht $\frac{400 \text{ mW}}{1000 \text{ lm} \cdot 10 \text{ nm}}$

POWERSTAR® HQI®/HCI®-LAMPEN | HQL®- UND HWL®-LAMPEN | VIALOX® NAV®- UND SOX-LAMPEN

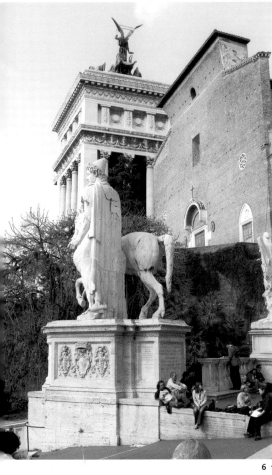

6 ▼

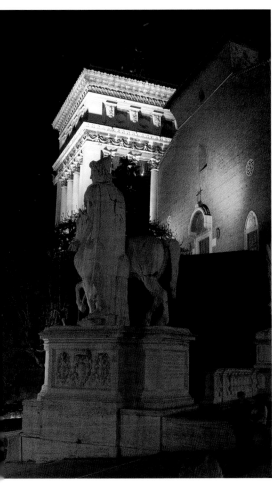

Daylight cannot be imitated; it simply is. The amount of daylight can change from one minute to the next. The colour of daylight changes from cool to warm; this so-called colour temperature is expressed in Kelvin (κ). Solar altitude cannot be matched. To make surroundings visible at night, artificial light must be employed. Lighting is a form of design; the illumination of buildings, monuments, fountains and parks demands professionalism. Lighting specialists have to take various elements into account:

· the effect that should be achieved and what needs to be made visible;
· the desired level of light (which allows the number of lamps and luminaires to be determined);
· what sort of lamp is most suitable;
· where the lights can be placed.

What people perceive is not the light falling on a surface, but the light reflected back from it: the luminance. To make a tall building appear relatively uniform when seen from the standpoint of a person, it is necessary to illuminate the highest part more intensively than the bottom. So the aspects from which a building is seen must always be taken into account. The lights must not be placed at that height, because there are no shadows in situations where people are looking directly along the path of the light. Only the combination of light and dark sections allows forms to be shown to their best advantage. Large contrasts in light on an exterior wall, however, result in an unpleasant appearance: keeping within a ratio of 1:10 is recommended. A certain uniformity in the object that is to be illuminated is generally desirable, as too great contrasts fragment the architecture. The further the lights are placed from the wall, the more uniform the effect. However, this also has drawbacks: the wall becomes 'flatter' and the further the light sources are placed from the wall the greater the likelihood that the surroundings will be disturbed.

Flat walls of buildings without projecting or recessed parts can be lit in an interesting way. No shadows can be created. The only form of plasticity and variation is to be achieved through a difference in brightness, for example, by an asymmetrical arrangement of flood-lights, or sometimes by a small difference in the colour of the light. At night, you look at buildings through eyes that are adapted to the dark, so the differences in brightness do not have to be large to be perceived, as long as the contrast with the surroundings is sufficient.

A detailed façade with many recessed and projecting sections sometimes results in strong shadows. To avoid this, the shadowy areas can be softened with additional direct light from another angle.

The amount of light and its distribution over the object, determined by the position of the lights and the choice of light source, is the most

important factor in achieving the desired result. As far as the positioning is concerned, a combination can be made of the following options:

· on the building
· on the ground in front of the façade
· on masts or poles
· on buildings in the area (when this is unavoidable)

Reflective façades produce specific problems. People want to experience the reflection, but at the same time not be blinded by it. If lights are positioned above eye level, there is a risk that people will be dazzled. Lighting from below produces reflections from the viewing angle. Lights are often reflected in the shiny surface when they have not been arranged properly. Lighting from above is preferable in this situation.

For façades that rise up out of water or stand close to the water, the lights must be placed as close as possible to the façade to avoid them being reflected in the water and creating rippling circles of light on the façade, so disturbing the exciting reflection of the architecture in the water.

Recommendations for the illumination of buildings are usually given in luminance values, which are related to the reflected light. The required illuminance is connected to the brightness, light or dark, of the surface (the reflectance) and to the light levels in the surrounding area. In dark surroundings a lower illuminance is necessary than in light surroundings. A freestanding building that stands out against a dark sky needs much less light than a façade in a brightly lit street.

The relationship between luminance, reflectance and illuminance is expressed in the following formula:

$$L = \frac{E \times \rho}{\pi} \quad \text{or} \quad E = \frac{\pi \times L}{\rho}$$

L	luminance (candela/m²)
E	illuminance (lux)
ρ	reflectance

Assuming a particular value for the luminance and where the reflectance of the surface to be illuminated is known, then this formula can be used to work out what the illuminance should be. Recommended luminances:

Situation	L (cd/m²)
freestanding building or statue	3.2–6.5
building in a street or on a square	
in dark surroundings	6.5–10
in well-lit surroundings	10–13

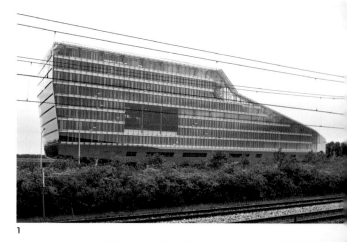

1

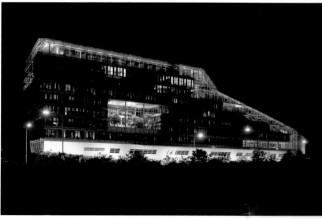

2

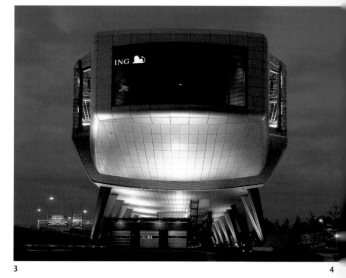

3 4

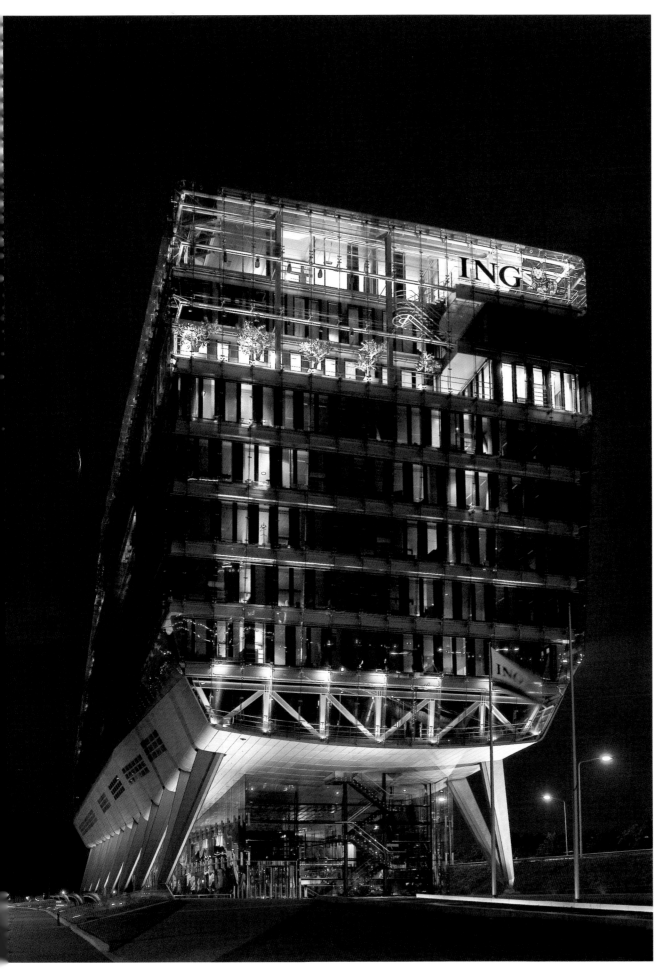

ING House, Amsterdam. The architecture catches the eye because of its shape and the combination of volume and glass. A characteristic feature of the design is that during the daytime it is possible to see inside the building. This quality should also be retained at night. The closed bulk of the building is illuminated and the transparent part is made visible without losing the shape of the whole. The illumination at night provides an intriguing view into the interior, with its indoor gardens and stairwells.
Lighting design Lite – Christa van Santen, Amsterdam
Architects Meyer en Van Schooten, Amsterdam

A dark wall absorbs more light than a wall with a light colour, with a number of variants in between. So, there is no point in lighting a dark wall. The reflectance of most building materials is known. In order to achieve some sort of effect, this must be equal to or greater than 0.2.

material	condition	reflectance
yellow brick	new	0.3–0.4
red brick	new	0.15–0.25
brick	dirty	0.05–0.1
white marble	clean	0.6–0.65
granite	clean	0.1–0.15
concrete	light	0.4–0.5
concrete	dark	0.2–0.3
concrete	dirty	0.05–0.1
plasterwork (pale yellow)	new	0.35–0.55

This information makes it possible to work out what illuminance is necessary in order to produce the desired luminance. Here are some examples from the luminance table, based on the lowest values: Illuminance E (lux) for a building in a street or on a square:

	dark surroundings	light surroundings
white marble	35	55
light concrete	50	80
yellow brick (new)	70	105
dark concrete	100	160
granite (clean)	200	310

The number and type of luminaires is determined by these figures and the selected lamp. To work this out, you need the documentation with the technical specifications of the luminaires. In addition to this, you have to know at what angle and from what distance the surface is being lit. Every lighting manufacturer supplies software for these calculations, which designers can use. Whatever the circumstances, when positioning the luminaires, care must be taken to ensure that the desired effect is achieved and that no glare is produced. The aim is to keep the lights out of the field of vision; they must preferably be arranged so as to be visible as little as possible.

The choice of the type of lamps depends on the colour and structure of the object that is illuminated. The variety of the same type of lamp has increasingly expanded in recent years. The two factors determining the choice are the colour of the light, which must fit in with the light of the surroundings, and the colour rendering, which must produce the best possible appearance for the illuminated surfaces and details. Good colour rendering in the light is primarily of importance when colours in the façade need to stand out. The following lamps are available for illumination:
· high-pressure sodium lamps
· metal halide lamps
· fluorescent and compact fluorescent lamps

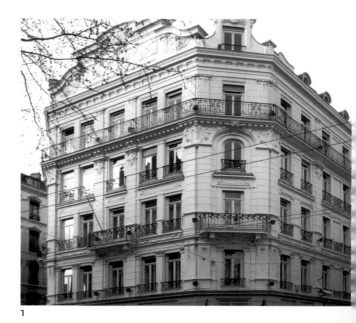

1

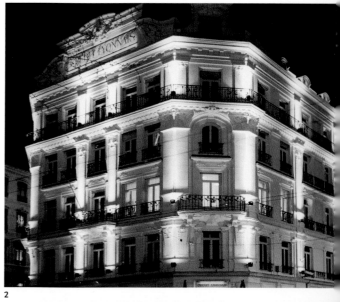

2

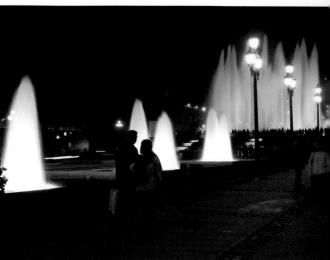

3

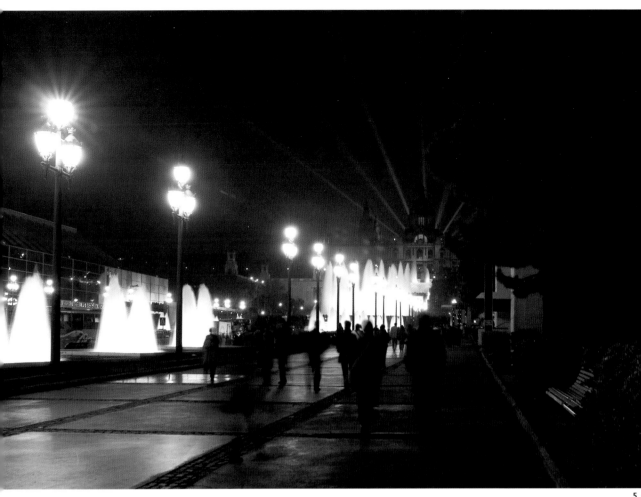

1/2
Section of the Banque de Lyon, Lyons, which changes with illumination. The building originally has a horizontal alignment. The illumination of the piers adds a vertical component, giving the architecture a different look. The position of the company name in blue is high enough not to be disturbing.

3/4/5
Avinguda de la Reina Maria Cristina, Barcelona. A recurring programme of water, light and sound forms an evening spectacle that attracts many visitors. The computer-controlled coloured lights create a varied and fascinating event.

5 ▾

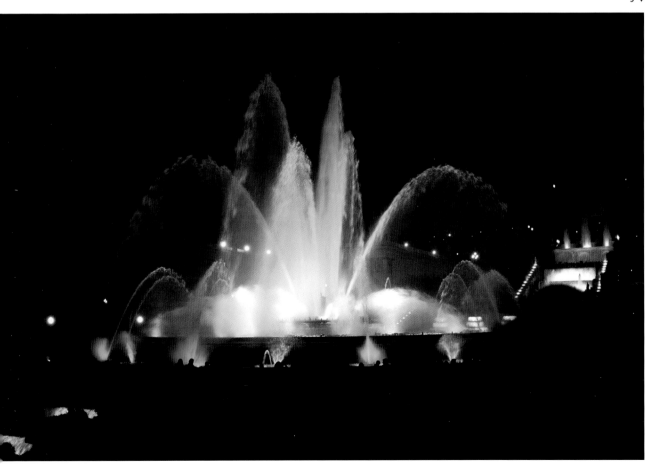

- halogen lamps
- high-pressure mercury lamps are still on the market, but are not used much now because of environmental concerns

High-pressure sodium lamps, with a colour of light ranging through many variants from golden yellow to whitish, are often used in the illumination of monuments made of brick, stone or stucco. The amount of light produced is greater than that of other light sources.

Metal halide lamps – every make has its own coding – are able to render red, yellow, green and blue. They are often used in more modern settings. With age, discoloration of the light can occur, a technical problem that still has not been completely solved. This is particularly noticeable when the lamps are in view. Like high-pressure sodium lamps, they have a long average life of 8,000–10,000 hours and a high degree of luminous efficiency. Both light sources can be used for luminaires with wide and narrow beams.

The large variety of fluorescent and compact fluorescent lamps makes it possible to select a particular light colour and colour rendering. Fluorescent lamps are often seen in street lighting as well as in the illumination of buildings, close to the façade or inside. Their shape means that these lamps cannot be used in floodlights, but compact fluorescent lamps can, because, as the name suggests, they have a more compact form. They also have an average life of 8,000 hours.

Halogen lamps are mentioned last because, compared with the other light sources, they are the least energy efficient, as they have a shorter life; depending on the make, they last for an average of 2,000–5,000 hours. However, new developments mean that manufacturers can now supply halogen lamps with a life of 10,000 hours. The colour rendering of halogen lamps is very good for all colours and the colour of the light remains constant, even when they become older. With the right choice of luminaires they can be used effectively for the accentuation of features of façades and sculptures. These qualities mean that halogen lamps are often employed in museums.

With the exception of the halogen lamp, which renders all colours well, it is necessary to know the spectrum (the spectral composition) in order to make the correct choice, i.e. which light source makes the colour and texture of the object look the best. Suppliers know the colour spectrum of every lamp.

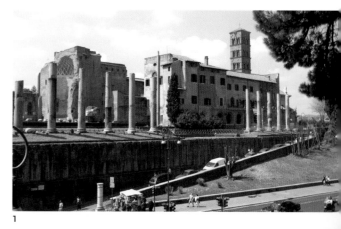

1

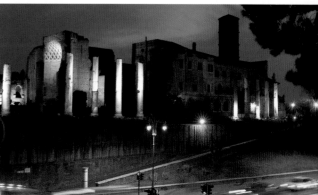

2

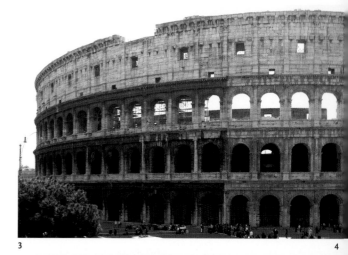

3

4

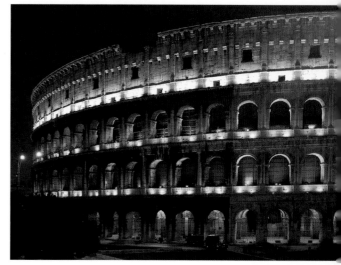

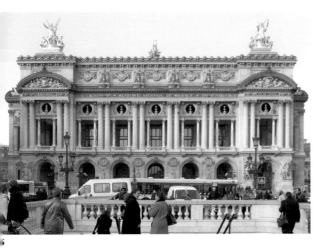

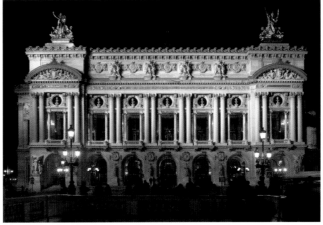

6

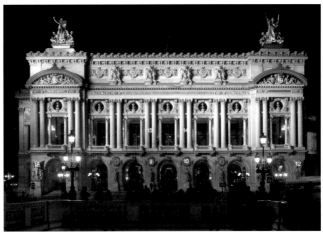

7

8 ▼

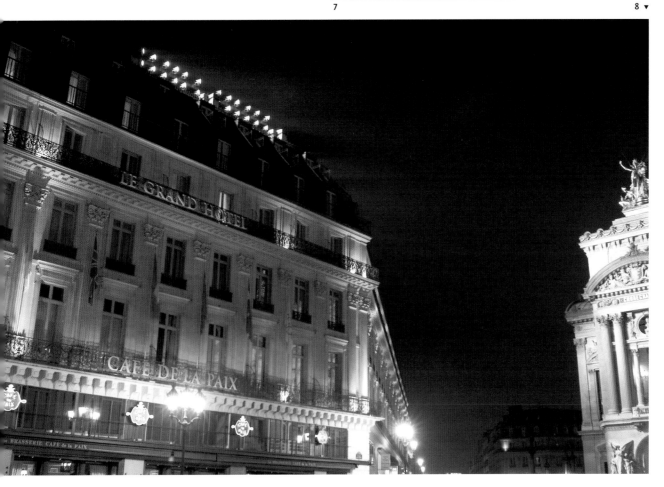

1/2

Forum Romanum, Rome. An exhibition of individual remains from different periods of architectural history. During the day they appear to form a coherent whole. The imbalanced illumination means that this coherence is lost at night, with the objects themselves appearing 'deformed'.

3/4

Section of the Colosseum, Rome. Form and plasticity are clearly emphasised through the use of light. The closed recessed upper part has a white shade of light. The open arcades and the background have a warmer light colour. The third dimension is clearly made visible by this illumination, looking as it does naturally during daylight hours.

5/6/7/8

The illuminated Opera Garnier, Paris, may be seen from afar, primarily because of the excess of light. This means that the colour differences in the façade are lost to a certain extent. The gold can scarcely be discerned. Floodlights create an imbalance in the illumination, particularly in the upper part. The sculpture on the roof receives more light on the left than on the right, which is the fault of the floodlights. A positive point is the fact that they are placed so high that they don't disturb people at street level. The figures indicate the level of luminance.

Page 60/61

Ponte Vittorio Emanuele II, Rome. City bridges are architectonic elements that are often illuminated. A bridge is a three-dimensional element that is determined by the passing traffic, going over it and under it. The emphasis here lies on the traffic over the bridge, further accentuated by the statues, which are only illuminated on the road side. Going over the bridge, you no longer see the water. The traffic upon the water goes its own way.

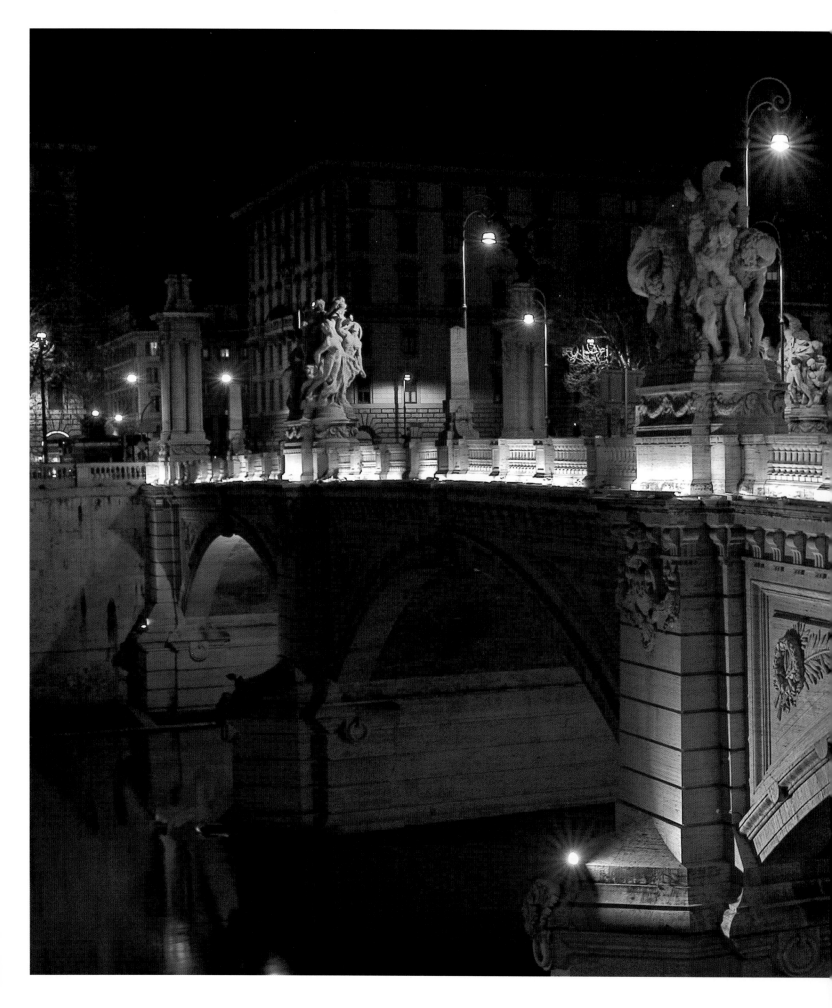

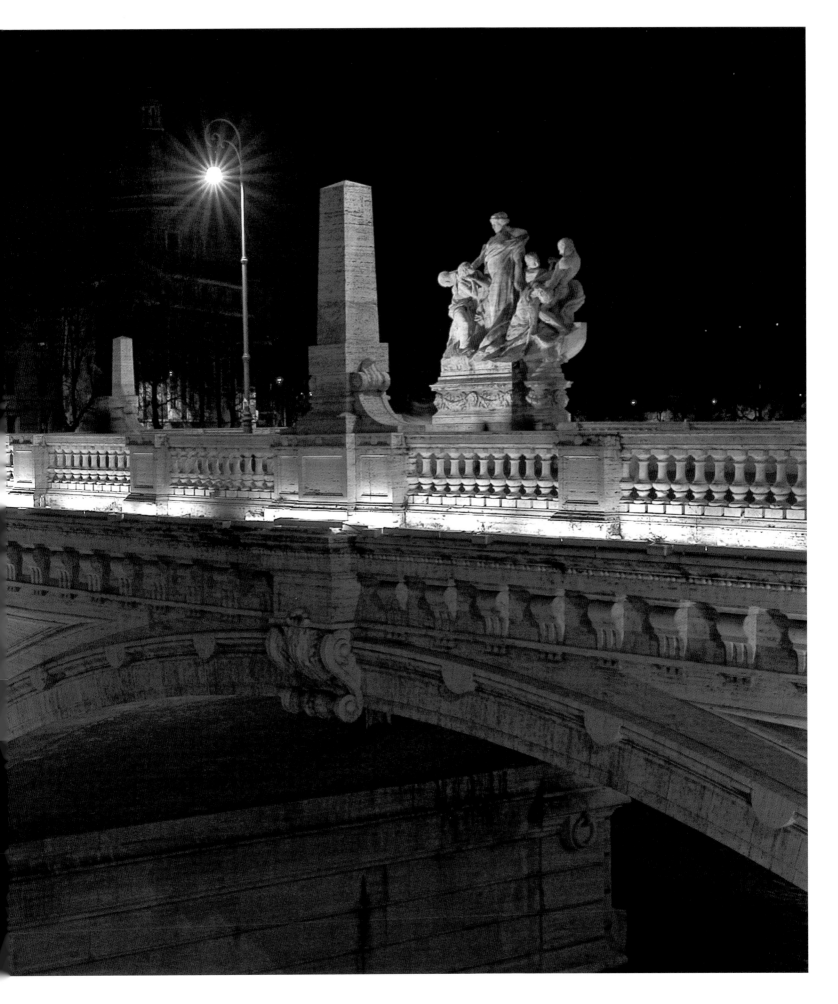

Illumination of a building in most cases implies: lighting from without and within. Illumination takes place from outside. Lighting from within usually means that some of the existing lighting is left on. Sometimes emergency lighting already shines out sufficient light or special arrangements are made. It is obvious that light from outside and inside the building needs to be brought into harmony. Light shining out of a building is an extra, the finishing touch of good illumination.

The aim is to create a sense of openness; architecture is all about space, light from inside can also help. A lack of openness comes about, for example, when various colours of light are used without any thought to their combination. A disjointed architectural image can also be created when incidental features are illuminated detail by detail. For example, when piers are lit up for no reason, the illumination breaks up the architecture. However, when a pier contains a special sculpture, it is appropriate that it be illuminated so that it receives attention.

Fountains are pleasant additions to the cityscape. An illuminated building, however beautifully it may be lit from within and without, is a static image. Stretches of water and fountains create liveliness and make the surroundings look particularly cheerful. Illuminated fountains look best against a backdrop that is as dark as possible, particularly when coloured light is used. Large squares or wide boulevards are suitable surroundings. Jets of water and vapour act as diffusers, absorbing and dispersing the light that is directed at them. It is best to position luminaires under the water surface; just a single light source under a jet of water produces an attractive effect. For wider screens of water, more lamps are needed. External light weakens the effect of the already 'weaker' fountain illumination.

The illumination of town parks demands special attention. In parks that are still open after sunset, the visitor needs to know what happens where. There must be a good view of the pathways, and that also applies to any cycle paths. The feeling of safety is also a factor. The transition from the well-lit street to the park must not be abrupt as far as light is concerned, but naturally tuned to the adaptation of the human eye.

In order to create a peaceful atmosphere, trees and bushes are often illuminated. In a park or a grassy area with trees and bushes, the choice of the right lamp is precise work. Deciduous trees need a different light source from conifers, for example. Quite a lot of light is lost in the illumination of trees and wooded areas. It is also true here that not everything has to be illuminated. On the contrary, trees with interesting shapes can just as well be left in the dark and be used as a silhouette, creating a feeling of depth and making the whole scene more lively.

1

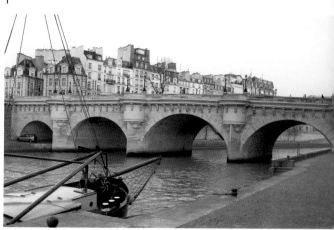

2

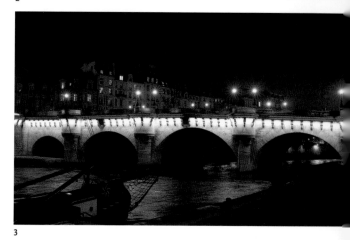

3

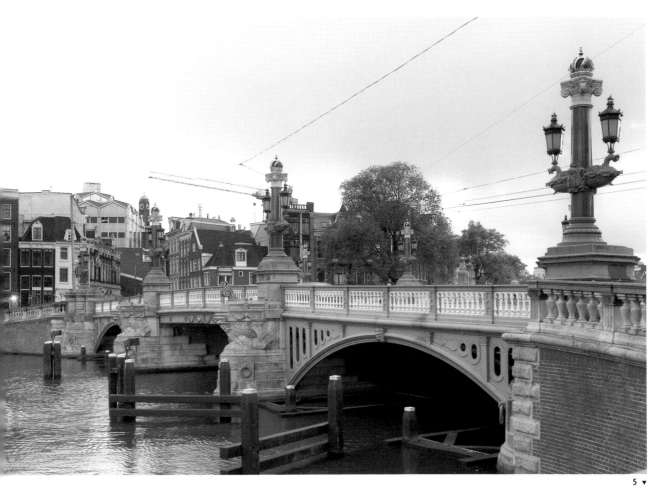

1

The Louis Philippe bridge over the Seine in Paris. The directions of the traffic on and under the bridge are made clear by the use of light. This three-dimensional presence has a harmonious appearance, with successful illumination of the whole bridge and of the view through the bridge.

2/3

The Pont Neuf, Paris, consists of two sections, connecting both riverbanks via the Île de la Cité. The Pont Neuf has a recognisable shape, which can be seen well both from a distance and from close up. A special feature of the Paris bridges is that traffic also passes under them along the banks of the Seine.

4/5

The Blauwbrug over the Amstel in Amsterdam with its sculpture work and double streetlamps, which are part of the total design. The sculpture work is illuminated; the passageway on the water is missing from the illumination.

5 ▼

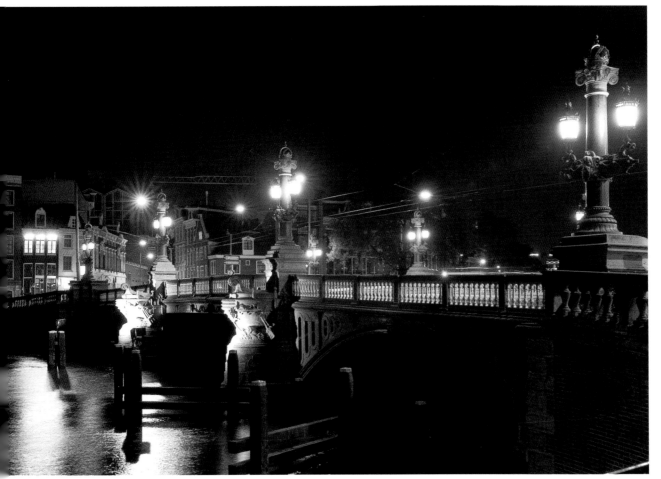

1/2
Magere Brug, Amsterdam. A typical feature of the illumination of Amsterdam bridges is the emphasis of the contour with a string of small lamps. This is not three-dimensional illumination. The structure of this lift bridge is made clear by the outlining. The passageway underneath does not appear to have any volume, but fits into the structure like a drawing on · a plane surface.

3
Herengracht, Amsterdam. Uniform illumination along a canalside wall made up of different house fronts. It is unavoidable that contrasts are created by this uniform lighting and the differences between the architecture of the various houses. If the light shines out from inside the building, a natural appearance is created; however, when the illumination from outside lights up the interior, this creates a 'ghostly' effect. A degree of nuance for each house front would be appropriate here.

4
Hohenzollern Brücke, Cologne. Railway line with a pedestrian bridge over the Rhine. A great deal of use is made of this connecting route between the two parts of the city. The strong, robust form of the large-scale construction is more than a match for the uneven illumination, so it does no harm.
Lighting design Philips Lighting, Harry Hollands (the Netherlands) and René van Ratingen (Germany)

5
The façade of the Konzerthaus, Gendarmenmarkt in Berlin, presents a varied image of lighting from without and within, from in front to behind, from inside to outside. The sculpture in the foreground is lit so strongly in comparison to its plinth that it appears to be floating. The wall behind the foremost tympanum is illuminated too strongly, which disturbs the balance, because the eye is automatically drawn to the brightest point in the field of vision. The figures indicate the level of luminance.

6
The careful illumination of the Brandenburger Tor, Berlin, with some luminance values. There is a difference between the top and the bottom of the columns, caused by the floor spotlights, which is acceptable here because of the large distance. In the side sections (to the left and right), the luminaires in the ceiling are so close to the wall that a contrast has been created between the upper and lower parts of the wall.
Lighting design Kardorff Ingenieure, Berlin

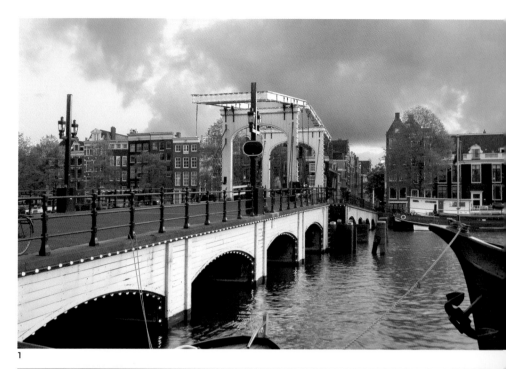

1

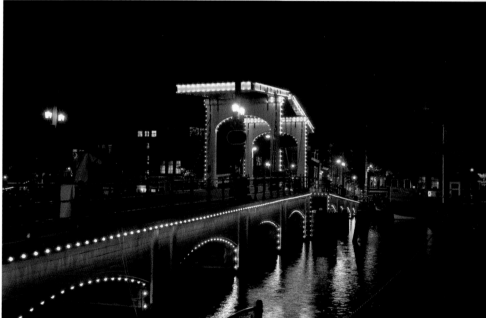

2 3 ▾

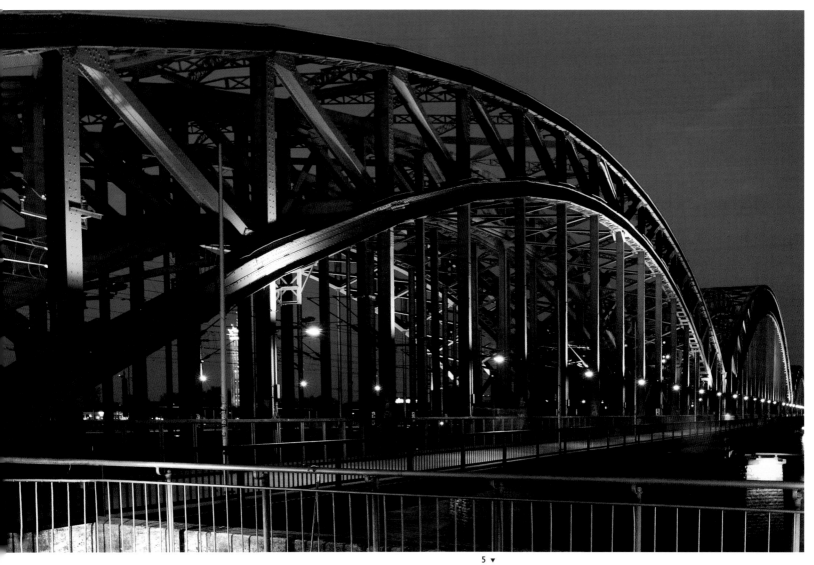

5 ▾

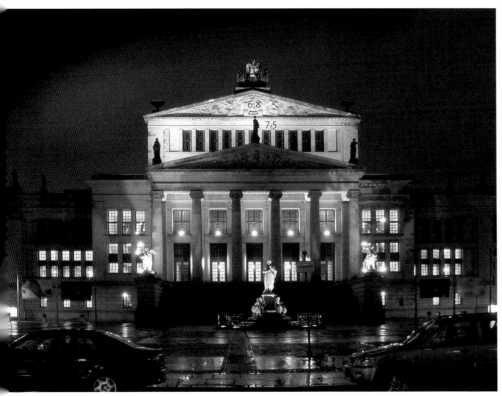

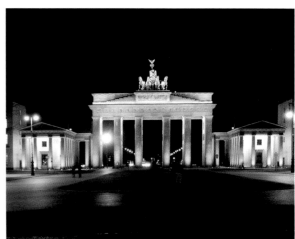

6

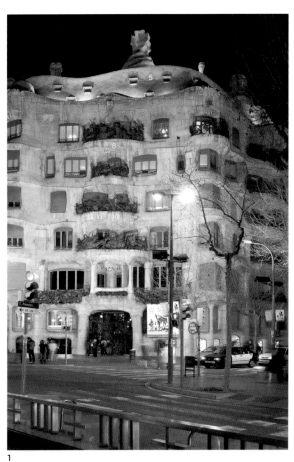

1

2

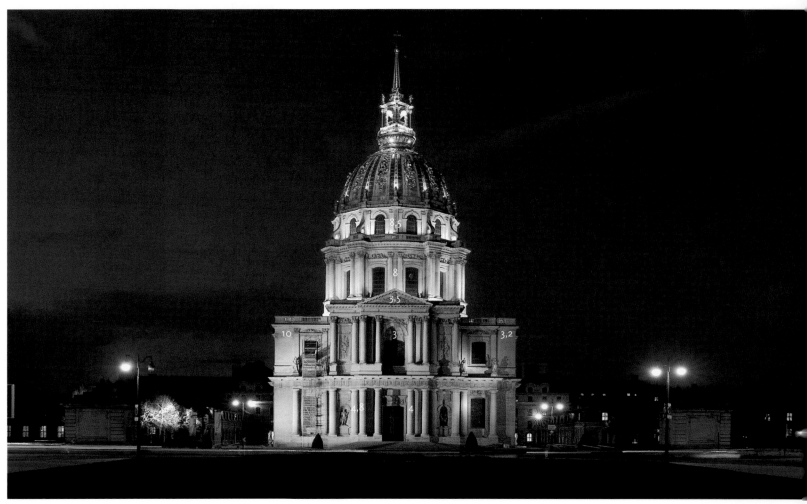

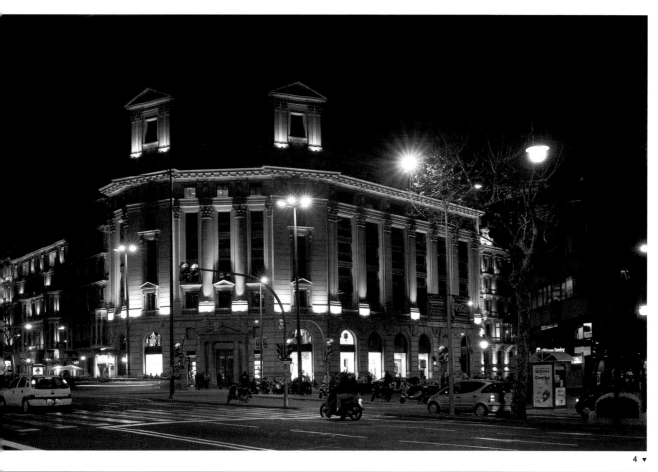

1

Casa Milà by A. Gaudí, Barcelona. The scene in the evening is very similar to its daytime appearance. At night, the façade is lit with a flood-light and the balconies catch light from below, which can be seen in the difference in luminances. The recessed upper part is lit too brightly in some parts and not brightly enough in others. The figures indicate the level of luminance.

2

Dôme des Invalides, Paris. A uniform appearance has been created in the central section because more light falls on the top of the building than on the bottom. There is some difference at the sides, but that does not disturb the image of uniformity. The figures indicate the level of luminance.

3

Passeig de Gracia, Barcelona. An 'unhappily' illuminated corner property. The short distance between the lamps and the façade means that there is so much contrast in the illumination of the columns that distortion has occurred. The same applies to the two dormers, which are 'floating' above the eaves. There is no coherence within the building itself or with the surroundings.

4 ▼

4

Palais de la Bourse, Lyons. Difference in volumes and construction materials. The pale stone façade has a warmer appearance than the dark slate roof. The use of different light sources has created clear differentiation. Unfortunately, contrasts have come about because of the excessive amount of light. The difference in colour is in itself an interesting idea when it works as a whole. However, the contrasts here mean that it falls short of its goal.

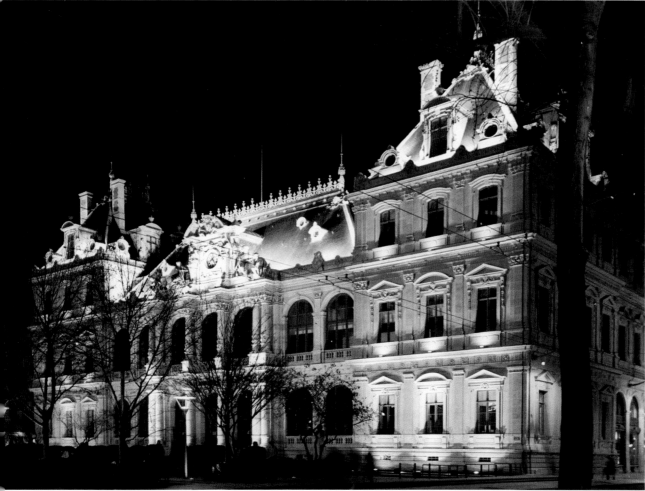

The Illumination
of Buildings

Even before the invention of artificial light, buildings were lit up at night, as is illustrated by historical pictures. This usually happened during festive events, with the light coming from candles, oil pots, torches or gas flames. The advent of the light bulb offered wonderful opportunities for enhancing special occasions through the illumination of buildings. Initially, light bulbs were used only to emphasise the outlines of the buildings, and the architecture itself and its surroundings were not lit up. From the 1920s, buildings were mainly illuminated for advertising purposes, a method that is still used – and abused – to make people aware of the presence of information. Even in those days, some people pointed out that it was important to install illumination with sympathy for the aesthetics of the architecture, whether the aim was to advertise or to draw attention to the splendour of the building. Since then, there have always been architects who, when choosing the material for the façade of a building, have kept in mind the way that their building is going to look after dark.

We have become accustomed to illuminated buildings. The phenomenon may be seen in many important city centres. The illumination and spotlighting of monuments, objects and other places of interest is a fixed part of the urban scene; it livens things up. Illumination also helps people to find their bearings.

Designers of illuminations know that the architecture of every building is different and so cannot be treated in the same way. Buildings are not theatrical scenery. Every building tells its own story and the purpose of architecture can be expressed through good and well-considered illumination that does justice to the construction materials. If it's done well, the whole building can be brought into harmony with the immediate environment. For this to happen, the illumination must be evenly distributed, without becoming boring. Although some contrast is desirable – it's surprising, stimulating, it grabs the attention – the illumination of the adjoining areas and objects must not be overdone, but applied with skill and understanding. Balance and harmony are connected with the volume of light and colour that is aimed at a building or an object; with the direction, colour and the colour rendering of the light source; and with the reflection and the colour of the illuminated surface, such as wood, brick, glass, synthetic sheets, and so on. All this affects what we perceive.

It is generally undesirable to use floodlights and place a building completely in direct light. This draws all of the viewer's attention to one object and the strong contrast means that the prospect of the immediate surroundings is lost. Also, placing the floodlights a long way away inevitably flattens the whole image. Any three-dimensionality is lost because of the lack of shadows. The coherence that is experienced in daylight must also be present in the evening.

When illuminating a building, it is sometimes enough to high-

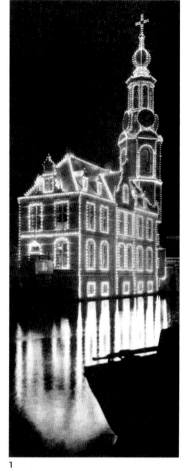
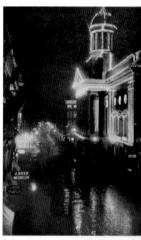
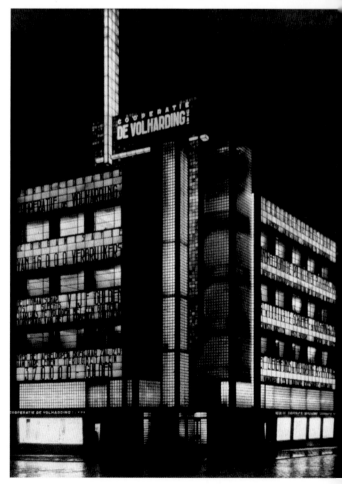

1 2 3

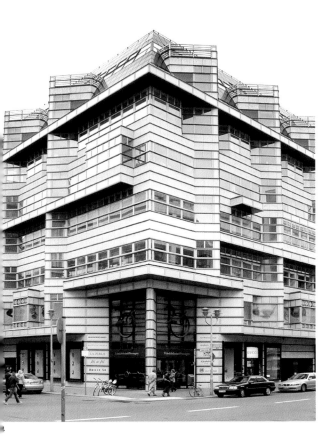

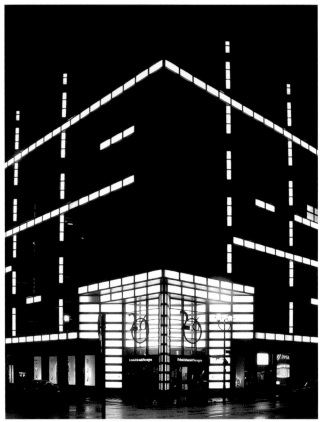

5

6 ▼

1
Illuminated house and tower. Munt-toren, Amsterdam (1938)

2
Illuminated town hall, Rotterdam (1913)

3
De Volharding in The Hague (1928), by Jan Buys (Buys and Lürsen) is an early design that could be referred to as 'night architecture'. The building was designed as an advertisement for De Volharding, a cooperative society. The use of glass blocks and opal glass wall sections (now replaced by synthetic sections with the same effect) made it possible to light up adverts on the front the building from behind. The light shining out from inside the building was a striking advertisement for the client and for the architecture itself. This building, designed in the style of Nieuwe Zakelijkheid (New Object-ivity), is also worth visiting during the daytime. De Volharding has been restored after a period of neglect.

4/5/6
Friedrichstadt-Passagen, Berlin-Mitte. This new city block consists of one building with shops on the ground floor and offices above. The architects and lighting designers came up with concepts for the day and for the evening that would each create a distinct image. The entrances occupy two floors, which stand out during the day because of the difference in scale, whilst during the evening they function as illumin-ated accents making up part of the horizontal and vertical interplay of lines in the total architectural con-cept. Behind the opal plates are fluorescent tubes that can be adjusted to give different amounts of light. It is a decorative approach to the façade that does not say anything about the architecture itself.
Architects Ted Mushow, Pei Cobb Freed and Partners
Lighting design Paul Maranz, Chicago and Anton Hansen, Guust de Jong, Wolfgang Kunkel, Philips Lighting, Germany

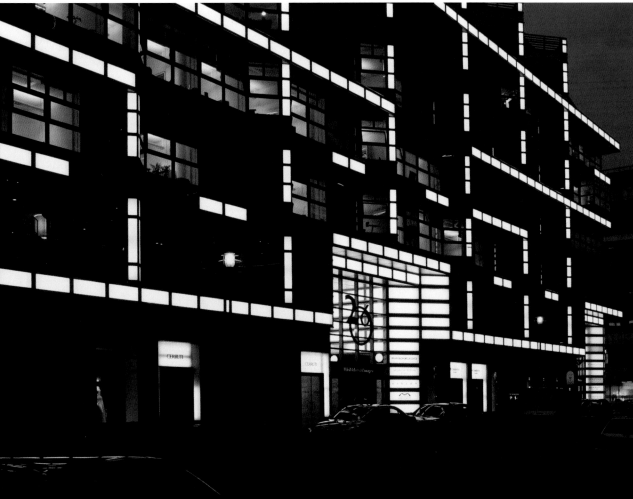

light a single element. Historical buildings often have a cornice or a sculpted tympanum as the finishing feature of the façade, something that you don't normally register during the daytime, but which lighting can draw attention to when it's dark. This illumination should not be distracting, and such a detail must fit in with the surroundings in a natural way. Whatever form of illumination is used, the character of the architecture needs to remain intact. Deliberate effects such as the projection of stripes, circles and the like onto the façade are taboo.

Discretion is needed when selecting which buildings to illuminate. Illumination can have a commercial significance, but it can also be of social importance or interesting from a historical point of view. It is not necessary to include every building in the illumination, just as it is not necessary to light up every selected object in its entirety.

The city becomes attractive when light shines (in a natural way) from within houses and buildings. Light shining out from the inside, in combination with an illuminated exterior, is sometimes enough to reveal a great deal about the architecture, certainly in a three-dimensional sense. Architecture is all about space. If it is visible, the space behind the façade forms the third dimension for the exterior design features. Interior light becomes exterior light.

Some architects let their buildings function as 'bearers of light'. For example, they choose to use glass blocks in combination with lamps and light fittings in corridors, stairways and halls. If some of that lighting remains on after office hours, it can give a good impression of the architecture. Sometimes this is even possible with just the emergency lighting. An unusual window can be seen from outside as a surprising feature when it is illuminated by artificial light from the room behind.

In shopping centres, illuminated display windows can be an asset, if they don't radiate too much light. The roll-down shutters that are used to prevent vandalism have increased the sense of insecurity because they don't allow any light through. It would represent an improvement in public spaces if these shutters were somewhat transparent and the light behind – however sparse it may be – could make the display windows visible again.

In no way should the illumination have a disturbing effect on the surroundings or strike any false notes. A relationship with public street lighting must be strived for, so that a balanced composition of the total light can be achieved. This is not simple, because much of the night-time appearance of an area is determined by random circumstances that cannot be controlled or organised. When public lighting and illuminated buildings and objects are brought into line with each other, a relationship between streets, roads and squares

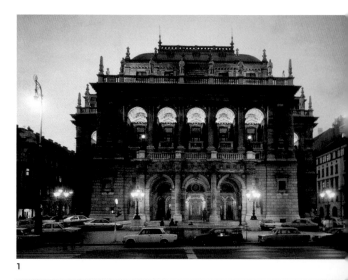

1

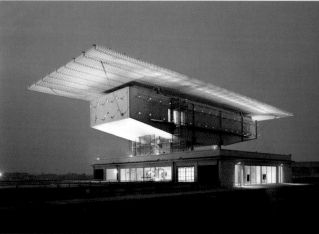

2

3

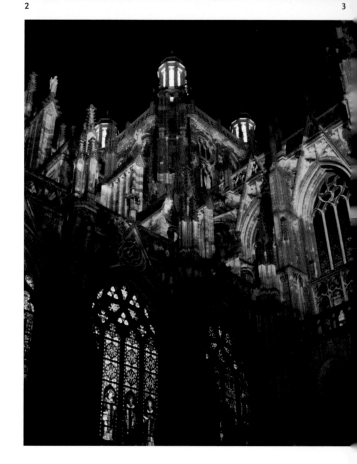

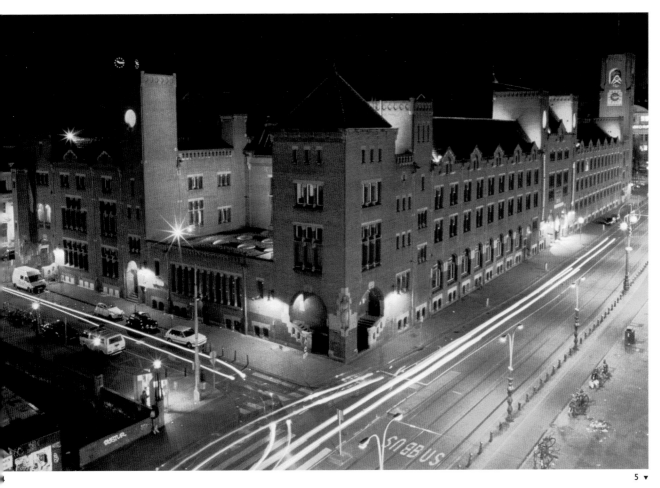

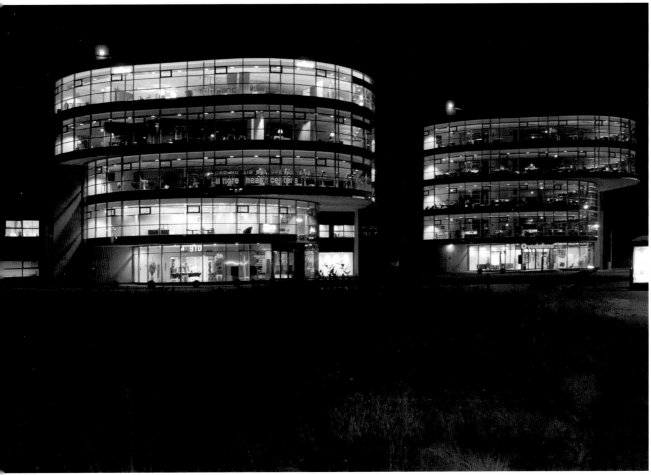

1

Opera, Budapest. Unity between the illumination and the lamps on and in front of the building. The illumination and spotlights permit a fine view of the architecture, the porches, the loggias and the staggered structure of the building and the roof.

2

The Agnelli Art Gallery in Turin, by Renzo Piano, is a free standing building with striking architecture. The lighting comes from within and from the surface of the building itself. The roof construction is illuminated by floodlights that are distributed at intervals over the closed vertical surfaces. The underside of the roof structure is illuminated from the top of the ground floor. With the light coming from the rooms, it all forms one composition.
Lighting design Piero Castiglioni

3

The Sint Janskathedraal in 's-Hertogen-bosch and its interior and exterior lighting. At street level, the light inside the building shows the windows in all their glory. The illumination in the 'pepper pots' of the tower is the crowning feature of a large-scale building that is situated in a city centre and so cannot be seen in its entirety from close up.
Lighting design LITE – Christa van Santen/ir A.J. Hansen, Amsterdam

4

The high standpoint makes it possible to show the plasticity and coherence of the illumination of the Koopmans-beurs, Amsterdam (H.P. Berlage, 1903). The long façade on the Dam-rak is not illuminated, because it receives sufficient light from its surroundings. The entrances have their own luminaires and are marked by a wall lamp. Attention has been paid to the third dimension in order to emphasise the plasticity of the solid-looking building. There is light in the louvred openings, the loggia and the atrium. The short sides of the building are gently illuminated. During exhibitions, light comes out of the large hall of the building.
Lighting design LITE – Christa van Santen/ir A.J. Hansen, Amsterdam

5

The exterior walls of the Il Fiore office complex in Maastricht are almost invisible at night. The lighting transforms the interior, with its differently furnished showrooms, into the exterior. The companies ultimately want to have a presence that is also visible from outside.
Architect Herman Hertzberger, Amsterdam

can develop and have a positive effect on the continuity within the town. There are examples where the two kinds of lighting form a harmonic whole.

The optimal effect is achieved when a total design for an area, a so-called master plan, is drawn up, in which public lighting and illumination can be tuned to each other in a creative manner. In such instances, the 'upper limit' of the light levels must be controlled more strictly than has previously been the case. One illumination should not be allowed to overwhelm another. It is possible to imagine situations where there is more street lighting when the building illuminations are not switched on, and vice versa. It should be remarked here that illumination cannot replace public lighting. The relationship between the two must be assessed on an individual basis.

It is of course a challenge to install and distribute the different types of light so that the city also has a story to tell at night, about its structure, about its construction, about its most important places. Artificial light must be manipulated. Expertise in the field of lighting is vital if you want to put together an aesthetically responsible illumination programme. Suppliers of light fittings are often seen as lighting specialists. This is usually incorrect. It is the lighting designer who has a vision of the connection between the illumination and the continuity of the exterior design features. Using a few general principles as a sort of manual is not sufficient; every situation is unique and makes it own demands. There are always several possible solutions. The result is a choice.

We only need a little light to see each other, at least when all the light sources are in harmony. It is often possible to do more with less light – more light is not always better, particularly when it increases contrasts. And illumination is not necessary everywhere; after all, the idea is that we should still be able to see the stars in the sky.

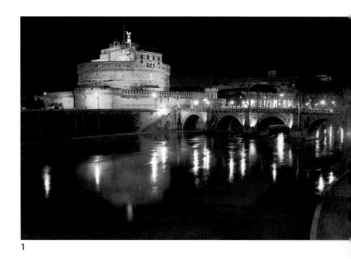
1

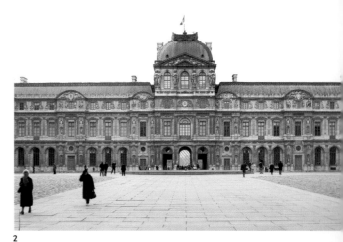
2

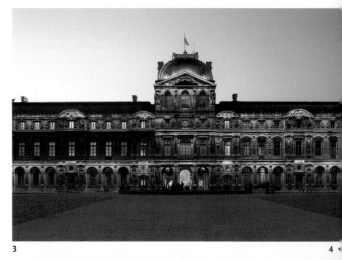
3

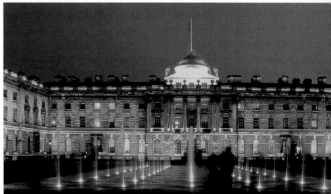
4

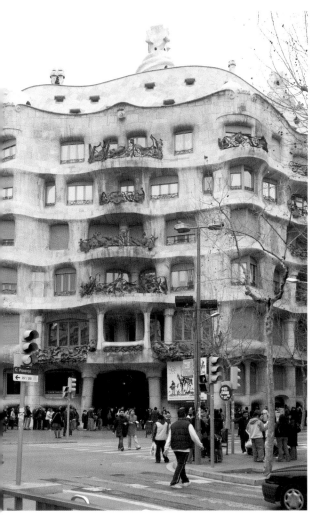

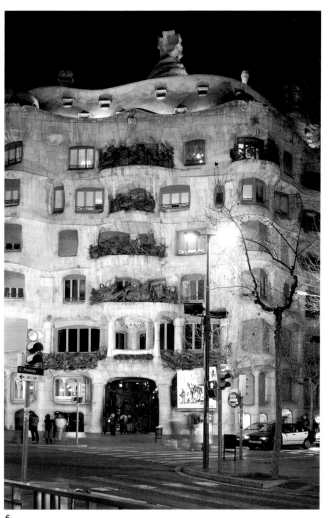

1
Castel Sant'Angelo, Rome. An interesting ensemble: the castle with the bridge and its reflection in the water. The form and composition are supported by the consistent nature of the lighting and the colour.

2/3
The façade of the Sully wing is displayed at its best. It is one of the façades of the Louvre in Paris that are illuminated by lights incorporated into the front of the building. The three-dimensionality of the whole is maintained. This makes a peaceful impression, which corresponds most closely to its daylight appearance. The fact that some of the illumination has stopped working is a defect that immediately attracts attention.
Lighting design E D F (Electricité de France)

4
The restoration project for Somerset House, London, is apparently straightforward. A closer look draws our attention to the diversity: the loggia on the first and second floors, the illumination of the tympanum and the dome. The over-illumination means that the tympanum practically disappears, which disturbs the image.
Lighting design Phoenix Large/lightmatters.

5/6
The illumination of Casa Milá, Barcelona (architect: A. Gaudí), is a design with no pretensions. The consistent lighting does justice to the architecture, which is more or less in line with its daytime appearance. The incidental light from the building is an addition. The receding rooftop unit can clearly be seen, but stands out because of its irregularity.

6

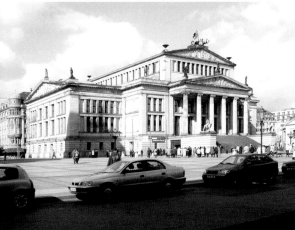

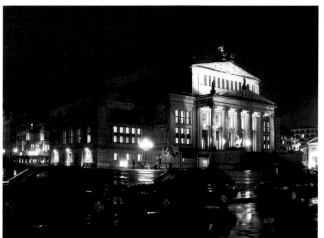

8

7/8
The Konzerthaus on the Gendarmenmarkt in Berlin during the daytime. Only the front façade is lit at night, which means that the rest becomes invisible. The porch behind the pillars of the entrance is illuminated and the recessed part with the tympanum is also lit, which makes the depth visible. The excess of light makes the tympanum above the pillars disappear.

Page 76/77
Paris at night. The monuments are like diamonds sprinkled over the city. From this position the Eiffel tower and the Hotel des Invalides can be seen.

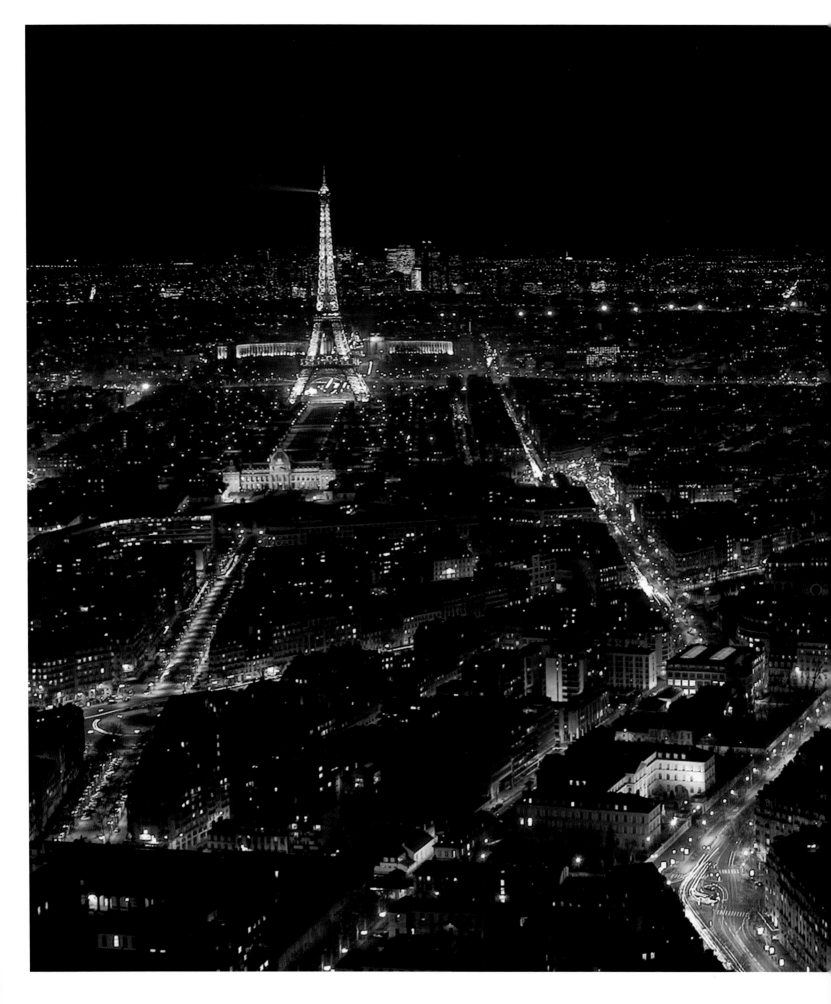

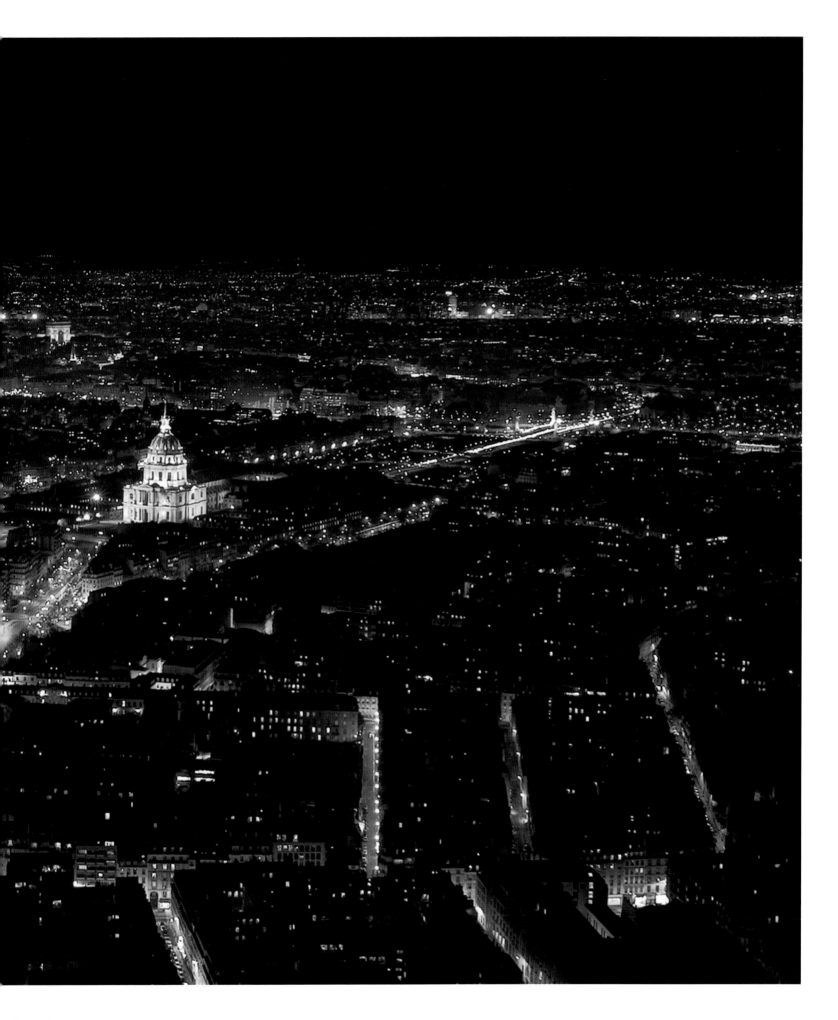

Summary

· The points of a building that deserve attention, the characteristic features of the architecture, must be illuminated.

· The totality must be preserved; no distraction should be caused by the illumination of details.

· Three-dimensionality (including protruding and recessed elements) may be accentuated (this depends on the shadows; looking in the same direction as the beam of light results in an absence of shadows).

· Architecture is space and mass, so not only the façade should be illuminated, but the depth should also be accentuated.

· If a building is sufficiently transparent during the daytime, then it should also be the same at night. A controlled amount of artificial light is necessary for this.

· In general, the lighting of buildings must be moderate, or the relationship with the environment is disturbed.

· Lighting up many details makes information unclear and impossible to 'decode'.

· If the use of different coloured lights is overdone, the lighting effect itself becomes the aim, instead of the accentuation of the architecture.

· The addition of decorative patterns such as lines, spots or dashes is not appropriate in an architectural context.

· If possible, light fittings need to be installed where they can't be seen; the operation of the light should never be distracting.

· Construction materials are only shown to their best advantage when the light source optimises their colour (such as brick, concrete, wood, metal) through good colour rendering.

· The illumination of white material offers a great deal of possibilities.

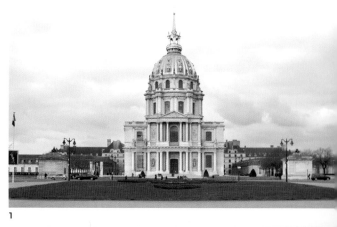

1

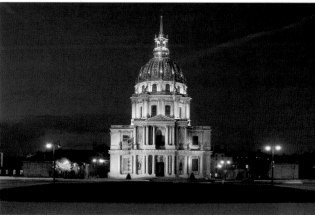

2

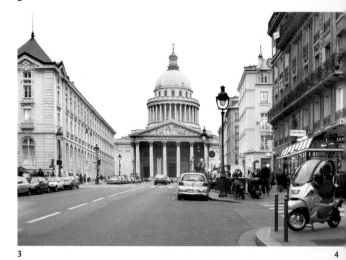

3

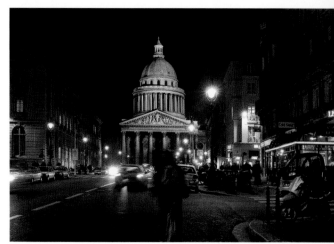

4

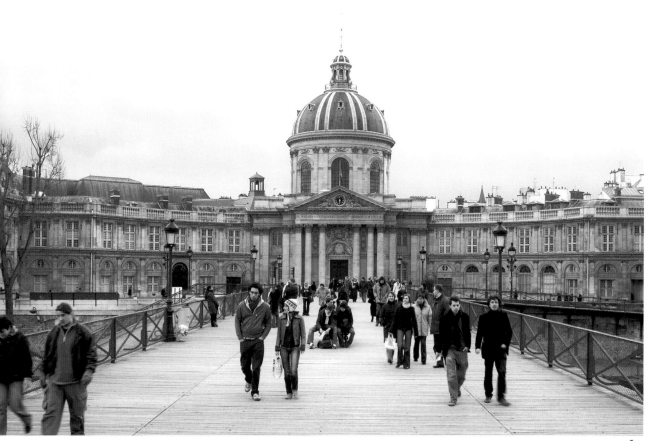

1/2

Dôme des Invalides, Paris. Many monuments in Paris have a dome. During the daytime they resemble each other, but at night the differences are discernable.
The method of lighting the dome and the light at the top make this very well-known monument recognisable from afar at night. The entrance, standing outside of the illumination, disturbs the otherwise harmonious image.

3/4

During the daytime, the Pantheon in Paris fits into the scene as far as its scale and colour are concerned. At night, the consistent, soft lighting ensures that the building, including the dome, presents an image of unity.

5/6

Collège de France, Conseil d'Etat, Paris. The illuminated dome has been treated like a 'lid' on the building. Some elements are missing from the illumination of the left wing. This illustrates that maintenance is necessary if the desired image is to be preserved.

6 ▼

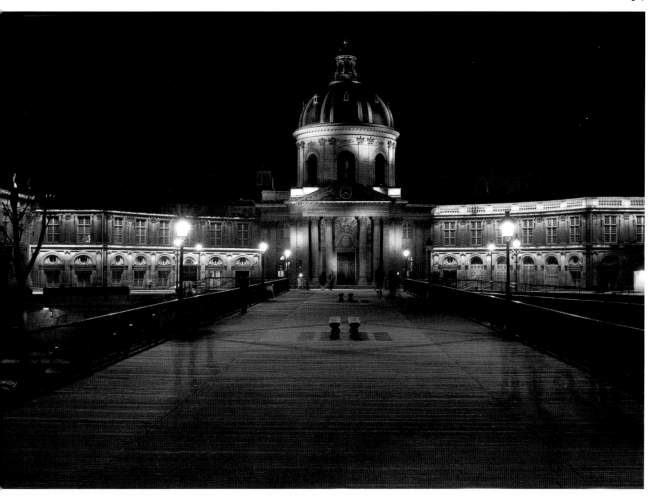

1/2

The imposing architecture of the Vittorio Emanuele II monument in Rome also makes its presence very much felt at night. Closer observation reveals that the abundance and the unevenness of the lighting has led to contrasts. The idea of creating difference in the three-dimensional effect is in itself a sound principle. Unfortunately, this effect has to a certain extent been lost.

3

One of the fountains of the Vittorio Emanuele II monument on Piazza Venezia, Rome. The reflection of the surface of the water on the underside of the basin and on the rear wall is caused by the lights in the water basin. With its combination of light and water, this is a place that stimulates the imagination.

4

At close quarters, it can be seen how large the contrasts are in the entrance porch, with shadows and inconsistent lighting. The tympanum is lost because of the contrast between the porch and the tower.

5

The Neue Wache is one of the many edifices in Berlin designed by the important architect Karl Friedrich Schinkel (1781-1841). The building is now a memorial to the victims of the First and Second World Wars. All the illumination is directed at the meaning of the interior space, where there is a statue by Käthe Kollwitz. The different colours and light levels achieve an atmosphere that is appropriate for this monument.
Lighting design LichtKunstLicht, Bonn.

6/7

The Französischer Dom on the Gendarmenmarkt in Berlin. Of the whole complex, only the entrance porch and the tower are illuminated, along with limited illumination of the dome. Directing the same lighting onto different-coloured construction materials has created a contrast. The atmosphere of the square (at street level) is not affected by this contrast.

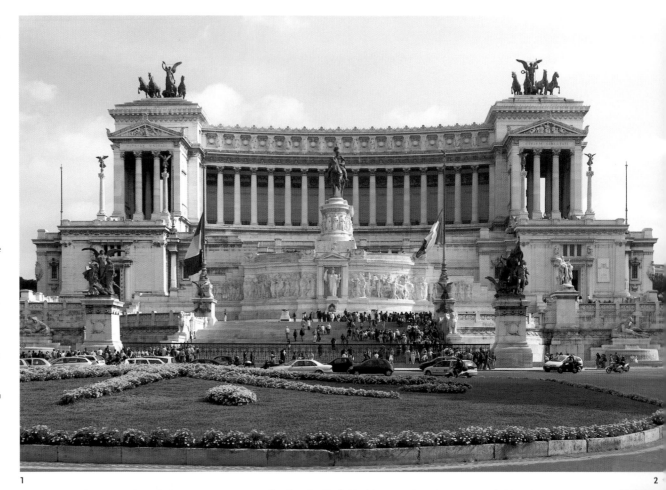

1

2

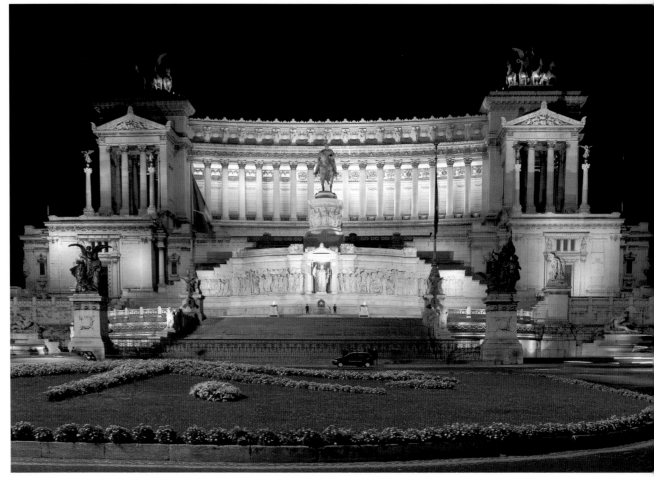

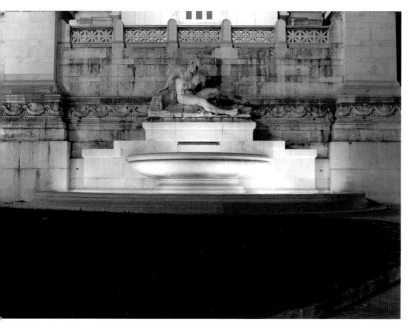

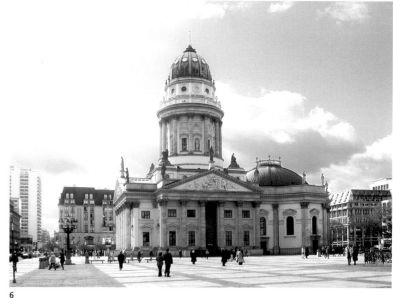

6

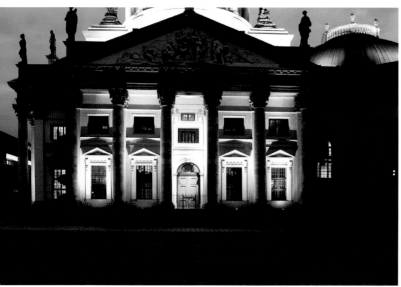

5 ▼

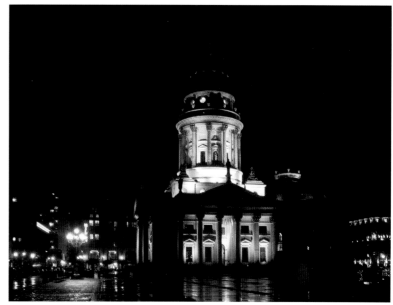

7

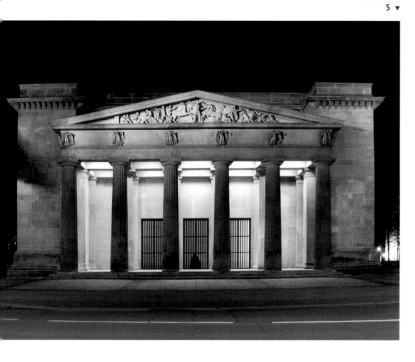

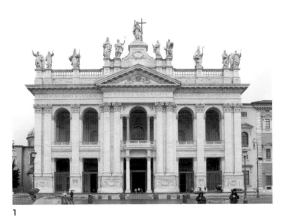

1

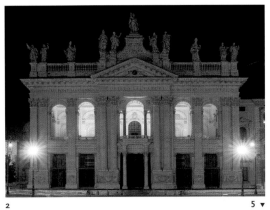

2

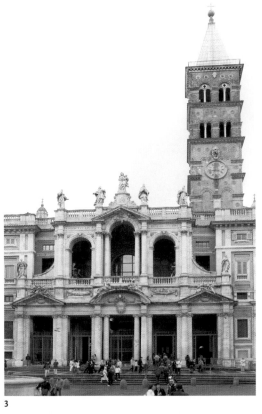

5 ▼ 3

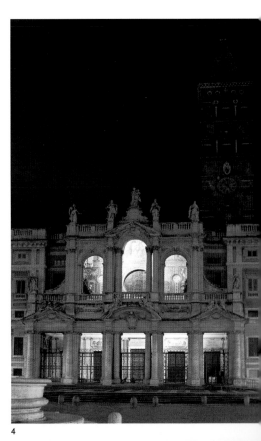

4

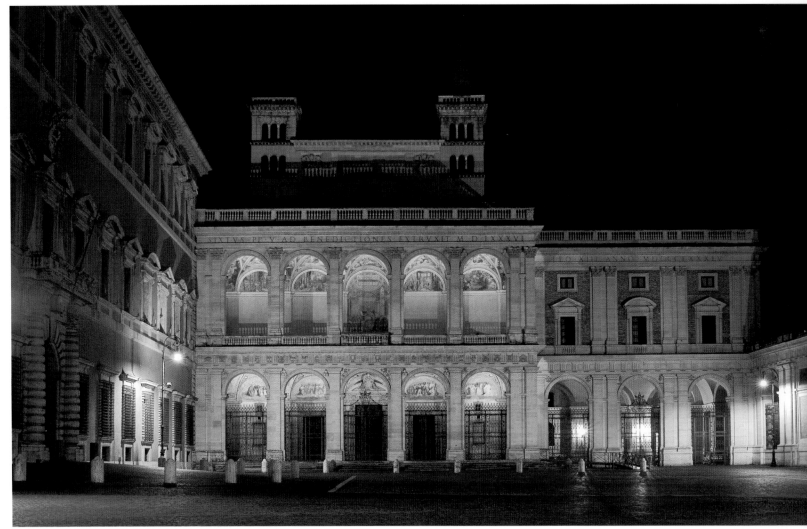

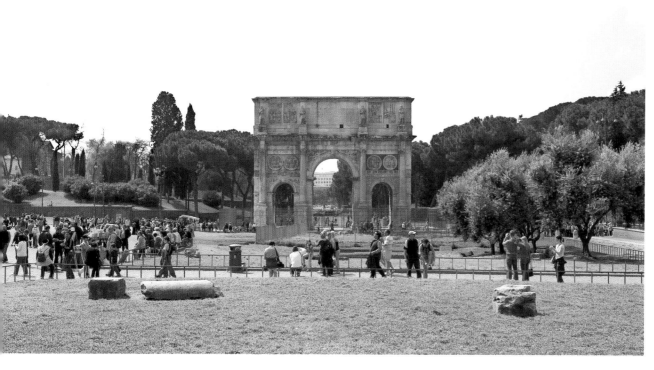

The large-scale church façade of the Basilica di San Giovanni in Laterano, Rome, is in the first instance seen from a distance. The two lamps in the foreground are so dazzling that the façade appears not to be illuminated. However, a closer look shows that it is in fact lit up, although only gently. In contrast, there is a lot of light in the gallery on the first floor, which makes the unlit ground floor appear incongruous.

3/4

In the large basilica of Santa Maria Maggiore, Rome, the illumination of the entrance porch and the rich mosaic in the loggia offers a response to the architecture of the double façade. The frontage fits in with the line of buildings. The tower does not contribute to the night-time scene.

5

Part of the Lateran Basilica. This is also gently illuminated, with light in the gallery upstairs and on the ground floor. The wall-lights have the unintentional effect of creating atmospheric surroundings at eye level.

6/7

The Arch of Constantine (312) in Rome stands like a museum piece in its surroundings. It is one of the remains from the past, as underlined by the illumination. The unity is not disturbed by the shadows of the reliefs. On the contrary, this makes them easier to see.

8/9

The triumphal arch for the World Exhibition in Barcelona (1888), a large-scale red-brick structure, functions as a gateway between the city and the park. A striking feature is that the plasticity of the arch is clearer at night than during the day. The columns look their best at that time.

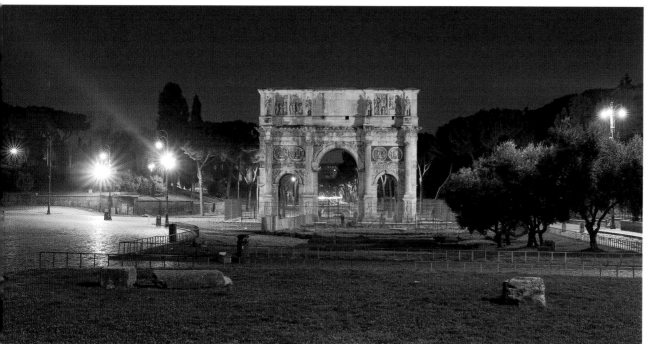

8 ▼ 9 ▼

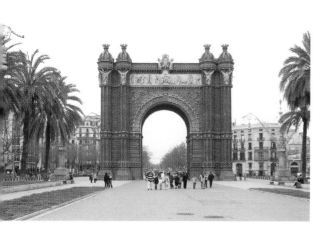

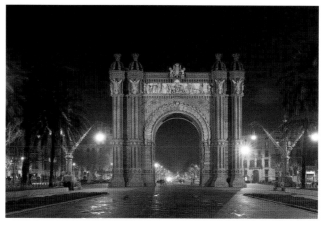

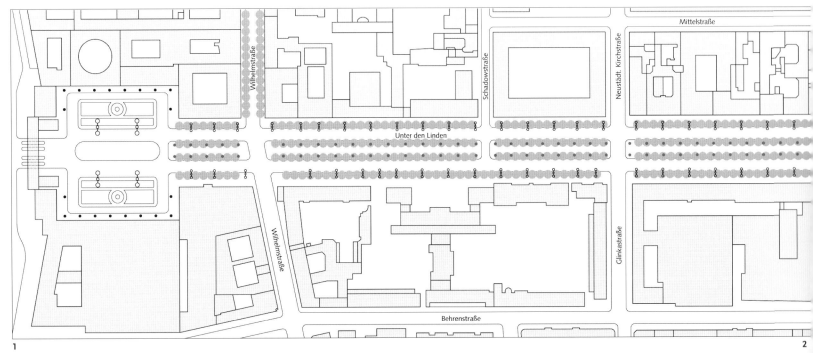

Wilhelmstraße
Schadowstraße
Neustädt. Kirchstraße
Mittelstraße
Unter den Linden
Wilhelmstraße
Glinkastraße
Behrenstraße

1 2

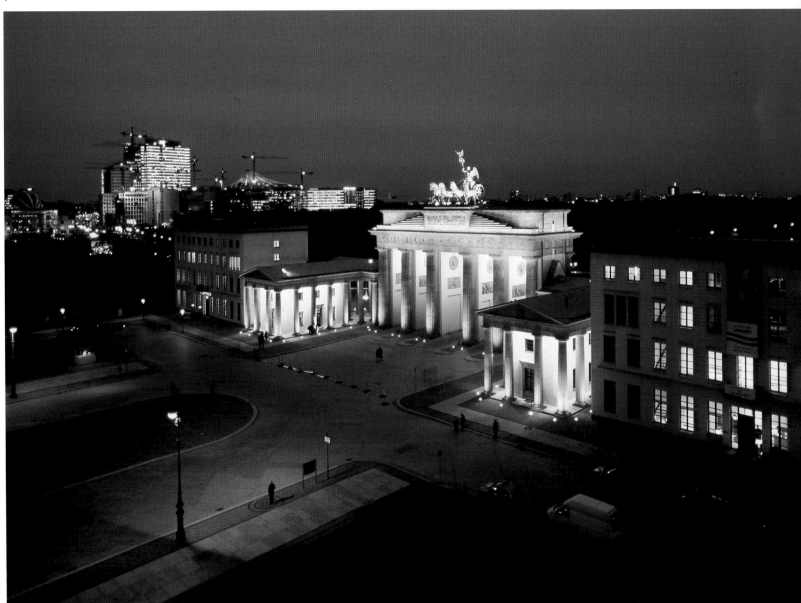

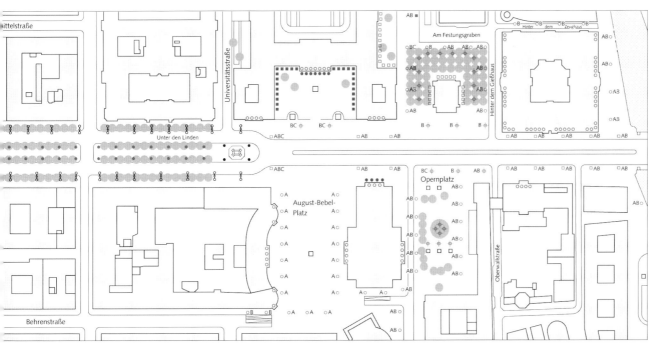

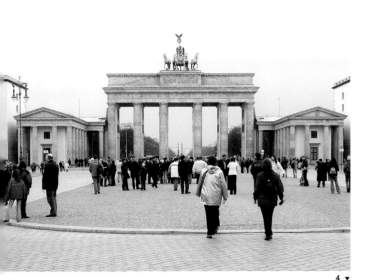

4 ▼

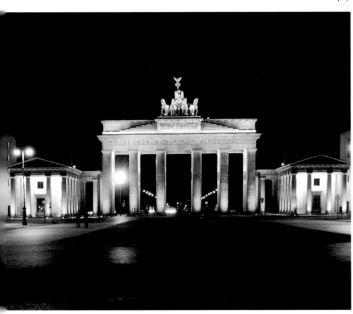

5

The Brandenburger Tor has become the symbol of the reunification of Germany. This building by Carl Langhaus was built completely in sandstone in 1791 and was restored in 2002. One side of the gate was designed to face the country; the other faces the city. The city side (Pariser Platz) has been incorporated into a development around a square; on the other side it is clearly an entrance gate to the city. Both sides of the structure radiate a great sense of harmony at night. The light makes the dimensions visible. The three-dimensionality of the building and the colour of the sandstone have been taken into account during the illumination. The quadriga on the top is lit in such a way that no disruptive shadows are visible.

All the illumination has been installed directly on or near the structure, with the exception of two lampposts on both sides of the gate on the country side. Because the original construction meant that the light fittings in the structures to the left and right of the gate were to close on the walls, the upper sides of these are illuminated too brightly. In the open interior space of the gate buildings on the country side, the original pendant fitting have been retained and adapted. This emphasises the sense of scale and the elegance.

The columns of the gate are only partially lit by ground-level recessed spotlights, which emphasises the fact that the columns are clearly standing on the ground.

Lighting design Kardorff Ingenieure, Berlin

A master plan for the illumination from the Brandenburger Tor to the Schlossbrücke was the aim of a contest organised by the city developers in Berlin. The winning design came from Kardorff Ingenieure lightdesign office, who, in addition to the plan for the street lighting of Unter den Linden, also did the illumination for the Brandenburger Tor, the Humboldt Universität and the Deutsche Staatsoper. The lighting of the remaining buildings was carried out by various lighting designers, following the principles of the master plan. This is a successful example of the integration of public lighting and the illumination of buildings.

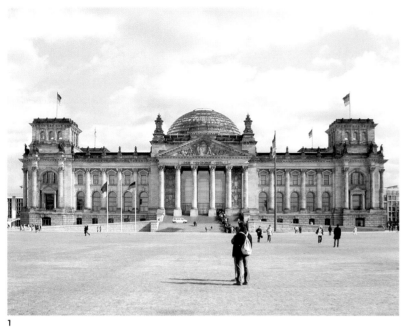

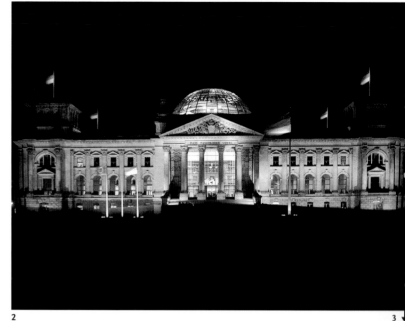

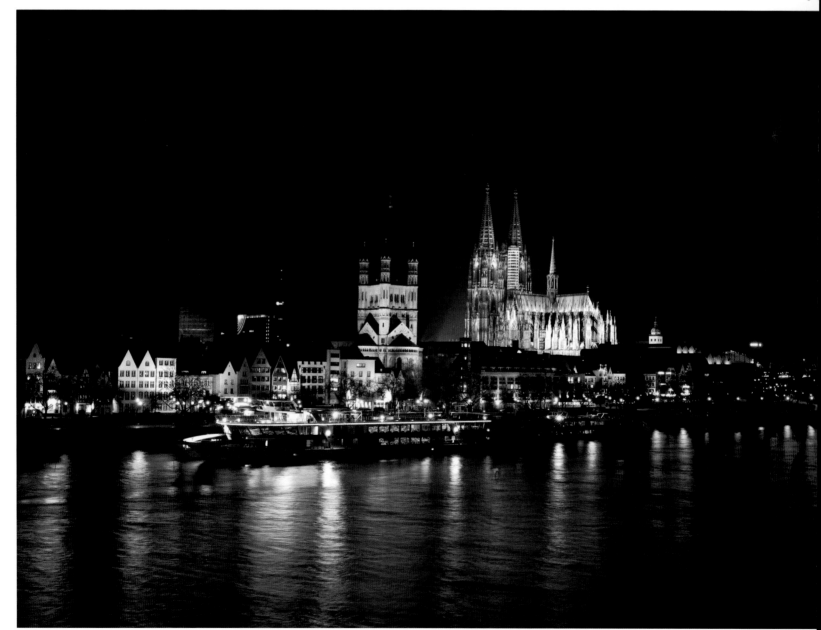

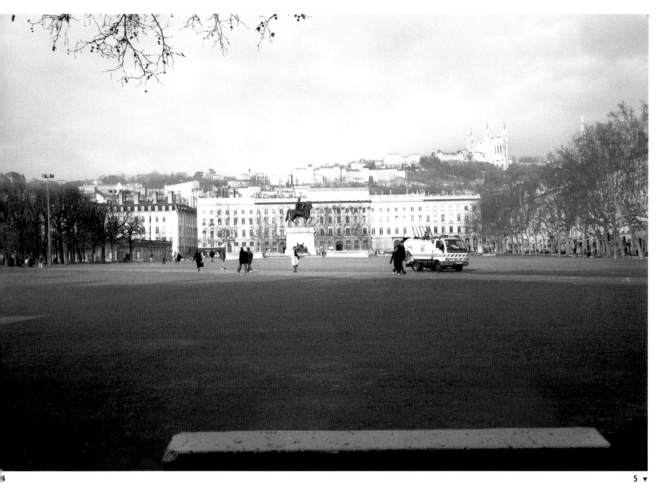

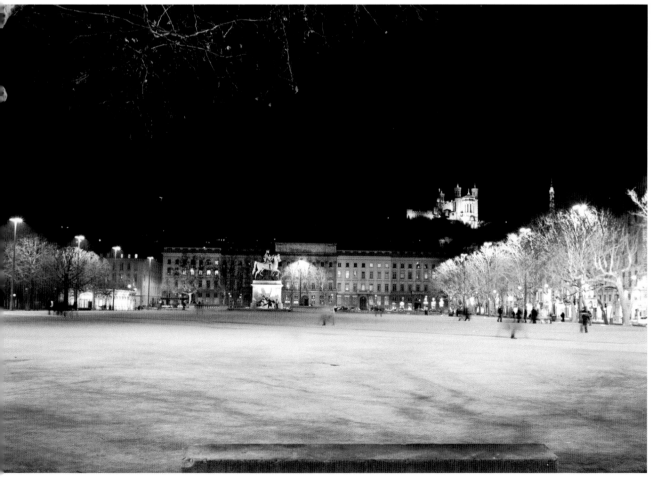

The Reichstag, Berlin, the symbol of popular representation in the new Germany. The glass dome, with which architect Norman Foster opened up the Reichstag, is visible at night because of its illumination. The light streams out of the large assembly room into the hall and the dome. The façades to the left and the right are illuminated from close up.
Lighting design Claude Engle, Chevy Chase a.o.

3
The banks of the Rhine in Cologne with the cathedral and Groß St. Martin. The cathedral stands out because of its detailed, cool illumination (4200κ). The cool impression is the result of the material, sand-lime brick, and the colour of the light. In spite of the fact that every detail is illuminated, the building as a whole still remains intact. The contrast with the warm illumination of Groß St. Martin creates a striking impression.
Lighting design René van Ratingen, Philips Lighting, Germany, with Gerhard Kleiker, GEW Cologne.

4/5
From Place Bellecour, a large rectangular piazza, the Basilique de Fourvière can be seen on a hill in old Lyons. During the day the church stands against the background of a green hill. At night the church is over-illuminated, so it seems to float in the air. It draws all the attention towards it.
Lighting design Architecture Lumière, Lyons

1/2

During the daytime, Gaudí's fairytale Casa Battló is part of the row of façades along the Passeig de Gracia, Barcelona. At night, the filigree façade stands out because of the over-illumination of details, the floodlighting and the inconsistent reflection from the differently coloured tiles of the façade. It becomes almost unrecognisable.

3/4

Commercial illumination in various shades of light on the Place du Luxembourg, Rue de Rivoli in Paris. The excess light blocks out the illumination of the gallery on the ground floor, in spite of the shop lighting. To prevent too much light in the hotel rooms, it was decided to illuminate the piers. The amount and colour of light have turned the buildings into pieces of scenery, in contrast to the gently illuminated building in the background.

5

This office building on Domkloster, Cologne, with shops on the ground floor, was built in 1952 for 4711 (Eau de Cologne). The decorative illumination, not intended as an addition but as part of the design of the façade, is a surprising feature, as is its colour.
Architect Wilhelm Koep

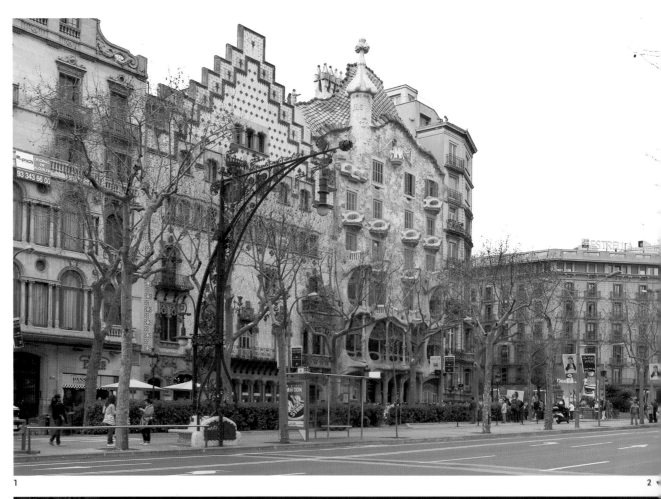

1

2

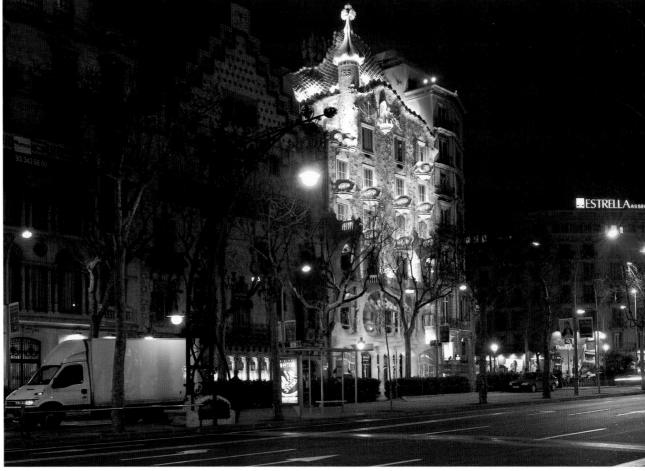

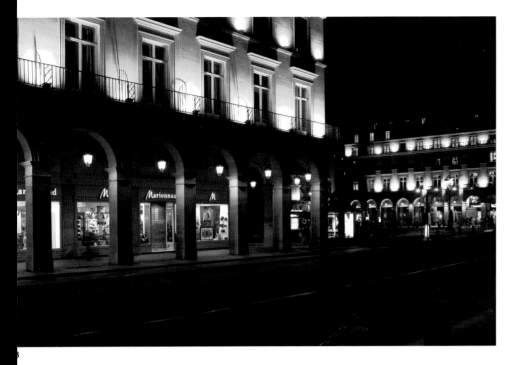

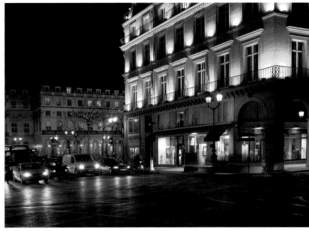

4

5 ▼

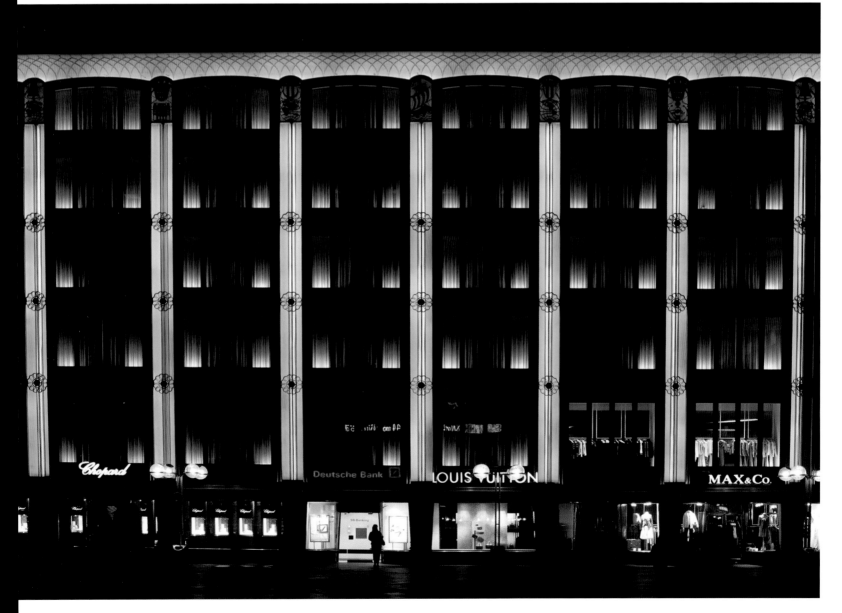

Case Studies

Brandenburger Tor, Berlin

Somerset House, London

Cathedral Basilica of Sint-Jan,
's-Hertogenbosch

Colosseum, Rome

Ostend

Bridges

Use of Colour

Brandenburger Tor, Berlin

The Brandenburger Tor, or Brandenburg Gate, which until the Wall came down was situated on the border between East and West Berlin, was thoroughly restored between 2000 and 2002. The front of this historic gate dating back to 1788 is on Pariser Platz and the rear side is on the edge of the Tiergarten city park. It is a symmetrical complex that serves as a passageway and forms a spatial unit with the adjoining buildings on Pariser Platz. This square runs into Unter den Linden, with its famous buildings such as the Humboldt University, the Neue Wache, the Staatsoper and a number of embassies. A competition was organised for the allocation of the contract to illuminate the Brandenburger Tor, with Kardorff Ingenieure Lichtplanung winning the contract to develop the proposed lighting plan into a master plan for the whole area.

The lighting plan is conservative and elegant and makes it easier to recognise the features of the square. Important characteristics of the plan are:
· the depth of the gate is made visible;
· the colour of the light is uniform, which ensures that the sandstone of the gate is displayed at its best advantage and that the complex is perceived as a whole;
· the use of existing luminaire positions to avoid damaging the monument.

The illumination of the Brandenburger Tor can be seen from many angles. The lighting is subdued; there are no banks of lights set up at a distance. Nearly all of the 250 luminaires are built into, or fixed

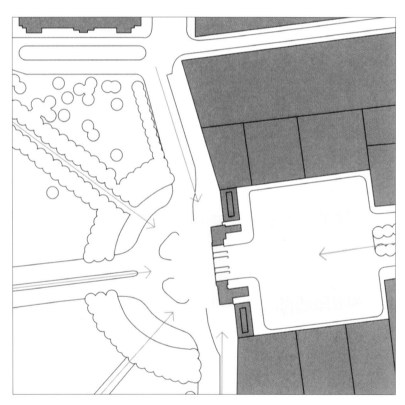

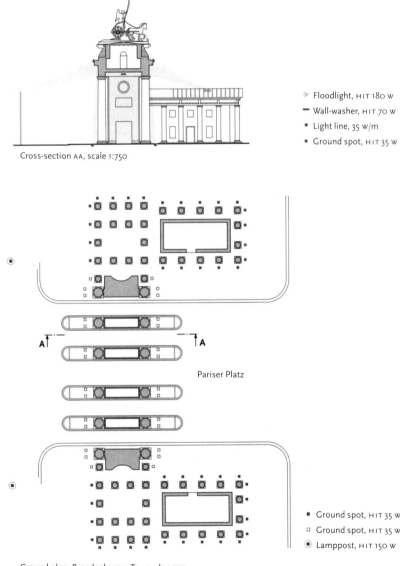

▷ Floodlight, HIT 180 W
— Wall-washer, HIT 70 W
· Light line, 35 W/m
■ Ground spot, HIT 35 W

Cross-section AA, scale 1:750

Pariser Platz

■ Ground spot, HIT 35 W
□ Ground spot, HIT 35 W
◉ Lamppost, HIT 150 W

Ground plan, Brandenburger Tor, scale 1:750

closely to, the building, with the exception of the lights mounted on two posts on the Tiergarten side of the gate.

There is a difference in the lighting of the front and the back of the monument. The quadriga faces Pariser Platz and is illuminated in a sophisticated and professional way, with lights that are situated under and alongside the horses and inside the chariot. From street level, nothing can be seen of these luminaires. Seen from the Tiergarten, the quadriga is dark, and the sculpture is only visible as a silhouette. The passageways through and the interior spaces of the three-part gateway can be clearly seen at night. The lighting as a whole has been brought into equilibrium: the floodlighting of the columns, the illumination of the walls in the main passageway and the archways and the lighting of the architrave.

The line of lighting around the top of the gate at the front and the back consists of 35w/m fluorescent tubes. The other light sources are all metal halide (HIT with ceramic burner) with a warm colour because of the colour rendering of the pale-beige sandstone. A cool version was selected for the quadriga.

It is usual for a mock-up to be made for a lighting design, so that the positioning of lights can still be changed or more or less light can be used. The restoration of the gate meant that this was not possible in this case, so a 3D model was developed, which accurately portrayed the proposed plan. The light from each luminaire was simulated to assess the combined effect of the different light positions. When the plan was implemented, the simulation model proved to be in line with the actual situation, so no adjustments were required.

Lighting design Kardorff Ingenieure Lichtplanung, Berlin
Photo Linus Lintner

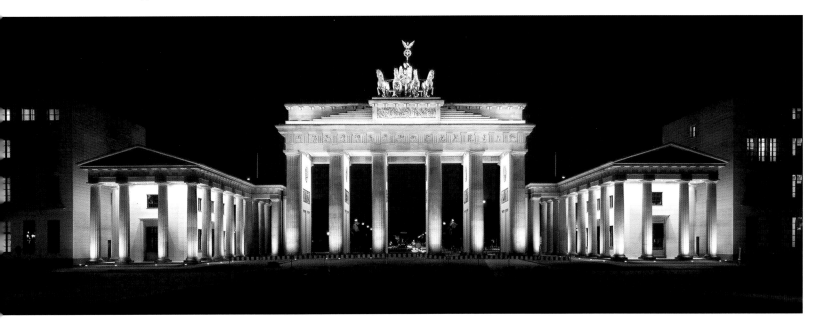

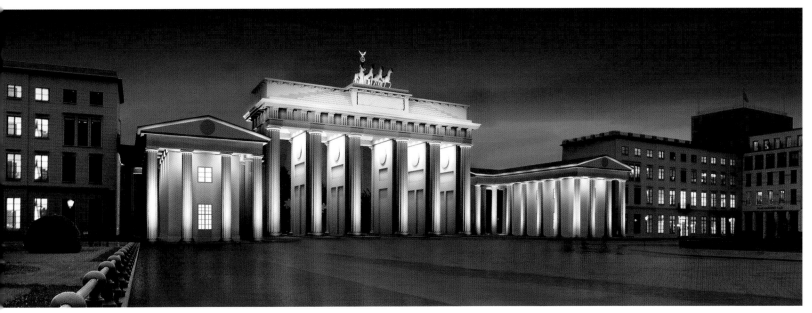

Somerset House, London

Somerset House in London, built (1776–1801) by William Chambers and recently completely restored, houses various museum collections, as well as a restaurant and a café with a terrace. The lighting plan for the complex was designed by the London firm Lightmatters. The main aim of the design was to recreate the historical lighting that was discovered in paintings and prints of the period and in accounts of the construction. Many original fittings were refurbished or remade. In addition to this, architectural wash lighting was applied to each elevation with an added layer of lighting to highlight architectural details at a higher brightness level. For the River Terrace on the Thames side of the building, the existing lighting was retained. The fountain design for the courtyard has been implemented.

The u-shaped courtyard of Somerset House is very suitable as a backdrop for concerts, operas and other events. One of the requirements was that the lights should not be visible. It was possible to

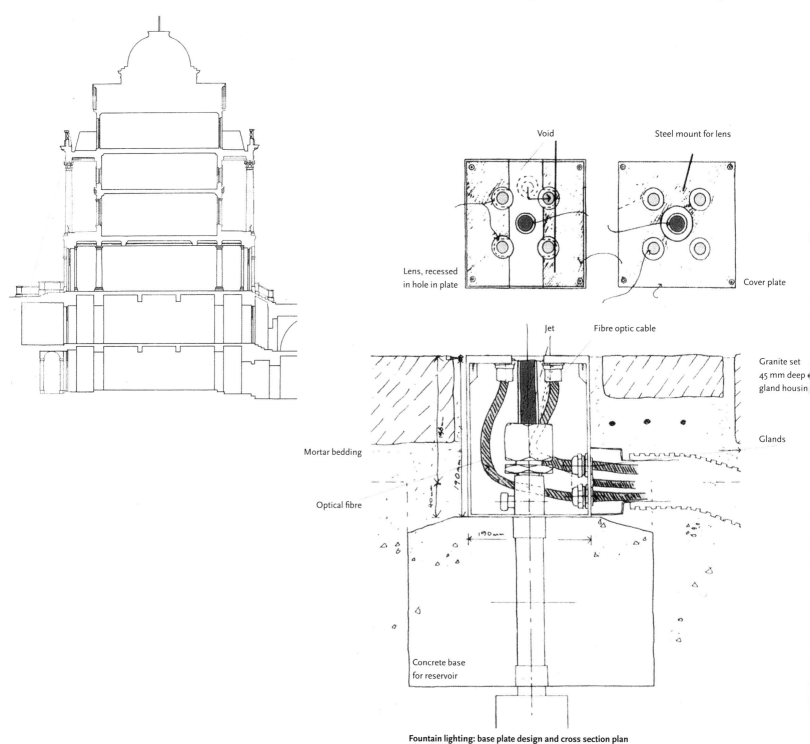

Fountain lighting: base plate design and cross section plan

conceal the various lights by using the wall opposite the exposed basement. The basement has the height of a full storey and the lights that are attached on the opposite inner wall are positioned at such a height that they do not cause any disruption.

A great deal of attention was paid to the fountains and their coloured lighting. The fountains had to form a unit with the u-shaped rear wall. In the floor of the courtyard, laid out in a rectangular pattern, there are 55 computer-controlled spouts, at a distance of three metres from each other, with jets of water varying in height from 0.5 to 5 metres. The illumination of the fountains is done with glass optical fibres, supported by projectors built into floor wells with a 150 W HQI light source. The spouting of the water jets and the changing of the colours are synchronised and have no regular repetition. The illumination of the façades and the fountains is a complete surprise for anyone looking through the gate on the Strand into the courtyard. The fountains add to the feeling of a secret oasis of calm within the hustle and bustle of London.

Lighting design Lightmatters, London
Graham Phoenix/Sharon Stammers

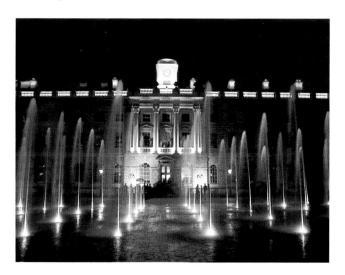

Cathedral Basilica of Sint-Jan, 's-Hertogenbosch

The cathedral is the central point of this lively provincial Dutch city. The residents of 's-Hertogenbosch are very involved with 'their' Sint-Jan. Any changes are viewed critically. This lighting design was based on a conservative approach to the building, which took into account its usage and position.

The lighting design was based on the following principles:

· reinforcing the unity of this complex building;

· retaining the sense of intimacy that comes from its location in the old town centre;

· making it possible to enjoy both the interior and the exterior of the church;

· optimising the profile of the building so that it could be recognised from a considerable distance.

The architecture of Sint-Jan is complex, with different atmospheres created by the different periods of construction. The complexity of the exterior required illumination that would reinforce this unity, whilst retaining the different atmospheres. The length and height of the cathedral had to remain visible at night, as did references to the interior, such as windows.

The illumination of the central nave makes the height of the church visible from outside. The perception of the architecture as a whole is supported by the illumination of the windows of the side

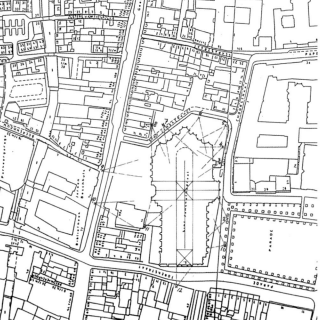

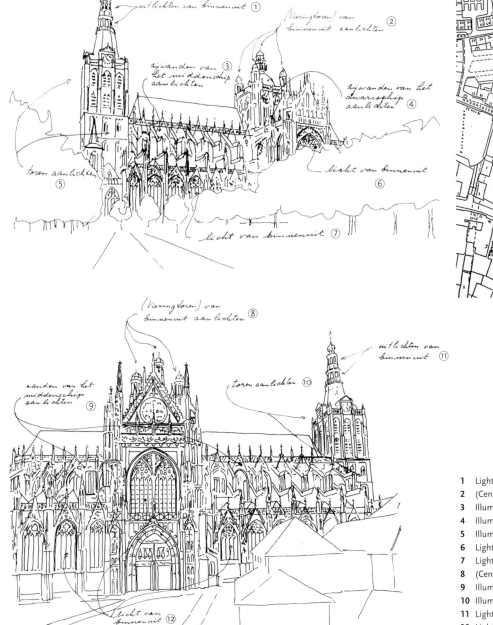

1 Light from within
2 (Central tower) Light from within
3 Illuminate nave walls
4 Illuminate transept
5 Illuminate tower
6 Light from within
7 Light from within
8 (Central tower) Light from within
9 Illuminate nave walls
10 Illuminate tower
11 Light from within
12 Light from within

aisles and the illumination of the choir aisle from within, which was done by adapting the existing luminaires. An absence of luminaires in the transept meant that its windows had to be directly lit with floodlights, which were installed as unobtrusively as possible.

When you are approaching 's-Hertogenbosch, you can see the outline of Sint-Jan and its towers, an important symbol of the city. The west tower, although maybe not the most interesting part from an architectural point of view, requires particular attention and now has external illumination on all sides. The spaces in the spire are lit from inside, as are the five 'pepper pots' of the central tower.

The usual entrance is on the western side under the tower, which has been the property of the town council since time immemorial. This entrance has an informal character and is very welcom-

ing for visitors and people coming to pray. At night, two simple lamps mounted on the fence are the only points of interest at ground level.

The illumination from outside consists of 62 lights with a metal-halide light source (HIT warm white). In the choir, there are five lights of 150 w; the side aisles have 46 lights of 250 w; and the tower has 11 lights of 400 w.

Lighting design LITE, Amsterdam
Christa van Santen/ir A.J. Hansen

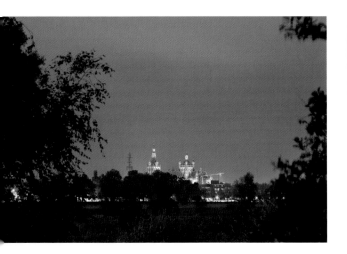

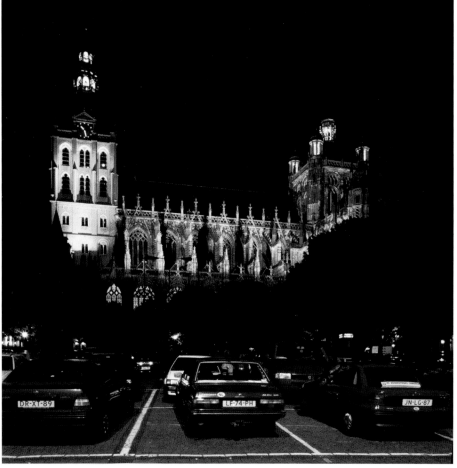

Colosseum, Rome

The official name of the Colosseum in Rome is the Amphitheatrum Flavium. This enormous oval construction had eighty entrances and could accommodate 50,000 people from all walks of life. Part of the Colosseum, which was inaugurated in AD 80, has been preserved. Together with the Arch of Constantine (in the background) and the Forum Romanum, it makes a trip to this part of Rome most enjoyable both during the daytime and in the evening.

The 'white' light under the arches and along the highest section, with its travertine marble cladding, comes from metal-halide lamps (3000 K). In total, 140 CDM-T 35 Watt and 67 CDM-T 70 Watt Schréder Corus spots have been used, all emitting light asymmetrically. Extra light may be added for special events: 32 HPI-T 2000 Watt (4700 K) lamps in an Olimpia 3 luminaire from Schréder. Seen from below, these narrow beams come from the third row of arches.

In the background, the warm light of high-pressure sodium from an earlier illumination plan can be seen. The combination of these two types of light makes the building stand out and reinforces its character.

Lighting design Remo Guerrini, Stefano Santia, Daniele Cicco (ACEA Spa, Rome)

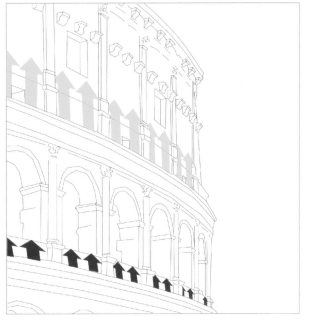

Corus 35w, intensive grazing light distribution

Corus 70w, grazing light distribution

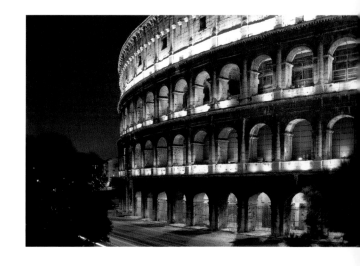

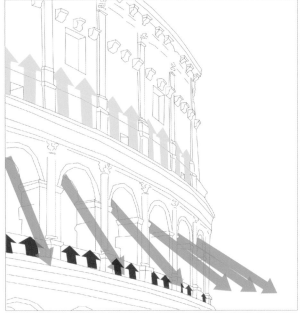

Corus 35w, intensive grazing light distribution

Corus 70w, grazing light distribution

Olimpia 2000w, narrow beam

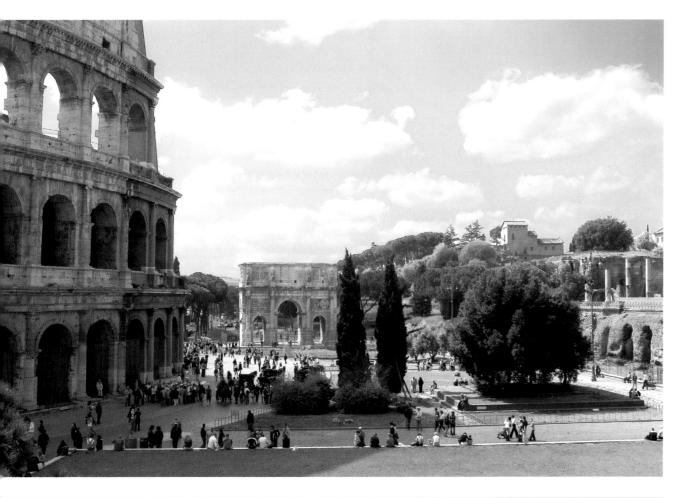

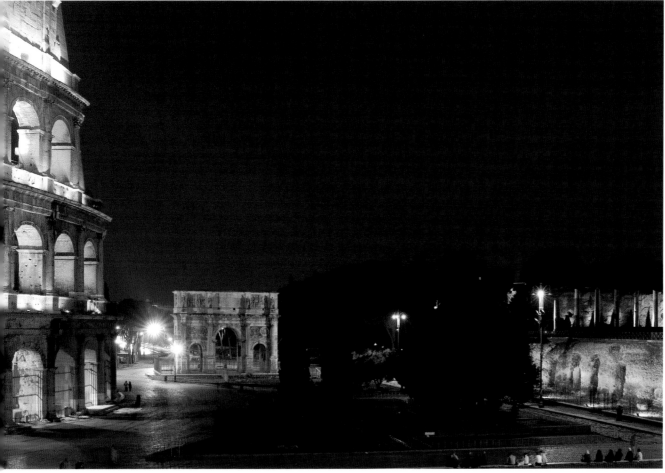

Ostend

Increasing tourism frequently results in the improvement and beautification of places that receive a lot of visitors. Ostend, often referred to as Queen as the Bathing Resorts and one of the few large towns on the North Sea, has long been a popular destination, with its seawall, the boulevards and the harbour area. The Albert 1 Promenade from the Casino to the Venetian and Royal Galleries, where the Thermae Palace Hotel is situated, and the seawall in the Mariakerke area of town have now been redesigned. As part of this redesign, the illumination has also been renovated. The first part, as far as the galleries, was completed in 1998, followed by the harbour area, with the next step being the section from the pier to the Casino. In the section that has not yet been modernised according to the new design, there is a single row of concrete posts that have two arms with luminaires giving off evenly distributed light from a height of 12-14 metres. This provides sufficient light in the pedestrian zone, the neighbouring buildings are lit up to the third storey and much of the beach can be seen. With the waves in the background, this makes the beach an inviting place to visit even in the evening.

The design for the section that has already been completed consists of a carefully constructed series of round and straight wall sections with a row of four-metre-high light pipes running down the middle (Vigo design by Hess with a 70w metal-halide lamp). Blue compact-fluorescent ground spots, which do not attract any attention in daylight, have been installed in the edges of the stone surrounds. The streetlamps, together with the lights positioned high up on the façades of the apartments, which have asymmetric optics and a 400w high-pressure sodium lamp, provide sufficient illumination to light the way and to allow people to see each other clearly on the promenade. Floodlights with a 150w metal-halide lamp fixed on

the upright wall of the promenade are used for the illumination of the sand. The combined reach of this light is comparable with that of the old streetlamps in the section that has not yet been redone.

Three types of light have been necessary in the new design to match the amount of light provided by the old streetlamps: lights on the apartments for illuminating the boulevard, lights on the upright wall of the promenade to illuminate the beach and light pipes running along the length of the boulevard/promenade. The decorative surrounds with the inbuilt blue lights are no more than an additional feature, but it must be said that the new design creates a livelier atmosphere than the tall concrete lampposts, which give good visibility, but illuminate the area in a comparatively unexciting way.

The positions of the illumination devices are given to scale in the two blue cross-section sketches.

The lighting plan for the whole of the seawall including the harbour area is by Atelier Roland Jéol (Lyons, France), in collaboration with Filip J.M. Vanhaverbeke, process and project director for the modernisation of Ostend.

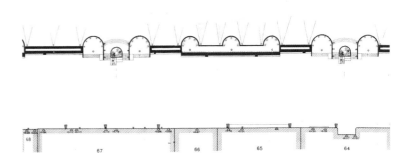

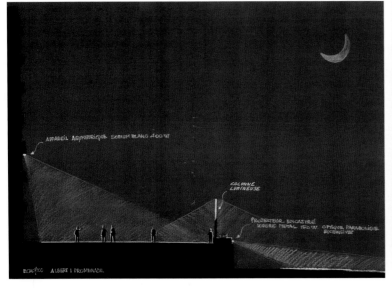

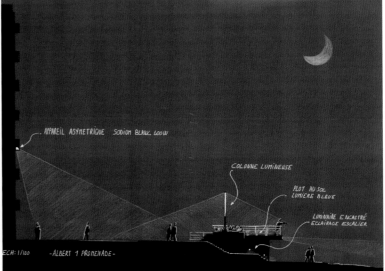

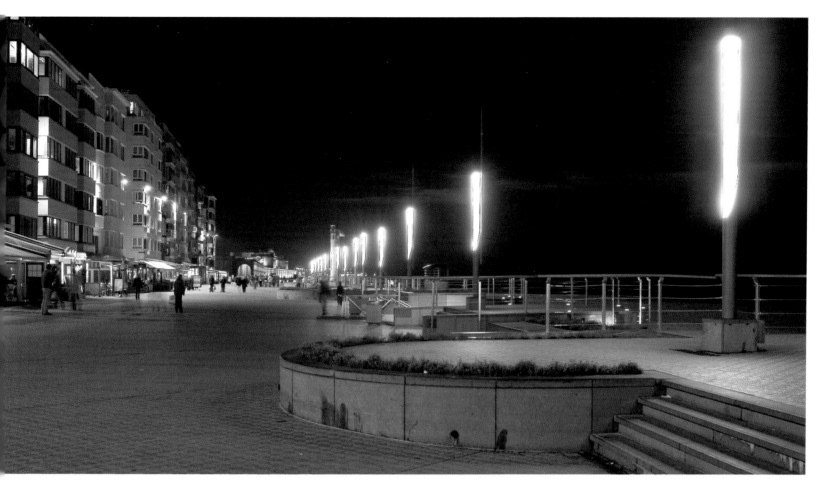

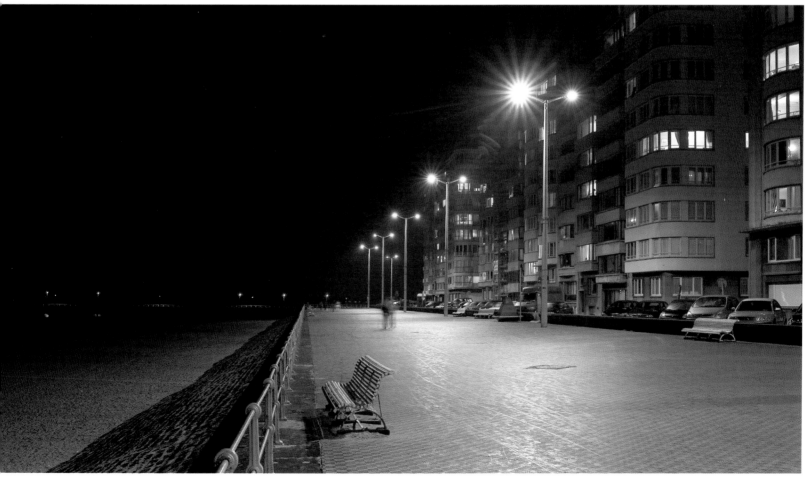

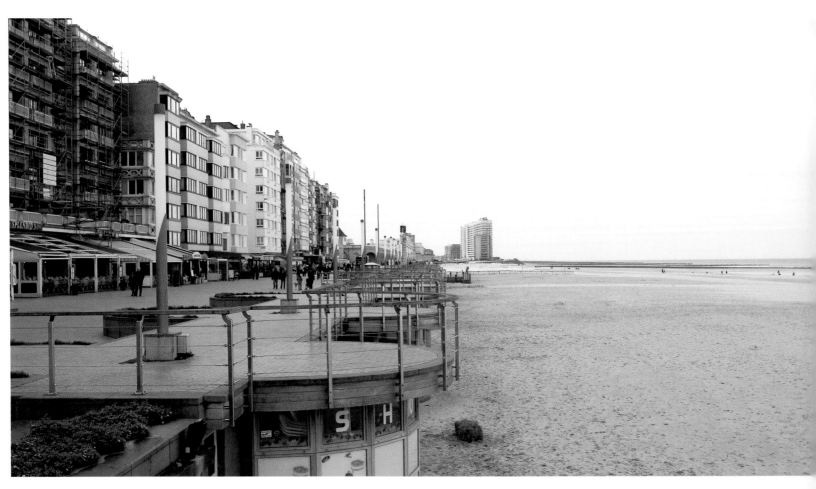

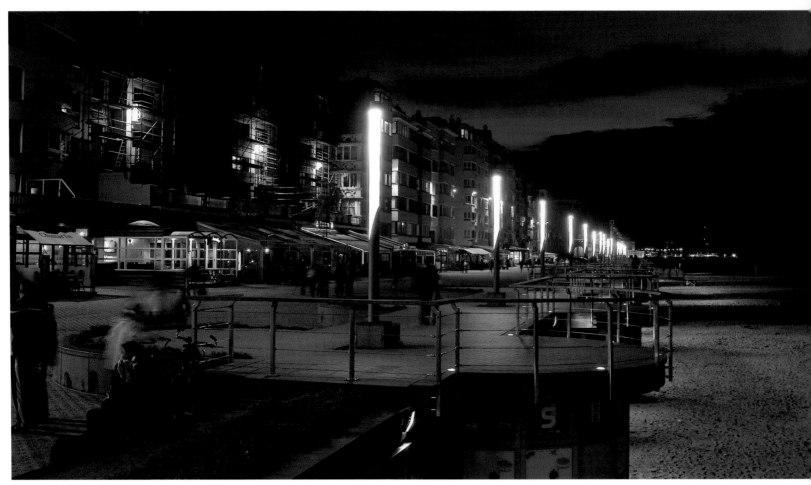

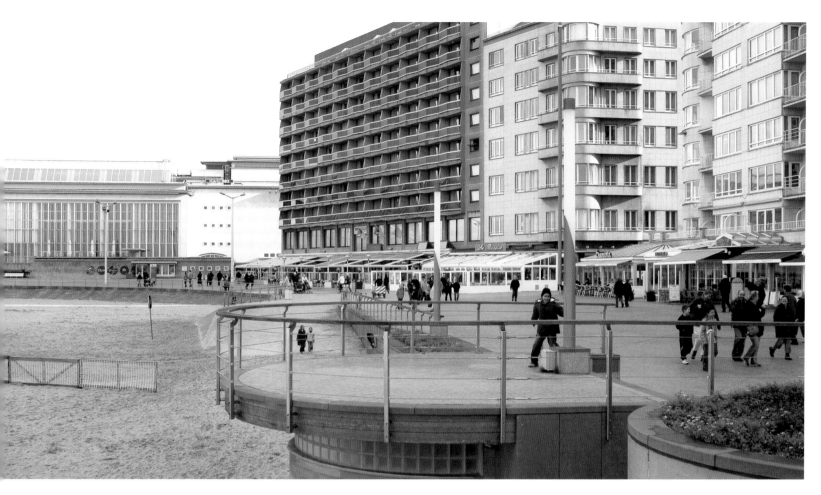

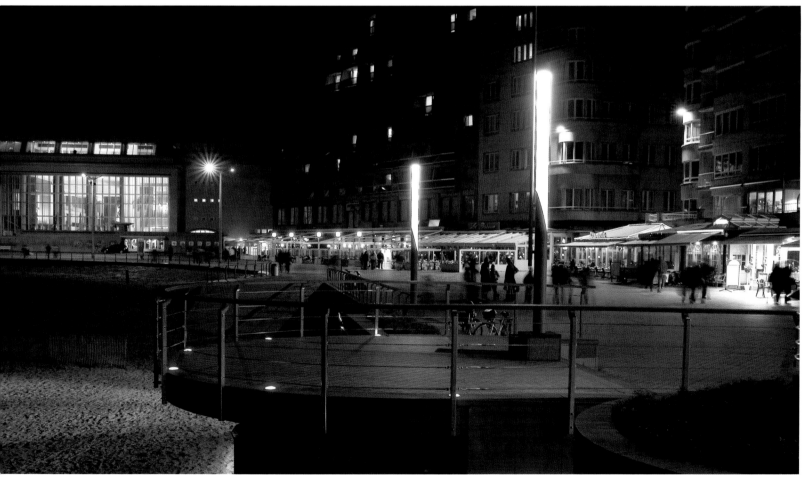

Bridges

Bridges are functional constructions made of stone, brick, concrete or metal, sometimes constructed entirely of wood or of a combination of materials that gives character to the design. City bridges provide routes over rivers and canals, over railway yards and valleys, often serving as points of orientation for people in the surrounding areas. In the evening and at night, street lighting is generally used to guide pedestrians and other traffic over the bridge. In cases where the bridge goes over water, shipping traffic always needs to be taken into account in the plans for illumination. Glare may be not caused, at quite a distance from the bridge and the routes underneath the bridge must be easily visible. Illumination plays a role in two directions: over the bridge and underneath it. Design and illumination can work against each other. City residents can see for themselves that there are different opinions on this subject.

Below is a selection of some types of bridges that are used (mainly) by pedestrians.

The bridges over the Seine in Paris form an important element of the City of Light, as Paris is often called. A master plan based on a number of interesting principles has been formulated for the bridges over the Seine. The categories are:
· stone bridges: the material and details are accentuated by the light;
· iron bridges: the structure is made visible by light with a cool colour;
· historic bridges: the light serves to emphasise historic and cultural aspects;
· central bridges (links between riverbanks at important points): these have more illumination than the other bridges, both on their surface and on the details.

Pont Neuf, Paris

The Pont Neuf in Paris, the oldest bridge over the Seine, is illuminated by compact fluorescence, fluorescent tubes and a line of xenon lamps. The details and the surface of the bridge are illuminated by compact-fluorescent lighting with a colour temperature of 2700 K. The balustrades are illuminated by a line of xenon lamps. The arches are lit by the 3000 K fluorescent tubes positioned at the top of the pilasters.

All of the light sources are covered by a screen (in the same colour as the stones of the bridge), so that there is no dazzle to disturb the traffic on the river or the pedestrians on the banks. The lampposts for public street lighting that were later added to the bridge constitute part of its architecture during the daytime. In the evening and at night, the lampposts blend into the surroundings and are no longer noticed.

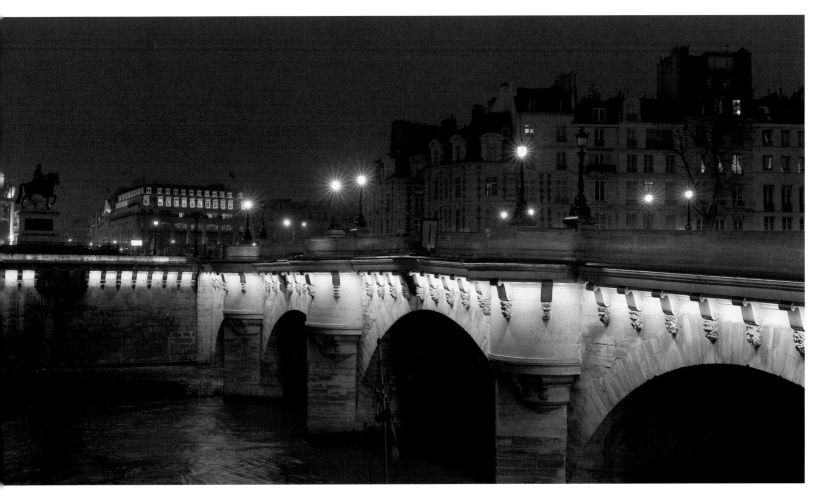

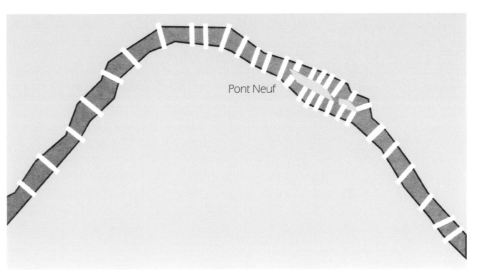

Pont Neuf

Amsterdam

In Amsterdam, the arches of the bridges are simply accentuated by a circular row of bulbs of 7.5 w and 30 v that operate on undervoltage, housed in a specially designed vandal-resistant cover. This lighting has nothing to do with the third dimension of the bridge, with its architecture and depth. It is a two-dimensional addition, which is seen by the many tourists as characteristic of the city.

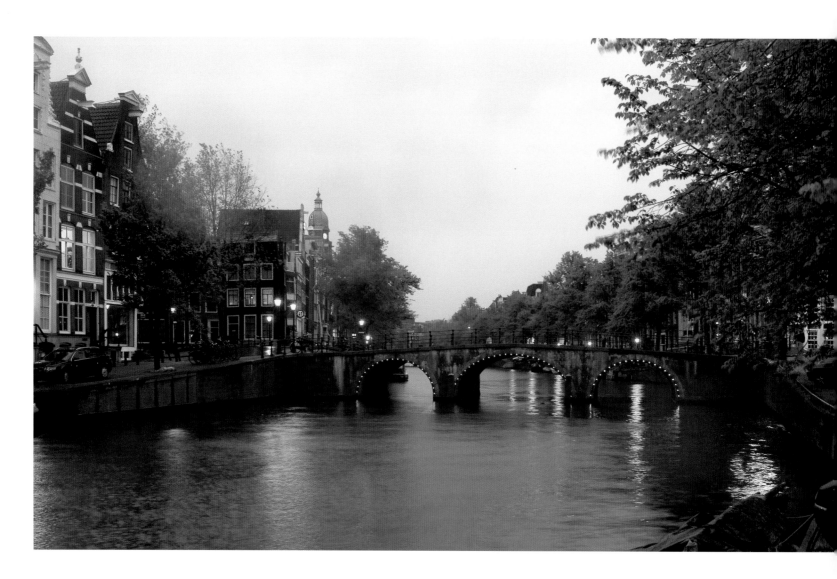

Millennium Bridge, London

The Millennium Bridge over the Thames in London links the City (St Paul's Cathedral) with Tate Modern. The competition for the design of the bridge was won by architect Norman Foster and sculptor Anthony Caro. It is a pedestrian bridge, 320 metres in length, an apparently simple aluminium construction with a four-metre-wide walkway. The railings, balustrades and louvres are made of rustproof steel. The aim of the designers was to allow as unobstructed a view as possible over the river in all directions. The light marks out the breadth of the walkway and runs the length of the bridge. The low positioning of the light means the view is undisturbed.

The illumination is created by the spots fitted into the dark sections of the bridge. These light up the reflective material on the inner side of the tubes, turning them into an evenly distributed light source with no visible lamps. This is a good solution for a bridge that moves.

The public reacted so enthusiastically to this new bridge that the construction was seriously put to the test by the masses of visitors. Further work was undertaken on the bridge for safety reasons and the official opening took place in 2002.

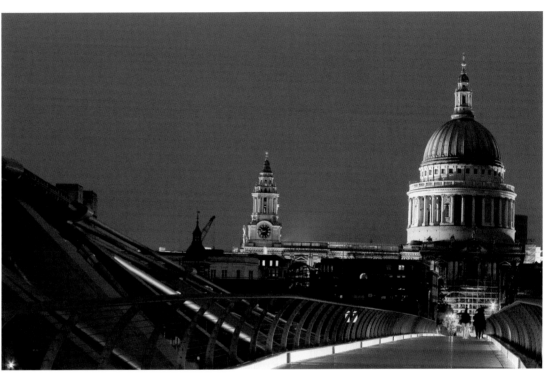

Hoge Brug, Maastricht

The Hoge Brug in Maastricht, a bridge for pedestrians and cyclists, links the new district of Céramique with the old town centre. This bridge over the Maas is 164 metres long and around 7 metres wide. Compact fluorescent lamps have been discreetly fitted into the railings on either side of the bridge, providing sufficient light for the pedestrian and cycle paths. A nice detail is the fact that the light can be seen on the outer sides of both railings through small round openings by the light source. The bridge can be reached from either riverbank by a lift or by a long, low flight of so-called 'lazy' stairs. The view over the Maas is unimpeded, as the bridge is around ten metres above the water when the river is at its normal level. The bridge is used a lot in the evening as well.

Bridge design architect René Greisch, Bureau d'études Greisch, Liège, Belgium

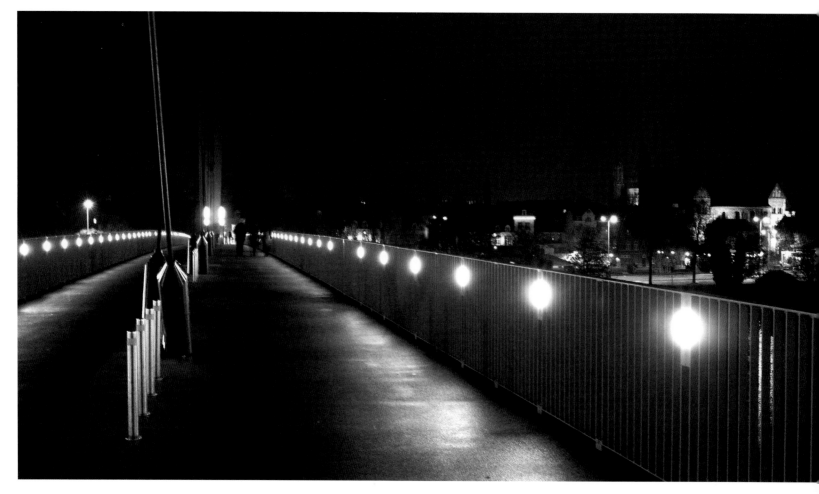

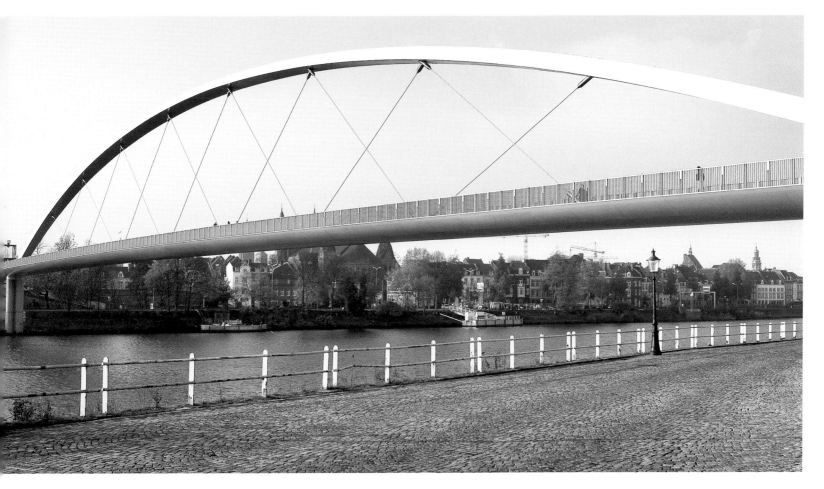

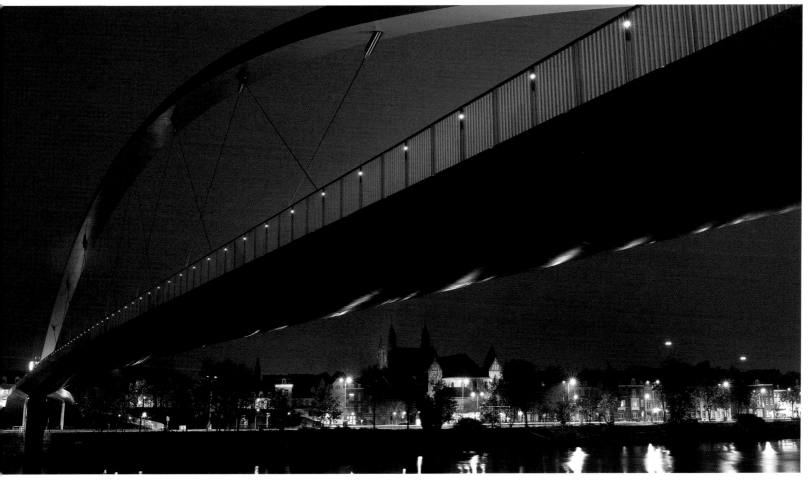

Use of Colour

The use of computer-controlled 'colour wheels' (colour filters) and the constant advances in LED technology that allow all sorts of different shades to be created have produced many new possibilities for programming coloured light. These possibilities are also accompanied by challenges that are not limited only to advertising purposes. The use of blue, red, green, yellow, etc. for the lighting and illumination of buildings in the public space is approaching levels that used to be common only in advertisements. There is no objection in principle to the use of colour for temporary, festive, special events, nor is there in cases where a material is shown to its best advantage in a particular light source. Sometimes, in unexciting environments such as tunnels, the use of coloured lamps helps to create a sense of security.

Excesses of coloured light will have to be ruled out or restricted in the long term, just as advertisements that give off too much white or coloured light are now subject to regulation in many cities. The use of coloured light in the public space also demands special provisions as far as damage and maintenance are concerned.

This penchant for colour, often prompted by commercial interests, disturbs the neutrality and anonymity of the evening atmosphere. Reputable designers have demonstrated sensitive use of the various options. Blue, for example, is a colour that clearly inspires people. It is a colour of peace and calm; it gives a feeling of detachment and depth, in contrast with the active colours of red and yellow. Design-

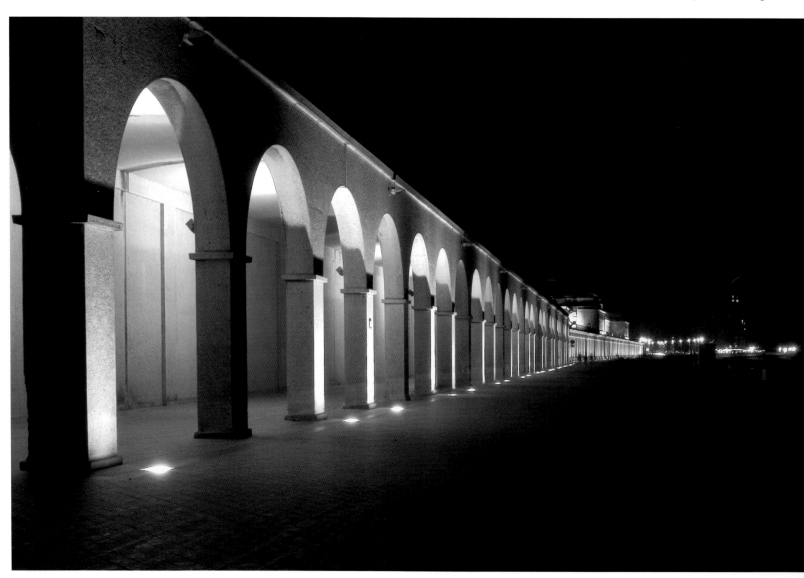

ers often refer to blue as a dreamy colour; it creates a certain coolness in the atmosphere.

Some residential districts and areas by the water, such as harbours, are placed in a blue light. The user of the space only notices that all the surroundings are illuminated with this colour when there is a contrast with another colour (for example, with light coming from a window). A wealth of choice is always interesting, but the master is revealed by a sense for restraint.

The illuminated Venetian and Royal Galleries in Ostend form part of the lighting plan for the seawall. The bulk of the hotel section above the Thermae Palace Gallery is illuminated in blue. The blue can easily be seen in this setting and the colour in itself generally does not cause any irritation. This lighting is part of the master plan for the city of Ostend, which is designed to draw additional attention to the buildings.

It is not (as yet) particularly common for public buildings that are not theatres or other entertainment venues to be illuminated with coloured light. The colourful combination of lights at the railway station in Eindhoven makes the building look attractive. The colour of the clocks goes from green to blue, to red, then yellow and white. Blue was selected for the canopy and this is reflected in the glass wall below. The view inside the building, where the relevant lights are located, gives a very lively look to the station as a whole.

Lighting design Raymonde den Uyl, Freestyle, Eindhoven

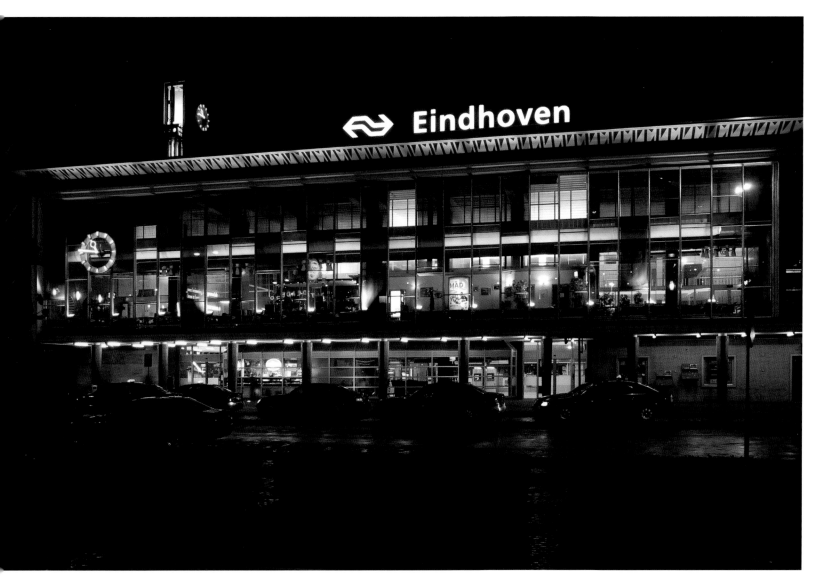

Chapel, Nijmegen

This chapel in the centre of Nijmegen, which dates from around 1431, is now used as a centre for meditation and cultural events. Lights with coloured LEDs, which are regulated by a computer program, illuminate the chapel walls with an alternating cycle of green, blue and purple light. The ground spots that are responsible for creating the different colours are installed at the base of the chapel. These changes in colour nullify the sacred atmosphere of the original chapel, and undermine the architecture itself, making this old building a foreign body in its surroundings.

Lighting design Marco de Boer Lighting, Primo Exposures, Hillegom

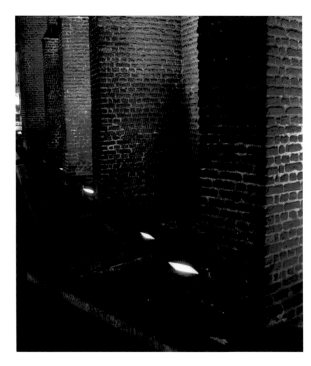

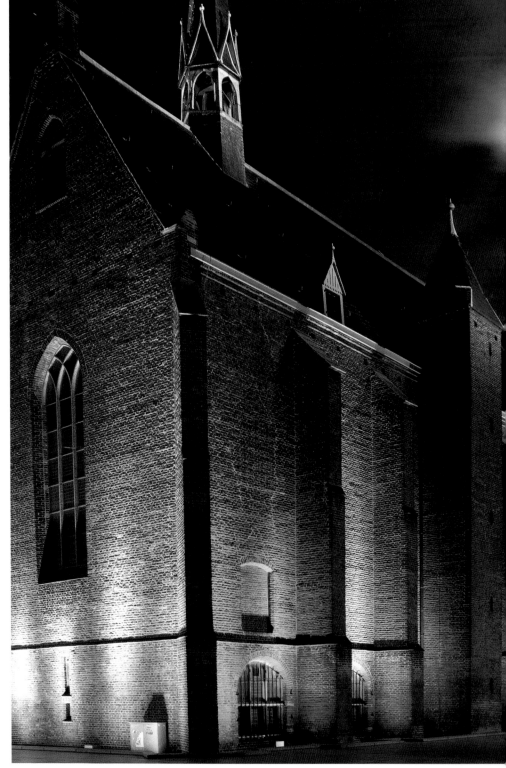

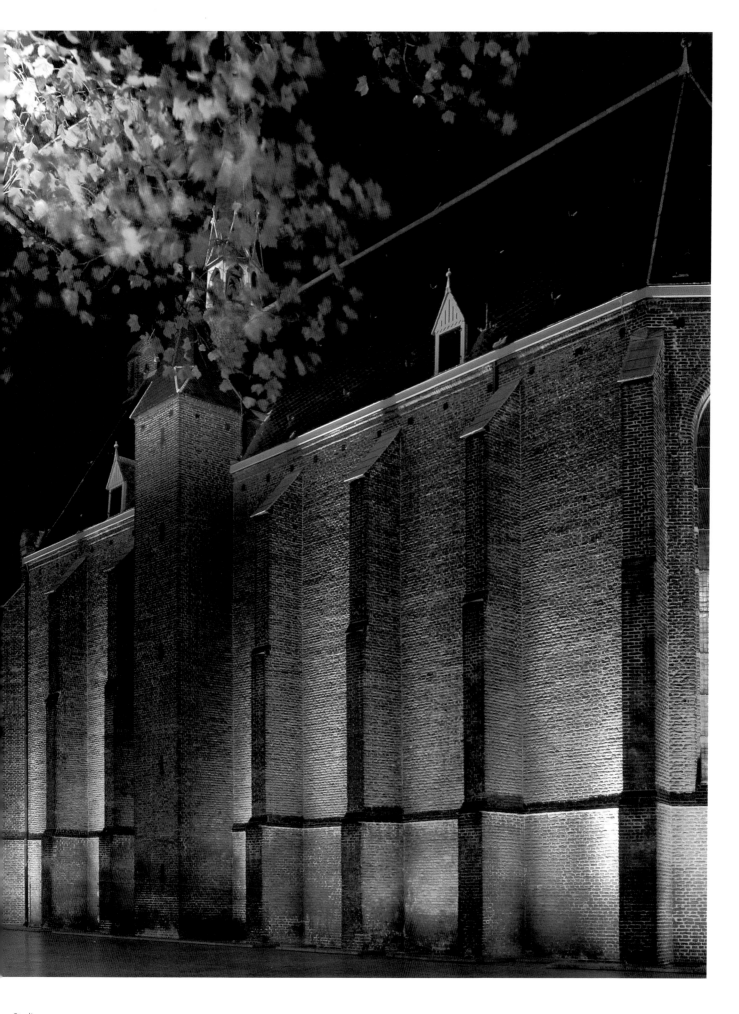

Light Pollution

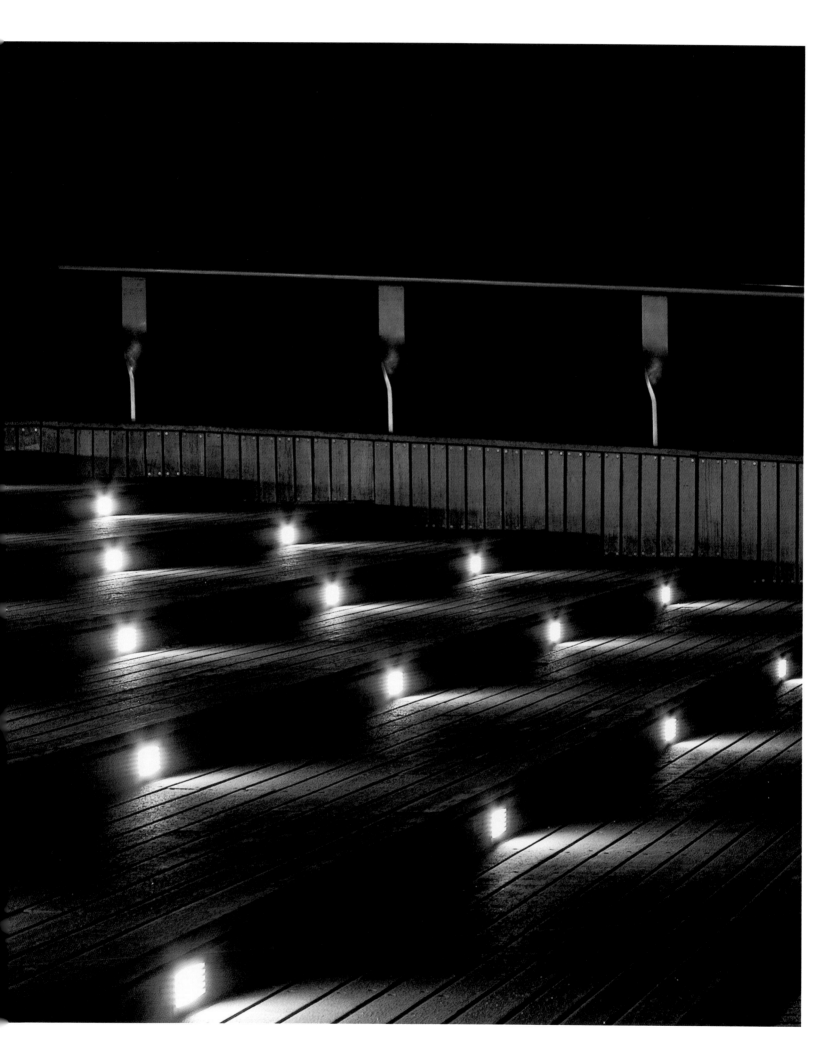

Rapid developments in the field of new light sources are seen as positive, yet at the same time we are sometimes overwhelmed by an excess of light. The increasing light efficiency of most lamps is recognised as a useful development, and there is now also a wider range of uses for this technology. Unfortunately, however, we use the improved light sources in a careless manner. Badly utilised lighting creates annoyance. A consideration of professional use of the technology would appear to be necessary.

The term 'light pollution' is used to describe an excess of light and/or light that is not directed accurately.

An annoying excess of light occurs with:
· greenhouses giving off light;
· illuminated advertising and display windows;
· over-illuminated buildings;
· excessive road lighting;
· sports lighting that extends over too large an area.

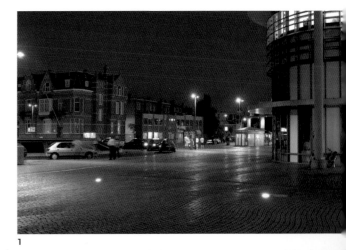

It has long been known that the growth of plants in greenhouses is encouraged by the light of a nearby streetlamp. Bright, modern lights in greenhouses on farms and in market gardens make the plants grow, but can also be detrimental to the surroundings. Greenhouses are situated outside built-up areas and their lights often make them visible from quite a distance. The nuisance created by this new method of cultivation has led to an organised response. Certain requirements have been stipulated following complaints about light pollution from greenhouses. Damage to third parties can result in costs; because money was involved, measures were introduced relatively quickly in this area.

In nature, inappropriate light has an influence on the rhythm of animals' lives; it may cause changes in behaviour, for example, with animals being active for too long or too early in the morning. Excessive light also has an impact on scientific research: disrupting telescope observations, for example.

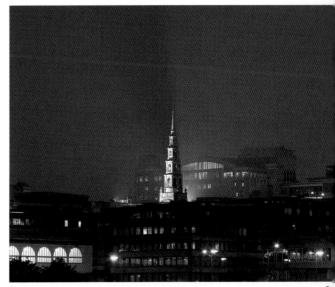

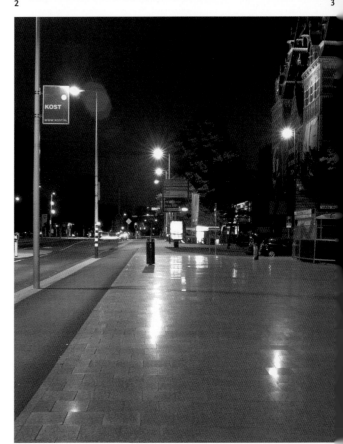

In an urban environment, there are situations that require the introduction of standards for lighting, particularly for illuminated advertising, display windows and buildings. These standards can also relate to the safety or to the aesthetic aspect of the illumination. Excess light creates a strong contrast with the surroundings. The excess of light coming from the advertising hoarding, the display window or the over-illuminated building makes the surroundings look even darker than they actually are. Sometimes public street lighting can scarcely compete with all the other lights.

The degree to which an advertising board causes a nuisance in dark surroundings is determined by the following factors:
· the luminance of the light source;

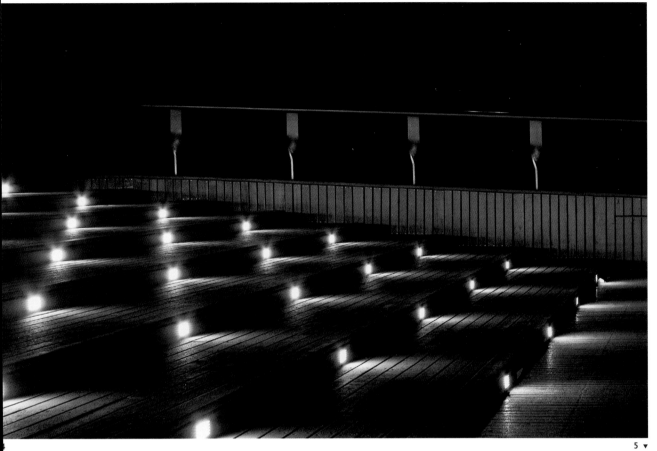

1
Light pollution is a waste of light, causing annoyance for users of public spaces and for residents in the immediate surroundings. Spotlights set into the ground are not always used appropriately. On this station square, they are not directed at a specific object, so they 'prick' the eye unpleasantly. These spotlights require a lot of careful maintenance and are vulnerable to vandals. Two of around thirty lights are working; they don't seem to be missed.

2
Badly adjusted or incorrectly selected floodlights direct more light into the sky than at the object. This is a waste of light and disrupts the darkness.

3
The light sources in this street lighting are reflected in the shiny polished-granite floor surface. This makes walking rather tricky because of the apparent slipperiness and the dazzle.

4
Incorrectly applied lighting to indic-ate the difference in height of steps. Anyone climbing the stairs is dazzled. The lighting does work when descending the stairs.

5 ▼

5
Badly shielded lighting in the railings of this bridge is a nuisance for anyone crossing. From this position, you can no longer see the water.

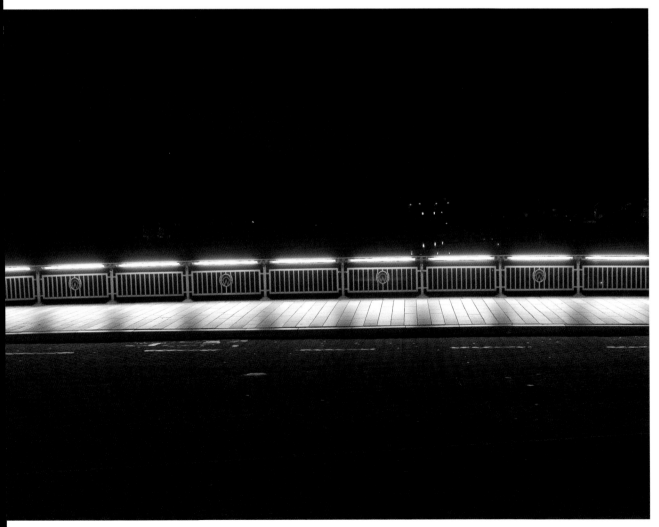

- the luminance of the surroundings;
- the solid angle from which the light source may be seen;
- the position of the light source relative to the direction from which the observer is looking, known as the 'position factor'.

It is interesting to note that changes in lighting (on-off-on-off) can be thought a lot more annoying than continuous light and that coloured light (from illuminated advertising) appears to be more of a nuisance than the same level of white light.

The Commission Internationale de l'Eclairage (CIE; International Commission on Illumination) has now established recommendations and standards to regulate the excess of light at an international level. Individual European countries are also dealing with the problem of light in their own way and have introduced rules for this purpose. To state just a few of these:
- light emitted should be reduced, where necessary;
- no public lighting should shine into houses, or the other way round;
- glare should be avoided.

Further conditions are that the night sky should remain visible, as should the natural surroundings.

Guidelines have been created for the design of advertising hoardings with regard to the ratio between maximum and minimum luminance values. In general, there are large contrasts on advertising hoardings, for example, between the letters and the background. This has the result that it is difficult, if not impossible, to determine the average luminance. It was therefore decided that the recommendations should indicate limits for the maximum luminance, depending on the surroundings and the surface of the hoarding. These are limited to dark surroundings, i.e. completely free of illumination, and surroundings that at least have normal public lighting. It appears that, for example, a large hoarding with a particular maximum luminance and a small hoarding with the same maximum luminance can have a different effect, depending on the size and colour of the notice. A message can be in white on a black background or in black on white.

Numbers and calculations only begin to play a part when an illuminated advert stands out in dark surroundings, causing a nuisance to local residents, motorists and other passers-by. In a light, busy environment, size and luminance need to be kept in check.

Excessive light can be annoying in a number of ways. Local residents might be troubled by the light falling on their exterior walls or windows from illuminated buildings, diffused light from floodlights or an object within their field of vision that is too brightly lit. For floodlights and objects that are too brightly lit, the limits relate to brightness and to luminance. The eye adjusts and determines the

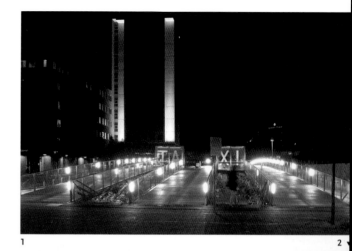

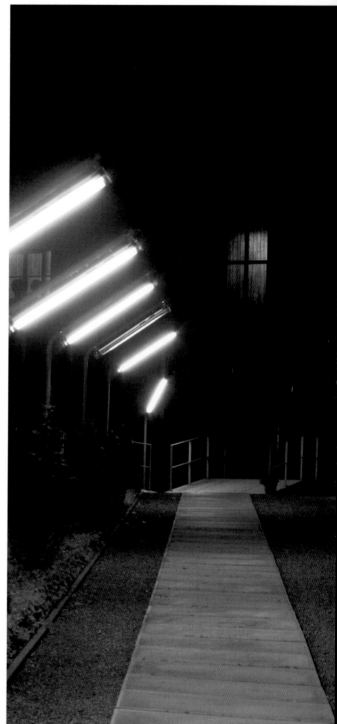

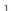

1
A taxi rank with so much unshielded, low-positioned light dazzles the drivers and drowns the surroundings.

2
A pathway across a courtyard in a residential building. The walkway is well lit, but the low-positioned, unshielded fluorescent tubes dazzle and block the view of the surroundings, also compromising safety.

3
Lights on a post directed at the surface of this rather narrow road dazzle the road-users. Motorists find it impossible to adjust because of the short distance between the posts and the speed of the cars.

4
A shopping arcade on two levels, which both have an excess of visible public lighting, advertising boards and illuminated display windows, so that you 'can no longer see the wood for the trees'. This is an example of an annoying excess of light.

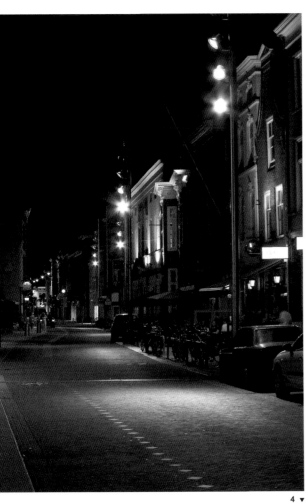

4 ▼

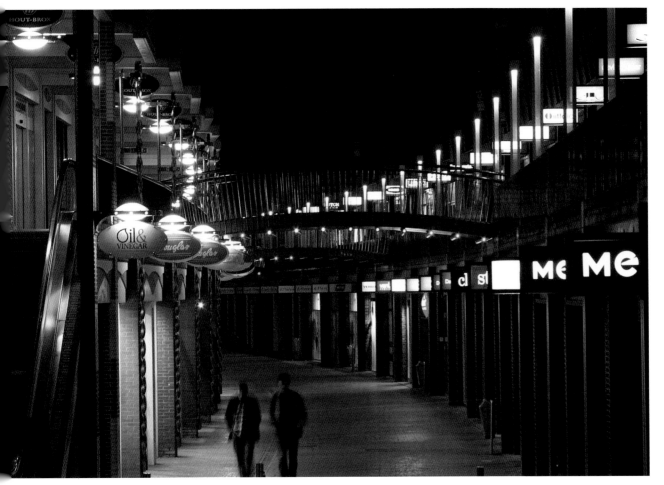

1

A house in a quiet residential area. Excess of light and colour do not do justice to the architecture. The advertising board in the foreground is too bright, making it a glowing focal point for the whole area.

2

Commercial properties on a long residential street alongside a park. The illumination is incongruous and dazzling. It makes the well-lit street appear relatively dark.

3

There is a tendency to light all properties in the same way. This sometimes doesn't work, as is demonstrated by the exaggerated illumination of the white façade. This façade receives unwarranted attention, detracting from the other illumination and disturbing the neighbours.

4

Buildings lit from inside can help to make the surroundings more attractive in the evening and at night. A pleasant effect can be achieved when the interior is made into the exterior. In this large building, part of a hospital complex, only the badly shielded lamps can be seen. This disrupts the whole area, also making it appear darker.

5

The advertising boards are high up, so the extremely high luminances do not actually disturb the pedestrian. From a distance, though, it is clear that the large surface area and the high luminances make this spot too much of an 'eye-catcher'. The contrasts are so great that the façade behind can no longer be seen, unless the lights are on inside the rooms. The lowest board is the most unpleasant, with a value of 300 cd/m².

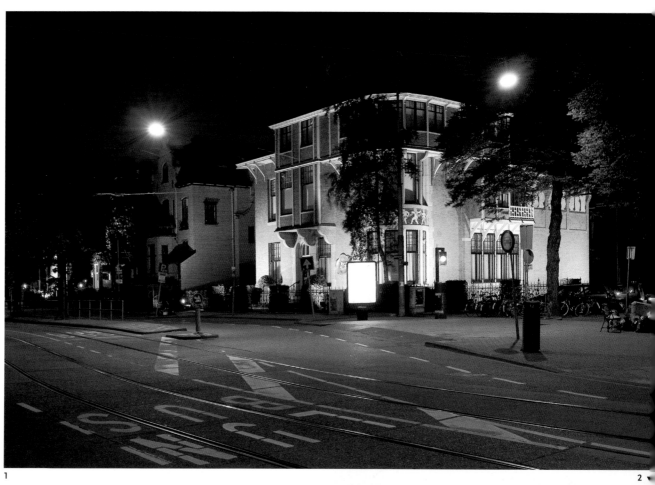

1

2

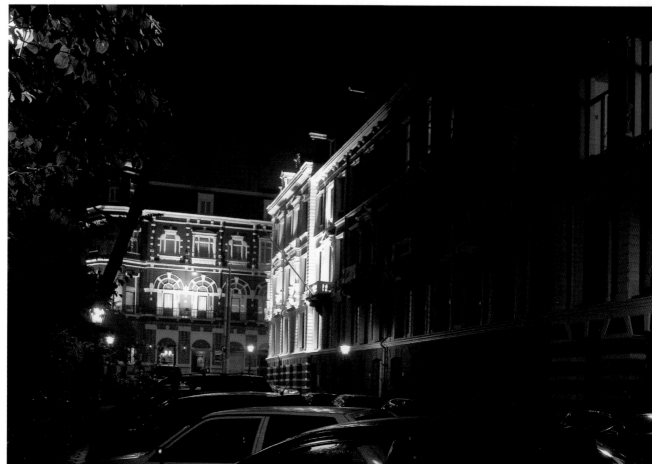

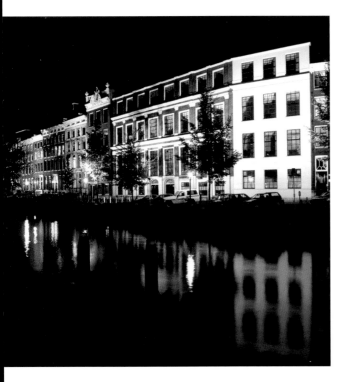

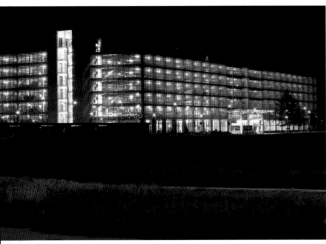

5 ▼

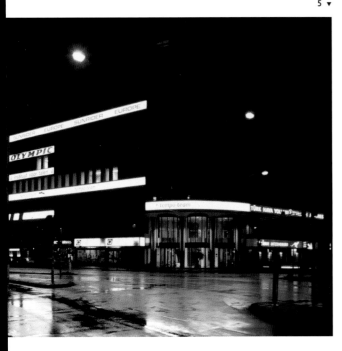

tolerable amount, depending on the light in the surrounding area.
The following tables serve as a guideline for lighting designers.

Parameters	Conditions	Surrounding zone			
		E1 Natural area	E2 Rural area	E3 Urban area	E4 City centre industrial area
illuminance E_v on the façade	daytime to late evening 07.00 – 23.00	2 lux	5 lux	10 lux	25 lux
	Night 23.00 – 07.00	1 lux	1 lux	2 lux	5 lux
luminous intensity (cd) of each luminaire	daytime to late evening 07.00 – 23.00	2500 cd	7500 cd	10 000 cd	25 000 cd
	Night 23.00 – 07.00	0 cd*	500 cd	1000 cd	2500 cd

* The light source may not be visible.

Illuminance relates to the permitted amount of light that may fall
on a façade (with windows).

Luminous intensity refers to the brightness of the light from a
floodlight or other light source that can enter the eye.

light-technical parameter	Surrounding zone			
	E1	E2	E3	E4
average luminance, façade or object (L_{avg})	0 cd/m²	5 cd/m²	10 cd/m²	25 cd/m²

The luminance values apply to a façade or other object that is visible
from the residence, for example an illuminated façade opposite the
window.

material of the illuminated surface	maximum permissible average illuminance (lux) surrounding zone			
	E1	E2	E3	E4
white stone white marble pale pastel colours (reflectance: 0.9)	0	18	35	88
lightly coloured stone lightly coloured marble pastel colours (reflectance: 0.6)	0	26	52	131
coloured stone cement coloured marble (reflectance: 0.3)	0	52	104	262
dark stone grey granite dark marble (reflectance: 0.1)	0	157	314	785
aluminium polished surfaces (be aware of possible reflection interference)	0	175	350	875

By way of illustration, these luminance limits are calculated in lux
values, linked to the reflectance of the various materials.

Recommended luminances for the illumination of buildings can vary widely, even in relation to the CIE guidelines. The figures stipulated by this international committee are limits that should not be exceeded. The values are different from those of public street lighting, where the important thing is that traffic should be visible. Illumination also involves avoiding annoyance to other people.

These values are high, when you realise that a dark façade in a light environment has a value of 785 lux, according to the table (illuminance on the façade). It seems inevitable that local residents and users of the buildings opposite will experience annoyance. Even in cases where there are no buildings opposite, there is still a waste of energy.

It is doubtful whether dark façades even need to be illuminated when they are in light surroundings. There are other ways to give them special attention, for example by lighting them from within, with well-chosen light sources and in moderation. In many cases, public street lighting can be sufficient; illumination is then, of course, superfluous.

For buildings in general, designers have their own opinions about the use of too much or too little light and about the creation of contrast. With historical buildings in particular, the cohesion of the features of the architecture is important for the unity of the whole.

Complaints about light pollution have led manufacturers of luminaires to look more carefully at the light emitted. Undesirable light emission results in both an excess of brightness and a loss of energy.

Technical ingenuity and the provision of rules must contribute to the harmony and aesthetics of the street scene, which are necessary conditions for the quality of the living environment.

Many lighting manufacturers have realised that directing and limiting the light emitted can be important in avoiding light pollution. Better optics (reflectors) and good shielding can help a great deal. (Illustrations used by permission of iGuzzini)

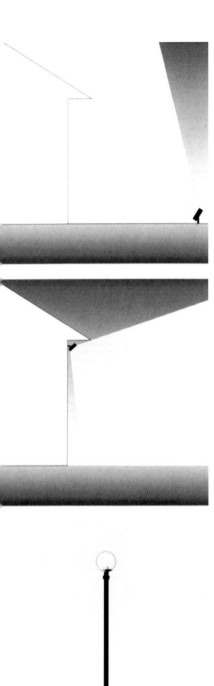

The façade of the building is lit up, but some of the light is lost upwards.

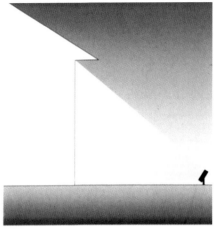

Whenever possible, the light should be directed downwards. If this is not possible, we recommend that light refractors, screens and asymmetrical optics be used as these aim the light flow onto the surface of the building and minimize the loss of light.

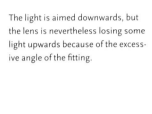

The light is aimed downwards, but the lens is nevertheless losing some light upwards because of the excessive angle of the fitting.

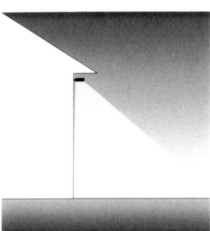

The use of asymmetrical optics enables a perfect illumination whilst avoiding the excessive angling of the other fixtures.

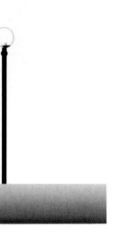

The diagram shows a fixture with a high degree of loss of light skywards: these are often used in pedestrian areas.

Correct illumination requires the use of fixtures fitted with light refractors or reflecting louvres.

In street lighting, it is extremely important to use cut-off optics which reduce direct glare.

The use of high-performance reflectors also provide energy-savings.

Maintenance

Street lighting, the illumination of buildings, the lighting of objects, fountains and such like all require maintenance. It is unpleasant when a section of the lighting stops working, particularly when street lighting is involved. A building that is only partially illuminated is not a pretty sight. In such a case, it is preferable to switch off all of the lighting.

Maintenance includes replacing the light sources in good time and keeping the reflectors (the interior of the luminaires) and the glass shades clean. The companies responsible for maintenance have schedules for this work. The cleaning of the luminaires takes place when the lamps are changed. This obviously used to happen more often than it does now. Lamps now last longer and this means that the intervals between cleaning are also longer; cleaning takes place every three or four years. Only rarely – it's a question of finance – is cleaning carried out more frequently, for example at critical points in the city, where replacement of the lamps takes place as quickly as possible. An incidental note on deficient maintenance: dirt reduces the amount of light by 20-40% and that's a significant amount.

Those who are responsible for the maintenance obviously take a critical look at the design. Engineers and installers are often good sources of information. They hope that rain and wind will have a chance to wash away some of the dirt and prevent the accumulation of dust. Designers of exterior luminaires are well aware of this, but cannot always accommodate such requests.

The light produced by most gas-discharge lamps reduces more quickly once they have reached their average life expectancy, but they still keep working. Some more recently developed light sources stop working at a point that is closer to the average life expectancy. This development has resulted in a demand for systems that indicate when a light source has stopped working without requiring individual observation. There are now systems that use a computer program to report when and where a certain percentage of lights is no longer working and needs to be replaced.

LEDs as street lighting and in floodlights are on the increase, with an attractive life expectancy of around 20,000 hours and more. When LEDs are nearing the end of their life, the whole luminaire is replaced. The amount of light emitted is not yet sufficient for the illumination of high walls and wide streets. Coming years will reveal whether this will be a viable option for such situations.

Floodlights are used for the illumination of fountains and other objects. They are treated in the same manner as public street lighting. The lighting of fountains is easier to maintain. When they are not in operation, usually in the winter, the luminaires are removed, cleaned and, if necessary, the lamps are changed.

Underwater spots always have to be accessible for maintenance. The vegetation in the water means that the lights get dirty and the amount of light is therefore reduced. The glass also needs to be cleaned in such situations.

Spotlights installed in the ground, which are mainly used for the illumination of buildings and other objects, may be vulnerable to damage in busy urban environments. Their horizontal positioning allows dirt and dust to settle on them. The position of the lights also invites vandalism and means that they may be covered up, intentionally or otherwise. This overheats the workings of the light and reduces its life expectancy. In pedestrian areas, the light can disturb passers-by.

Changing the light source in this sort of luminaire can be quite a tricky job, which needs to be done carefully. The luminaires have an IP 65/67 protection factor, so if they are not handled properly, that usually means the end of the protection. Condensation can occur and the mirror may become dirty.

As well as the light source, the rest of the system is subject to wear and tear. Electronics and wiring also have a limited life expectancy. The housing of lamps can, however, last for a long time, as is demonstrated by old streetlamps.

Good maintenance is a precondition for the successful functioning of illumination and public street lighting. A lack of funds for maintenance or insufficient attention from the responsible parties (council, contractors or special maintenance service) may result in deficiencies.

Christa van Santen is a visual artist and a lighting designer. Until 1990 she lectured in Study of Forms and in Light in Architecture at the faculty of Architecture and Planning, Delft University of Technology. Together with A.J. Hansen, she set up the lighting consultancy LITE daglicht - kunstlicht, which she continued after Hansen's retirement in 2001. She has co-written a number of books about illumination with Hansen: *Licht in de architectuur* (J.H. De Bussy, Amsterdam 1985), *Daglicht, kunstlicht: een leidraad* (Delft University Press, Delft 1989), *Zichtbaar maken van schaduwpatronen* (Publicatieburo Bouwkunde, Delft 1989), *Simuleren van daglicht* (Publicatieburo Bouwkunde, Delft 1991). Van Santen has also published articles in journals including *Licht und Architektur*.

Colophon

Author
Christa van Santen, Amsterdam

Project coordination
Astrid Vorstermans, Valiz, Amsterdam

Photography
Joke van Hengstum, 's-Hertogenbosch, except:
p. 32-1: Emilio F. Simion (for iGuzzini, Recanati, Italy)
p. 41-6: photo taken from *International Lighting Review* 1994/4
p. 52-1, 54-1, 2, 3, 55-4, 64-3, 65-5, 6, 71-4, 5, 72-3, 73-4, 75-7, 8,
81-5, 6, 7, 85-3, 4, 86-1, 2, 97 (right), 119-3, 5: Hans Krüse, Delft
p. 72-1: Christa van Santen, Amsterdam
p. 72-2: Giuseppe Saluzzi (for iGuzzini, Recanati, Italy)
p. 84-2, 93: Linus Lintner (for Kardorff, Berlin)
p. 74-4, 94, 95 drawing/photographs: Lightmatters
(Phoenix/Stammers, London)
p. 92: drawing Brandenburger Tor from *Licht/Architektur/
Technik* 2/2003
p. 105: taken from *International Lighting Review* 001
'city beautification'
p. 107: drawing from *Detail*, December 1999

Photographic manipulation
Hans Krüse, Delft with Christa van Santen, Amsterdam

Editing
Els Brinkman, Astrid Vorstermans, Amsterdam

Translation from Dutch into English
Laura Watkinson, The Hague

Graphic design
Piet Gerards & Maud van Rossum (bPG), Heerlen/Amsterdam

Lithography and printing
die Keure nv, Bruges

This book has also been published in a German language edition
(3 7643 7521 3).

A CIP catalogue record for this book is available from the Library
of Congress, Washington D.C., USA
Bibliographic information published by Die Deutsche Bibliothek
Die Deutsche Bibliothek lists this publication in the Deutsche
Nationalbibliografie;
Detailed bibliographic data is available in the Internet at
http://dnb.ddb.de.

© 2006 Birkhäuser – Publishers for Architecture,
P.O. Box 133, CH-4010 Basel, Switzerland
www.birkhauser.ch. Part of Springer Science+Business Media
Printed on acid-free paper and produced from chlorine-free pulp.
TCF ∞

Printed in Germany
ISBN-10: 3 7643 7522 1
ISBN-13: 978 3 7643 7522 5

9 8 7 6 5 4 3 2 1